The Annual of the Type Directors Club
Typography Twenty-Six

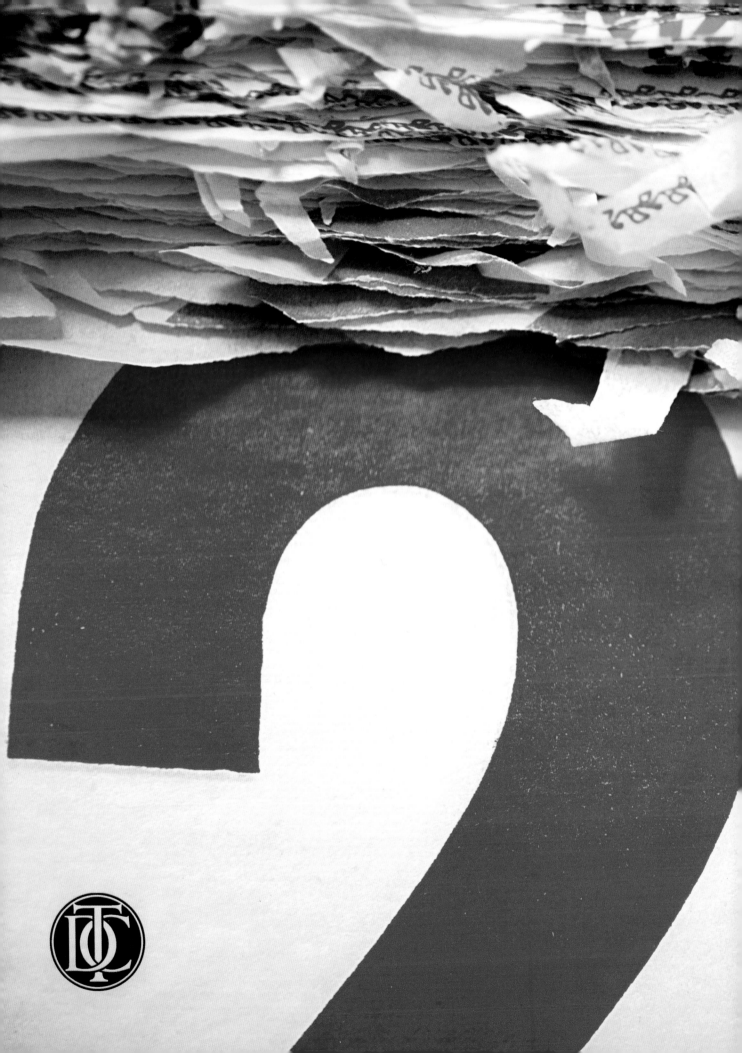

THE
ANNUAL
OF THE
TYPE
DIRECTORS
CLUB

TYPOGRAPHY
TWENTY-SIX

TDC 51

TYPOGRAPHY 26

Copyright © 2005
by the Type Directors Club

First published in 2005 by
Collins Design,
An imprint of HarperCollins *Publishers*

10 East 53rd Street
New York, NY 10022-5299

DISTRIBUTED THROUGHOUT THE REST OF THE WORLD BY
HarperCollins International

10 East 53rd Street
New York, NY 10022-5299
Fax: 212-207-7654

HarperCollins books may be purchased for
educational, business, or sales promotional use.
For information, please write:
Special Markets Department
HarperCollins Publishers Inc.

10 East 53rd Street
New York, NY 10022

THE LIBRARY OF CONGRESS
has cataloged this serial title as follows:
Typography (Type Directors Club (U.S.))
Typography: the annual of the Type Directors Club.
New York: HDI
2005-Annual.

Typography (New York, NY)
1. Printing, Practical – Periodicals.
2. Graphic arts – periodicals.
1. Type Directors Club (U.S.)

FOR INFORMATION
Harper Design Int'l
10 East 53rd Street
New York, NY 10022

FIRST PRINTING, 2005
Printed in China
Produced by Crescent Hill Books
Louisville, KY.

ACKNOWLEDGEMENTS

The Type Directors Club gratefully acknowledges the
following for their support and contributions to the
success of TDC51 and TDC² 2005:
DESIGN Pure+Applied
EDITING Susan E. Davis
JUDGING FACILITIES Fashion Institute of Technology
EXHIBITION FACILITIES Arthur A. Houghton Gallery,
The Cooper Union

CHAIRPERSONS' AND JUDGES' PHOTOS
Graham MacIndoe

TDC51 COMPETITION (CALL FOR ENTRIES)
DESIGN HONEST
PRINTER UNIMAC Graphics
PAPER Neenah Paper
PREPRESS SERVICES A to A Graphic Services, Inc

TDC 2005 COMPETITION (CALL FOR ENTRIES)
DESIGN Incipit

THE PRINCIPAL TYPEFACES USED IN COMPOSITION OF
TYPOGRAPHY 26 ARE
Miller Text Roman, Miller Text Italic,
MillerDisplay RomanSC, MillerDisplay ItalicSC

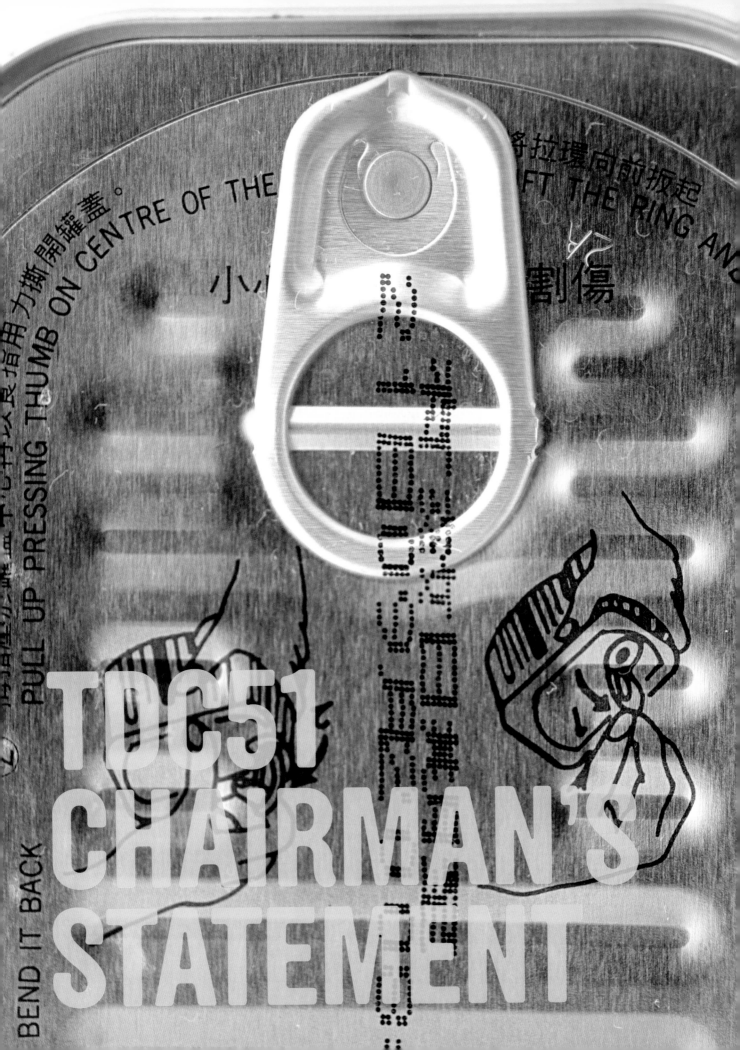

BOOKS COME IN THREE BASIC VARIETIES

The meal, the machine, and the metaphor. The meal is a book you read from beginning to end—one you consume. Fiction is the mainstay of this category. The machine is a reference book, one you use over and over again until it breaks down or its content loses relevance. The metaphor represents an idea through its very "bookness."

Typography 26 is part machine and part metaphor. Those talented enough to be included and those looking for a talented designer will use it as a search tool. They'll study specific parts—work by a specific designer, annual reports, typefaces used, etc. Students and hopefuls will use it as a cookbook—a set of recipes for giving form to content.

Its role as a metaphor, however, will be its most lasting. It's the role the Typography annuals have played since the first one was published in 1980. This book and the others before it are markers of time, markers of the who made and what made the best typographic design of a given year. Designers, art directors, studios, clients, and typefaces become part of the historical record by being recognized for their excellence.

Selecting the best typographic work of 2004 from the impressive pool of entries was no small feat. We are all grateful to the jury—Cecilia Dean, Evan Gaffney, Christopher Mount, Jonathan Notaro, Piet Schreuders, Patrick Seymour, and Gabriele Wilson—for taking time from their busy schedules, braving a New York blizzard, and pouring over the 2,456 entries from 37 countries.

Enjoy *Typography 26* as a reference book, as a buttress for bragging rights, and at some point in the future as a marker of the typographic times through which we lived.

CHARLES NIX, TDC 51 CHAIRMAN

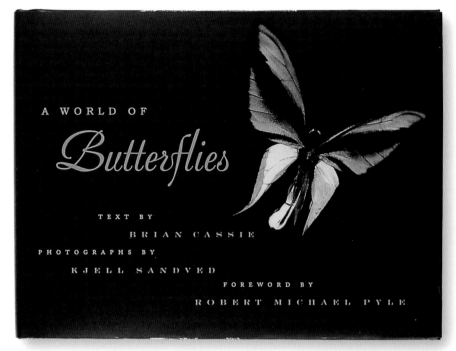

CHARLES NIX

Charles Nix is a designer, typographer, and educator. He is the chair of communication design at Parsons School of Design and a partner in the New York publishing firm Scott & Nix, Inc. He has designed over 200 books, including Norton's *Star Atlas*, one of the AIGA 50 Books of 2003.

FIGURE 7. *Different types of telescope mounting. (a) A simple altazimuth mounting for a small refractor. (b) a Dobsonian altazimuth mounting for a Newtonian. (c) a German equatorial mounting for a refractor. (d) a German equatorial mounting for a Newtonian. (e) a single-arm altazimuth fork mounting for a computer-controlled Schmidt–Cassegrain. (f) an altazimuth fork mounting for a computer-controlled Schmidt–Cassegrain.*

telescope to be moved less often to keep an object in view. While these eyepieces are generally very well made, with multilayer coatings to maximize the light transmitted through their many elements, they also tend to be quite expensive and heavy.

MAGNIFICATION The magnifying power of a telescope is determined by the ratio of the focal length of its objective lens or primary mirror to that of the eyepiece. For example, a refractor or Newtonian having a focal length of 1500 mm used with an eyepiece of 20 mm focal length will give a magnification or power of 1500/20 = 75 diameters, usually written ×75. Therefore the magnification provided by any eyepiece is not unique, but depends on the focal length of the telescope with which it is used.

High magnification, although it can show more detail than low magnification, has its drawbacks:

(a) the field of view is smaller

(b) the effects of bad seeing are more pronounced

(c) any tremors in the tube, or faults in the drive, become more noticeable.

In addition, low magnification reveals more detail in extensive objects such as comets or large nebulae by concentrating their light. A range of magnifications is therefore necessary for general work, and a minimum of three different powers should be available:

(a) *low power*, about 0.2 to 0.3 times the telescope aperture in millimetres (×20 to ×30 for a 100-mm telescope) for showing the greatest possible area of sky.

(b) *medium power*, about 0.5 to 0.8D (×50 to ×80 for a 100-mm telescope) for general views.

(c) *high power*, about 1.0 to 2.5D (×100 to ×250 for a 100-mm telescope) for studying objects such as close double stars and planets.

For larger instruments the medium and high powers may be cut down somewhat. Powers greater than about ×400 are beneficial because the slight atmospheric tremors that prevail even on the best of nights then begin to affect the image. Very high magnifications also tend to reduce the contrast of lunar and planetary markings, although they can improve the visibility of close detail.

THE BARLOW LENS is a small concave lens that, rather than converges light rays passing through it, is doubly achromatic. When placed before the eyepiece it has the effect of increasing the effective focal length of the telescope by a certain factor, usually ×2. Since the magnification of an eyepiece is proportional to the effective focal length of the telescope, the Barlow lens doubles the range of magnifications obtainable with a set of eyepieces. It also enables high powers to be obtained without the need to use eyepieces of very short focal length and correspondingly small eye relief.

TELESCOPE MOUNTINGS

However high a telescope's optical quality may be, the instrument will not perform as it should unless it is properly mounted. A good mounting must:

(a) prevent the tube from shaking – the image should not vibrate when the eye is brought to the eyepiece or when the focusing knob is turned

(b) allow smooth and responsive control, whether in turning the telescope to seek an object and bring it to the centre of the field, or in keeping it there as the Earth turns

(c) allow the telescope to be pointed anywhere in the sky, or at least to within a few degrees of the horizon.

[32] · PRACTICAL ASTRONOMY

TYPES OF MOUNTING Mountings can be divided into two main types: *altazimuth* and *equatorial* (Figure 7).

In the altazimuth type the telescope is linked to two axes at right angles to each other, one permitting motion in altitude (vertically) and the other in azimuth (horizontally). Traditionally the altazimuth has been associated with small, cheap 'beginner's telescopes', but its mechanical simplicity has led to its recent adoption not only as a popular mounting for more advanced amateur and computer-controlled telescopes, but also for the present generation of large professional instruments. Continual adjustment is necessary in both altitude and azimuth in order to follow a celestial object as the Earth spins, although this is an easy matter for telescopes equipped with a computer-controlled drive. The Dobsonian mounting is a variation on the altazimuth design. In recent years it

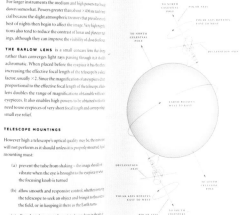

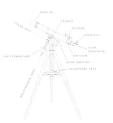

has become very popular for large-aperture, short-focus reflectors, its chief advantage being its simplicity of construction.

The equatorial mounting simplifies matters by having a *polar axis* aligned with the Earth's axis. Driving the instrument around this single axis once a day, in a direction opposite to the Earth's spin, keeps the telescope tube pointing at a given star, as shown in Figure 8. Initial pointing is done by moving the telescope in right ascension (RA), using the polar axis, and in declination, using the *declination axis*. An electric motor usually supplies the drive for the polar axis.

An altazimuth fork mounting can be converted to an equatorial simply by tilting the base at an angle equivalent to the observer's latitude. This is usually accomplished by means of what is termed a *wedge*, usually adjustable over a range of latitudes.

Refractors, reflectors and catadioptrics have different mounting requirements, so they are considered separately.

MOUNTINGS FOR REFRACTORS Since the eyepiece is at the lower end of the tube, and the tube is long, the mounting needs to be high off the ground. The traditional support for a small refractor is a tall tripod or, for apertures greater than about 100 mm, a permanently fixed column. Of the equatorial mounts, the German type has the advantage that it allows the long tube to be pointed towards the region of the celestial pole. Figure 9 shows a typical small refractor on a German equatorial mounting. The labelled parts and accessories are also found on other telescope designs.

MOUNTINGS FOR REFLECTORS Since the tube is relatively short, and the eyepiece (in a Newtonian) is near the upper end, a low mounting is most convenient. The Dobsonian altazimuth mounting has the virtues of cheapness and rigidity: the tube is pivoted

FIGURE 8. *The principle of the equatorial mounting. The polar axis is aligned parallel to the axis of the Earth and is turned east to west to counteract the Earth's rotation.*

FIGURE 9. *Parts of a typical refractor on a German-style equatorial mounting.*

ASTRONOMICAL INSTRUMENTS · [33]

Chart 15

Chart 16

การรถไ

ตั้

ฉบับผู้ถือใช้

ขบวน 201 วันที่ 14.

จาก อยุธยา

1031

จำนวน 1 คน

ค่าโดยสาร

ง่งประเทศไทย

ง

ฏ เลขที่ 497718

เท 4๗ ชั้นที่ ห้อง

.ถึง.........พิชณุโลก

1118

ท หมายเหตุ

11-1 54430

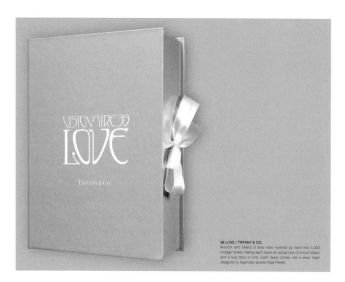

38 LOVE / TIFFANY & CO.
Artwork and tokens of love were inserted by hand into 4,000 vintage novels making each issue an actual one-of-a-kind object and a true labor of love. Each issue comes with a silver heart designed by legendary jeweler Elsa Peretti.

24 LIGHT / GUCCI guest edited by Tom Ford.
Twenty-four large-format transparencies, created by twenty-six artists, are each contained in a custom glossy, fully functional plexiglass light box—the first of its kind when produced in 2008.

12

CECILIA DEAN

Cecilia Dean was raised in California and began modeling at the end of high school when she met photographer Stephen Gan and make-up artist James Kaliardos.

Dean modeled in Paris, Milan, London, and Tokyo and has worked with photographers Richard Avedon, Mario Testino, Steven Meisel, David Sims, Steven Klein, Irving Penn, and Peter Lindbergh.

In 1991 Dean received her Bachelor of Arts degree in English and French literature from Barnard College, Columbia University. In April 1991 she launched *Visionaire* with collaborators Stephen Gan and James Kaliardos. In September 1999 *V Magazine* was launched along with the Visionaire Gallery. In September 2003 *V MAN Magazine* was launched.

Dean teaches a senior seminar on publication design at Parsons School of Design in New York.

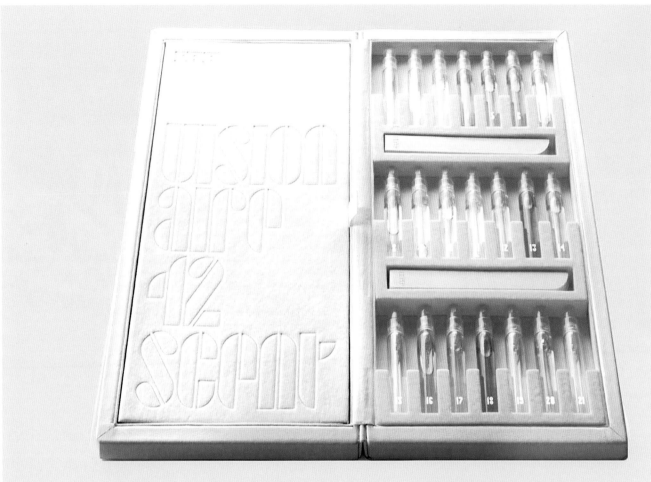

VISIONAIRE 42 SCENT / IFF
Visionaire teams leading visual artists with the professional "noses" of International Flavors & Fragrances Inc. (IFF) to create 21 original scents in numbered glass vials that correspond to 21 specially-created images by artists.

EVAN GAFFNEY

Evan Gaffney is a graphic designer specializing in packaging and collateral for book publishers, record labels, and cultural institutions. Clients include Doubleday, Vintage, Knopf, Simon & Schuster, W. W. Norton, Penguin-Putnam, Nonesuch Records, Public Art Fund, and Dia Art Foundation. Prior to working freelance, he worked as a staff designer at Viking-Penguin and St. Martin's Press. His work has been featured in AIGA 50 Books/50 Covers, the Type Directors Club Annual, *HOW* magazine, and the New York Book Show. Gaffney graduated from Maryland Institute College of Art in 1991 with a BFA in fine arts and currently lives in Brooklyn, New York.

A
MIND
OF ITS
OWN

A CULTURAL

HISTORY

of the

PENIS

·

DAVID FREIDMAN

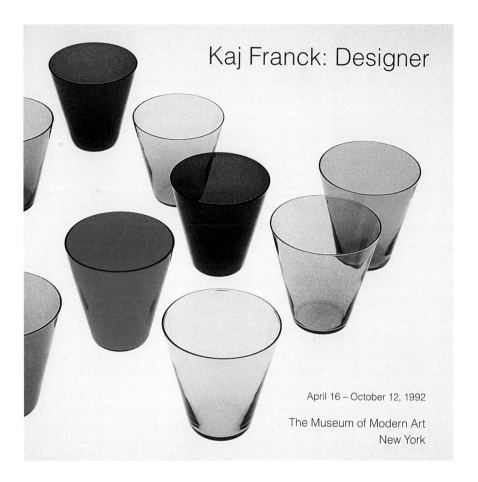

Kaj Franck: Designer

April 16 – October 12, 1992

The Museum of Modern Art
New York

CHRISTOPHER MOUNT

Christopher Mount is an educator, writer, and curator specializing in contemporary and twentieth century architecture and design. He is a professor of design history at the Parsons School of Design and in the masters program for decorative arts at the Cooper-Hewitt Museum. In addition, he has recently curated "Arne Jacobsen: A Centenary Exhibition" at the Scandinavia House, New York and is authoring an upcoming publication on Jacobsen for Chronicle Books. Mount has lectured extensively on design and has written about the subject for numerous general interest and professional journals, including *The Chicago Tribune*, *Dwell*, *Travel and Leisure*, *Architecture*, *Print*, *Glass Quarterly*, *I.D.*, *Interiors*, *eDesign*, and *Graphis*. He is the former editor in chief of *I.D.* Magazine and is currently a contributing editor at the magazine. Before that Mount was a design curator in the Department of Architecture and Design at The Museum of Modern Art, New York for fourteen years and still works as a consultant on the graphic design collection and acquisi-

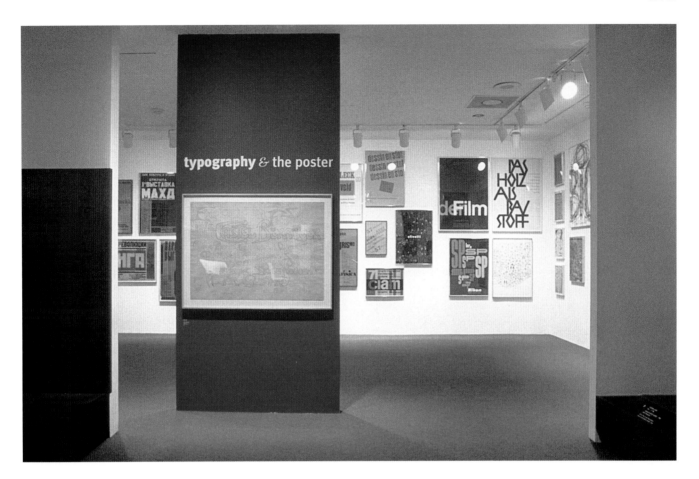

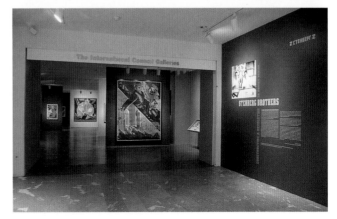

tions. While at the Modern he was curator of numerous exhibitions and author of a number of books devoted to architecture, industrial and graphic design. These included: *Modern Living, Different Roads: Automobiles for the Next Century, Stenberg Brothers: Constructing a Revolution in Soviet Design, Refining the Sports Car: Jaguar's E-type, Piet Mondrian's De Stijl Colleagues, Typography and the Poster, Designed for Speed: Three Automobiles by Ferrari, Projects 35: Stephen Kroninger, Kaj Franck: Designer,* and *The Graphic Designs of Herbert Matter.*

17

18

JONATHAN NOTARO

Already a rising star at Fuel/Razorfish by the time he was twenty-one, whiz kid Jonathan Notaro decided to try his hand at playing the game on his own terms. With a CalArts degree in his pocket and an ace up his sleeve, Notaro founded Brand New School, a boutique design company in Los Angeles, at the age of twenty-three. Brand New School's focus on motion graphics combined Notaro's interest in film and storytelling as well as his background in creating design-rooted structures. Two years after establishing BNS LA, Notaro took off for New York City and brought his innovative and stimulating imagery to Brand New School's Chinatown office. In June 2004 Brand New School LA was happy to welcome Notaro back home. Just like notable CalArts alumni before him, Notaro aims to create projects that stay relevant as opposed to pretty images that quickly expire. CalArts later honored Notaro with a teaching post at their Valencia campus, where Notaro was able to impart his design philosophies to a new group of designers not much younger than himself, who will once again rewrite the rule book like Jonathan Notaro did before them.

19

PIET SCHREUDERS

Piet Schreuders is a graphic designer based in Amsterdam who has designed scores of magazines, books, album covers, and CD packages. He is the author of *Paperbacks, U.S.A.*; *Lay In, Lay Out* (in which he accused the graphic design profession of criminal behavior); and *Voor Verbetering Vatbaar* (in which he corrected mistakes in "found" typography, particularly, street lettering); as well as co-author (with Adam Smith and Mark Lewisohn) of *The Beatles' London*. For years he has compiled, designed, and self-published the cult periodicals *Furore* and *De Poszenkrant*. Schreuders is a dedicated researcher of Hal Roach comedies, particularly those of Laurel and Hardy. His audio reconstructions of the soundtracks of Roach film composer Leroy Shield inspired the formation of Holland's Beau Hunks Orchestra.

EXTRA

★ EXCLUSIVE ★
5 PICTURES OF THE

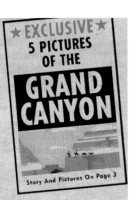

GRAND CANYON

Story And Pictures On Page 3

FINAL ★★

DAILY MIRROR

New York, N.Y.

Thursday, January 26, 1933

Founded 1922

TABLOID SUITE

FOUR PICTURES OF A MODERN NEWSPAPER

Composed by Ferde Grofé

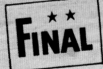

WEATHER
Sunny, 80s.
Tonight:
Cloudburst (44:38)
SUNSET: 8:16
SUNRISE (TOMORROW): 7:05

CONTENTS.

I—Run of the News.
"Tragedy" (Tele-type News Flash)
"Joy" (Tele-type News Flash)
"Sorrow" (Tele-type News Flash)
SPORTS—"They're Off"
II—Sob Sister.
III—Comic Strips.
Old Mickey Mouse at Play
His Lady Friend Joins Him
They Trip the Light Fantastic
Felix the Cat is About—Mickey
and Ladies Scurry for Safety
Old Felix on the Scene
Mickey Crashes Through Windowpane
"Friends Again!"
And They Went Their Ways
IV—Going to Press.
Police Whistle, Pistol Shots
"Scout Car 905 to West Side Trust"
Police Cars Chase Bandits
Police Car Overtakes Gangsters
Going Before the Bar of Justice
Commitment to Penitentiary
11 O'Clock
Electric Chair
Going to Press

JAN STULEN
conducting

METROPOLE ORKEST

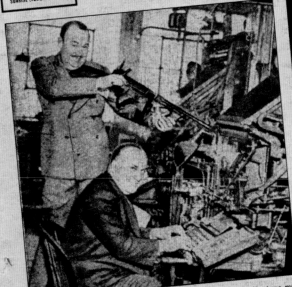

REMINGTON TYPEWRITERS

"Capturing" symphony of linotype machines with machine gun and pistols.

Newspaper Noise...
But It's
Music to Them!

"TABLOID" IN MUSIC — Absorbing auditory atmosphere in *Daily Mirror* editorial, composing and press rooms, Ferde Grofe wrote musical score "Tabloid" which will be rendered by Whiteman and his orchestra at Carnegie Hall.

The composer of "Grand Canyon Suite" arranged his "Tabloid" suite especially for the Whiteman outfit.

Applejack Killed Boy; Bootlegger Sued

Story And Pictures On Page 3

WM. DEMAREST
and
ESTELLE COLLETTE
PEGGY TAYLOR
& GARY LEON
THE MAXELLO

ALSO PLAYING:

GERSHWIN — CONCERTO IN F

Jan Willem Nelleke, piano

22

PATRICK SEYMOUR

Patrick Seymour is a founding partner of Tsang Seymour Design, a multidisciplinary studio focusing on content-driven projects for cultural institutions. A graduate of the Rhode Island School of Design where he studied graphic design and photography, Seymour is also a part-time faculty member in the communication design program at Parsons School of Design.

24

GABRIELE WILSON

Gabriele Wilson has been a book jacket designer at Alfred A. Knopf in New York for five years. She teaches graphic design at Parsons School of Design and is a freelance designer for numerous other publishers worldwide, as well as for The Public Art Fund and Nonesuch Records. Her work has been featured in *Print*, *Metropolis*, *Communication Arts* and in the AIGA 50 Books/50 Covers competitions.

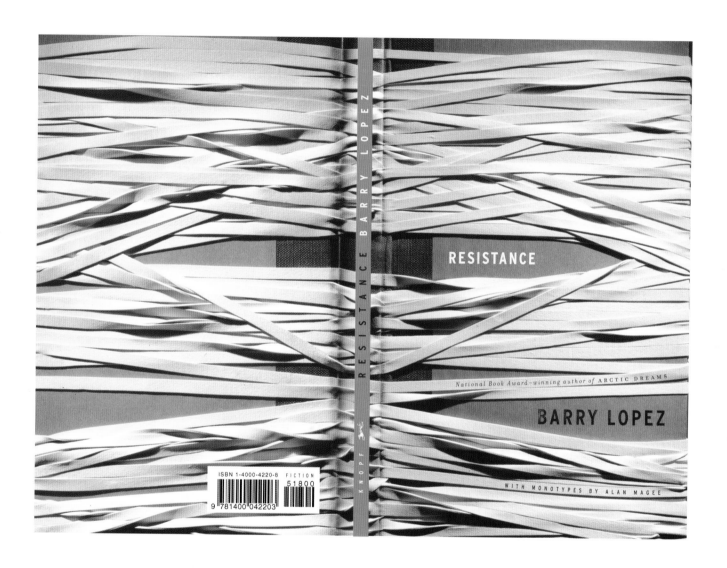

"Fan" Lau

中國上海 Sh

JUDGES'
CHOICES
&DESIGNERS'
STATEMENTS

衣皂

dry Soap

ANGHAI CHINA

衣皂

Werksbereich Schwelgern
Schwelgern plant
Hafen Walsum
Walsum harbor
Kokerei Schwelgern
Schwelgern coking plant
Leitstand Erzvorbereitung
Central tower ore dressing plant
Erzmischbetten
Ore blending beds
Hafen Schwelgern
Schwelgern harbor
Sinteranlagen
Sinter plants
Hochofenbetrieb Schwelgern
Schwelgern blast furnace plant
Werksbereich Bruckhausen
Bruckhausen plant
Feuerbeschichtungsanlage 1
Hot dip coating line 1
Kaltbandwerk 1
Cold strip mill 1
Elektrolytische Beschichtungsanlage 1
Electrolytic coating line 1
Gießwalzanlage
Casting rolling plant
Warmbandwerk 1
Hot strip mill 1
Stranggießanlage
Continuous caster
Eisenbahn und Häfen GmbH
Eisenbahn und Häfen GmbH
Gesundheitszentrum
Health department
Forschung
Research
Anwendungstechnik
Applications engineering
Oxygenstahlwerk 1
bof shop 1
Sozialbetriebe
Social center
Materialwirtschaft
Material management
Bildungszentrum
Training center
BesucherCentrum
Visitor center
Hauptverwaltung
Head office
Hochofenbetrieb Hamborn
Hamborn blast furnace plant
Schachtofen
Shaft furnace
Kraftwerk
Power station
Werksbereich Beeckerwerth
Beeckerwerth plant
Oxygenstahlwerk 2
bof shop 2
Stranggießanlage
Continuous caster
Warmbandwerk 2
Hot strip mill 2
Feuerbeschichtungsanlage 2
Hot dip coating line 2
Bandbeschichtungsanlage 1
Coil coating line 1
Werkfeuerwehr: Werkschutz
Fire department: Security
Bandbeschichtungsanlage 2
Coil coating line 2
Kaltbandwerk 2: TAKO
Cold strip mill 2: TAKO
Feuerbeschichtungsanlage 4
Hot dip coating line 4
Zentrallager
Central warehouse
Elektrolytische Beschichtungsanlage 2
Electrolytic coating line 2
Warmbandspaltanlagen: Solarwand
Hot strip slitting plant: Solartec façade

Standort : Location Duisburg

Standort Duisburg, ThyssenKrupp Stahl AG	The Duisburg location of ThyssenKrupp Stahl AG
Gesamtfläche: Neun Quadratkilometer	Total area: nine square kilometers
Werksbereiche: Schwelgern, Bruckhausen, Beeckerwerth, Hüttenheim	Four plants: Schwelgern, Bruckhausen, Beeckerwerth, Hüttenheim
Mitarbeiter: 13.000 Stammbelegschaft	Staff: 13,000 permanent employees
Eigenes Schienennetz auf dem Gelände: 300 Kilometer	Railway network on the site: 300 kilometers
Umschlagskapazität der eigenen Häfen: 25 Millionen Tonnen jährlich	Handling capacity of the company harbor: 25 million metric tons per year
Produktion: Elf Millionen Tonnen Rohstahl jährlich	Production: eleven million metric tons of crude steel per year
Betriebszeiten: 24/7/365	Operating time: 24/7/365

28 BOOK

DESIGN	Kerstin Weidemeyer
	Munich, Germany
ART DIRECTION	Kerstin Weidemeyer
CREATIVE DIRECTION	Annette Häfelinger and Kerstin Weidemeyer
DESIGN OFFICE	Häfelinger & Wagner Design
CLIENT	ThyssenKrupp Steel AG
PRINCIPAL TYPE	TK-Type Regular, TK-Type Bold,
	and Clarendon Bold
DIMENSIONS	8.9 x 12.6 IN. (22.5 x 32 CM)

Honestly, I would not normally pick up a book called *Discover Steel #1.* How boring does that sound? But the book is a good example of design and production working to sell a subject that I am not personally into. I like the fact that they put a piece of sharp steel on the cover. It's so literal and yet totally unexpected. I actually looked at this book because of the steel on the cover. The steel incorporated with the silver ink and the foil-stamping contrasting with the traditional cloth on the spine caught my attention. I really like the super-glossy varnished gradated dividers peppered throughout the inside the book. They're luxurious; they're tactile. It's unusual to see this type of production value for this kind of book, which makes you think about our notions of "kinds of books." Why does a book need to look corporate or boring? All books should look enticing.

DESIGNER KERSTIN WEIDEMEYER

Discover Steel #1 marks the beginning of a series of books on locations of ThyssenKrupp Steel that are intended to open new ways of looking at things. Everything changes—necessarily, in the course of time. Even a change in the angle of vision can enrich one's experience by revealing unfamiliar aspects. It can open up unexpected and interesting perspectives.

This idea was intriguing. It made us want to know from which angles it was possible to look at the Duisburg location of ThyssenKrupp Steel. We asked four photographers—two women, two men—to compile their various interpretations about the location. The eldest explored the place in spring. The youngest sent her eyes on a journey of discovery in winter.

The point was to document changes over the course of time and to point out relationships with corporate processes. On this basis, each of the artists was asked to document his or her own personal viewpoint by directing the viewer's gaze toward the unexpected.

29

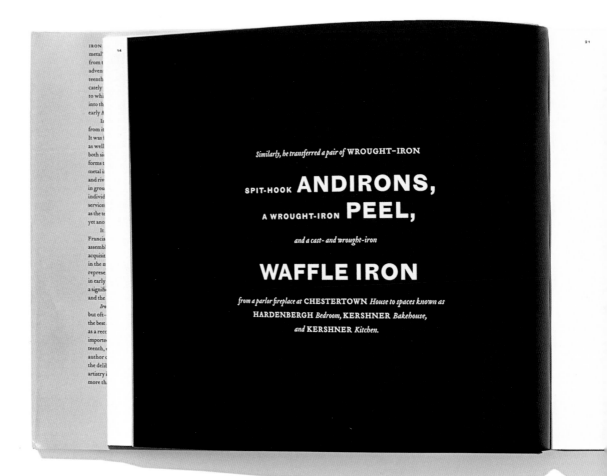

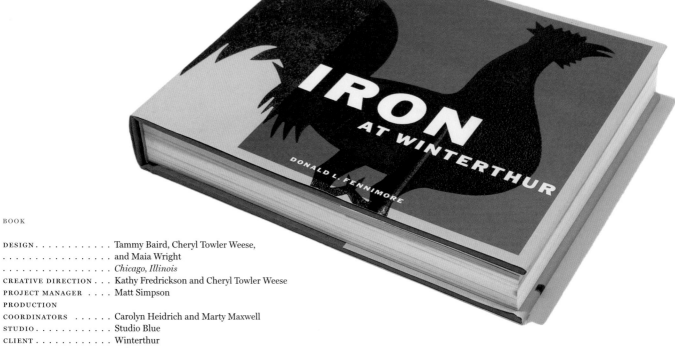

30 BOOK

DESIGN Tammy Baird, Cheryl Towler Weese,
. and Maia Wright
. *Chicago, Illinois*
CREATIVE DIRECTION . . . Kathy Fredrickson and Cheryl Towler Weese
PROJECT MANAGER Matt Simpson
PRODUCTION
COORDINATORS Carolyn Heidrich and Marty Maxwell
STUDIO Studio Blue
CLIENT Winterthur
PRINCIPAL TYPE Tribute, OL Franklin Wide, and Bureau Grotesque
DIMENSIONS 11 x 9.5 IN. (27.9 x 24.1 CM)

This list suggests that du Pont's interest was all-inclusive, ranging from the extraordinary to the mundane. On April 20, 1953, he bought from Carl Jacobs a "Fireback with Washington medallion, fine and probably unique," an exceptional example of cast iron that today forms a significant part of the collection (entry 16). By contrast, Charles F. Montgomery wrote to du Pont on March 15, 1945: "Today I wrapped a salt glazed tankard with pewter top, which we discussed as a possibility in the Hardenbergh room.... In the same package are about 150 [hand wrought] nails." Du Pont responded on March 29 that he was "returning the salt glazed tankard, but... keeping the nails."⁹ That decision hinged certainly not on their rarity; rather it indicates his concern for accuracy in even the smallest detail of the period rooms he was assembling.

By the time of H. F. du Pont's death in 1969, Winterthur's holdings encompassed one of the largest and most significant collections of early American iron in any public institution. Even though du Pont's death marked the loss of the museum's founder and primary benefactor, work with the collection continued and has included the purchase of significant iron, some of which is presented in this catalogue. In recent years, Winterthur has been the fortunate recipient of several gifts of iron as well. Among these generous donations is a rare and complete jamb stove made about 1768 at Marlboro Furnace in Frederick County, Virginia, presented by the World Furniture Foundation (entry 25). The late Charlotte Sittig bequeathed a large and attractively designed cooking pot made at the celebrated nineteenth-century Philadelphia firm of Savery and Company (entry 39). And the Wunsch Americana Foundation donated a dramatic and highly decorated parlor stove, dating between 1837 and 1844, that bears the name of Elisha N. Pratt of Albany, New York (entry 36). These and similar gifts constitute significant additions to the collection. They help broaden its scope and interpretive value as a tool for understanding the importance of iron in early America.

In addition, the museum has received two large, multi-object gifts – each a collection assembled over many years. Robert and Sandra Trump donated a group of almost one hundred English and American locks, latches, hasps, hinges, and other architectural hardware signed by their makers and dating prior to the end of the nineteenth century. The collection is a touchstone of sorts that provides a compendium of names for the craftsmen who actively supplied the architectural hardware trade. It also offers an insightful reference to all the major styles and types of such mechanisms in use on American buildings as they evolved through the seventeenth, eighteenth, and nineteenth centuries.¹⁰

When I first encountered *Iron at Winterthur* I felt the same rush of excitement I get when "That Perfect Thing" surfaces at a flea market—the joy of encountering an object designed with a simple dignity, which doesn't happen much in this era of overpromotion, overproduction, overeverything. I was struck immediately by the non sequitur of the rooster coupled with the word "iron," a simple trick that feels fresh in this era of ironic one-upmanship. The title type, Franklin Gothic, which most designers laid to rest after its widespread use and abuse in the early nineties, is recommissioned here with a robust and sincere cut that seduces with its quiet authority. It would have been easy to bludgeon the reader with tricks inspired by the crude heaviness of the book's material—three-dimensional typography, metallics, and threatening chunks of heavy metal—but instead the designers, Chicago-based Studio Blue, chose a faded palette and tactile honesty well suited to the collection's endearing practicality.

Inside, the iron artifacts are dispassionately cataloged in a rigorously applied grid system, which gets suspended on occasion by pages featuring nothing but large centered proclamations from the text. Like an art history lecturer unwilling to acknowledge his snickering students, the book proceeds in a stern deadpan tone that never wavers, no matter how extravagantly weird the objects become. The text face, Emigre's Tribute, first appears to be a perfectly safe choice, but its subtle eccentricities emerge slowly to nicely complement the peculiar vernacular possessed by many of the artifacts. (The type geek in me appreciated the use of a font that looks handmade but arrived by way of a notoriously modern type foundry.) In short, Studio Blue's design is a little bit square, but it won me over for having the sense to reference only one thing—its subject.

We wanted to design a book that conveyed the gritty resilience of cast iron objects, which were often used because they could withstand extreme temperatures and conditions. We used extremely large type and black solids along with details that highlighted the surfaces and textures of cast iron. We also wanted to evoke a sense of a past when the only advertising was print and tone was conveyed through typographic nuance, so we created "broadsides" using type excerpts as section dividers.

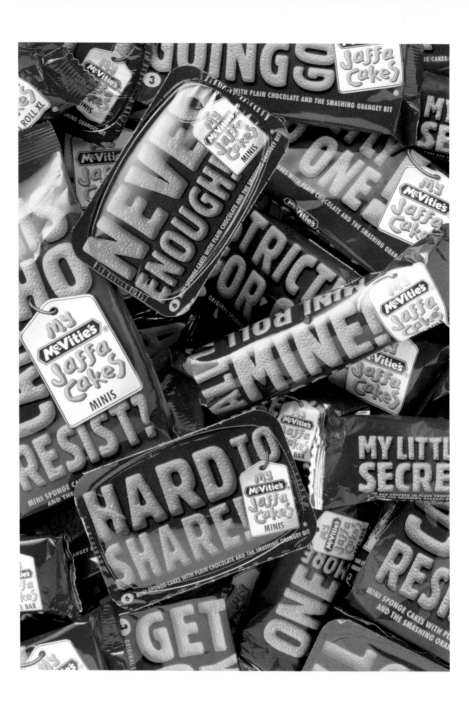

32 PACKAGING

DESIGN , Gareth Belson
. *London, England*
ART DIRECTION Garrick Hamm
CREATIVE DIRECTION . . . Garrick Hamm
LETTERING West One Arts
ILLUSTRATION Simon Critchley
AGENCY Williams Murray Hamm
CLIENT United Biscuits
PRINCIPAL TYPE Gothic 821
DIMENSIONS Various

What is interesting about the packaging is that the designers have created a variety of different phrases and then illustrated them with type that looks like the actual cookie. When was the last time anybody was so conscious of type design on commercial packaging? You might have to go all the way back to the days of Herb Lubalin and Tom Carnese when they produced such wonderful logos as those for Grumbacher paints, L'Eggs hosiery, and even Captain Crunch cereal boxes. As for Jaffa Cakes, both Lubalin and Carnese frequently created logos that mimicked the actual product itself; the liquid nature of the Grumbacher logo is perhaps the best example. The emphasis with the Jaffa Cakes packaging is on a sense of playfulness and wit, which in the end creates a wonderfully memorable product.

DESIGNER FIONA CURRAN 33

To establish McVities as the category-defining Jaffa Cakes brand, WMH decided to switch emphasis from the things the brand couldn't own, like the brand name and product attributes, to its real equity—great consumer affection and slightly self-centered behavior.

The answer was to celebrate consumer "truisms" on the packaging by putting a collection of personal phrases on the selling faces. The brand name is then used as a discreet sign-off to assert confidence and real leadership attitude.

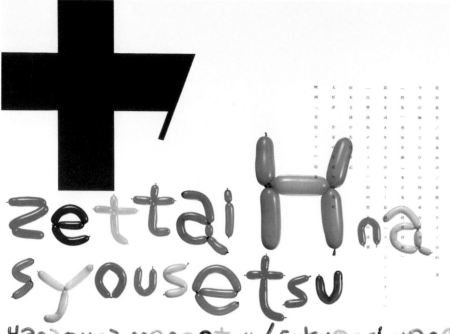

DESIGN Yuka Watanabe
. *Tokyo, Japan*
ART DIRECTION Norito Shinmura
CREATIVE DIRECTION . . . Norito Shinmura
LETTERING Norito Shinmura
PHOTOGRAPHY Kiyotusa Nozu
DESIGN OFFICE Shinmura Design Office
CLIENT Kadokawa Shoten Co., Ltd.
PRINCIPAL TYPE Handlettering
DIMENSIONS 28.7 x 40.6 IN. (72.8 x 103 CM)

JUDGE JONATHAN NOTARO

There are several reasons why I chose this series of posters as my favorite. In the landscape of entries, these images seemed to take themselves less seriously and were just plain fun. There is an inherent irreverence in Japanese culture that is evident in these pieces and perhaps that is what attracted me to them. Additionally, there are traces of craft and human touch in the posters that add to their charm as a group. The effort of the hand-cut letters, blown-up balloons, and so on makes the pieces much more human and accessible than the other entries. Lastly, these images completely negate any current trends in graphic design. Not only is this a relief, but it is also commendable at a time when graphic design seems to be suffering from a loss of the individual. Granted graphic design also seems to be suffering from confusion as art, and these pieces also do that, but at the same time they work and fulfill a purpose; thus they're design.

DESIGNER YUKA WATANABE

Since this poster is for the monthly novel magazine *Yasei Jidai* (Wild Age), I wanted to emphasize letters and create something only with letters. I made these letters with balloons, abacus, and other ordinary tools that we find easily around us because I wanted to express human feelings more than just using letters printed by computer. Making the letters was difficult, but selecting the materials to make the letters was even more difficult.

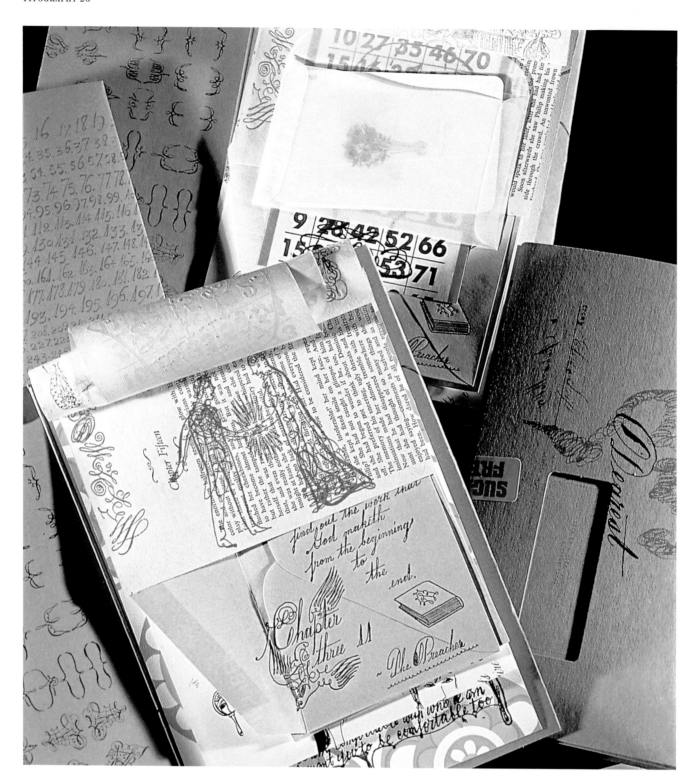

DESIGN Sharon Werner and Sarah Nelson
. *Minneapolis, Minnesota*
ART DIRECTION Sharon Werner
CALLIGRAPHY Elvis Swift
. *Naples, Florida*
STUDIO Werner Design Werks, Inc.
CLIENT Joanie Bernstein, Art Rep
PRINCIPAL TYPE Typewriter and handlettering
DIMENSIONS 6.9 x 9.5 IN. (17.5 x 24.1 CM)

PIET SCHREUDERS

On a rather gloomy January day in Manhattan, seven judges did their best to discover typographic needles among 2,000-plus graphic haystacks. This particular piece, a promo for the illustrator Elvis Swift, struck me as refreshing, a ray of light. I selected it as my Judge's Choice so I'd have a chance to see it again.

Elvis Swift is an illustrator; Joanie Bernstein is his art rep; Werner Design Werks is the Minneapolis design firm entrusted with the task of helping Joanie promote Elvis. They did this in a way that is totally original, free of any trend, not derivative of anything, while also displaying "excellence in the use of typography, calligraphy, handlettering, and other letterforms." Swift himself, of course, excels in calligraphic letterforms and free-form pen flourishes. Werner Design translated his personal drawing style to printed paper by letterpress and thermography printing on several kinds of paper stock. Thermography is a process often used to simulate engraving on traditional business cards. Here it adds that distinctive pebbly texture and glossy shine to the word "Dearest" and the return address on the envelope. Like all text for this project, the typography is either handlettered or typewritten; no computer typeface is anywhere in sight. That is what I call refreshing.

DESIGNER SHARON WERNER AND SARAH NELSON

37

Elvis Swift creates his art on random scraps of paper, bits and pieces of things from everyday life, all of which add to the beauty of the work. We wanted to capture this randomness and personal attention and then recreate it in a larger quantity of 4,000 units. We achieved the personal, tactile quality by letterpress printing on a variety of materials—everything from bingo pages to vintage wallpaper, the pages of old romance novels to naturally aged envelopes. No two pieces are alike. Everyone who received one of these promos is getting their own mini Elvis portfolio.

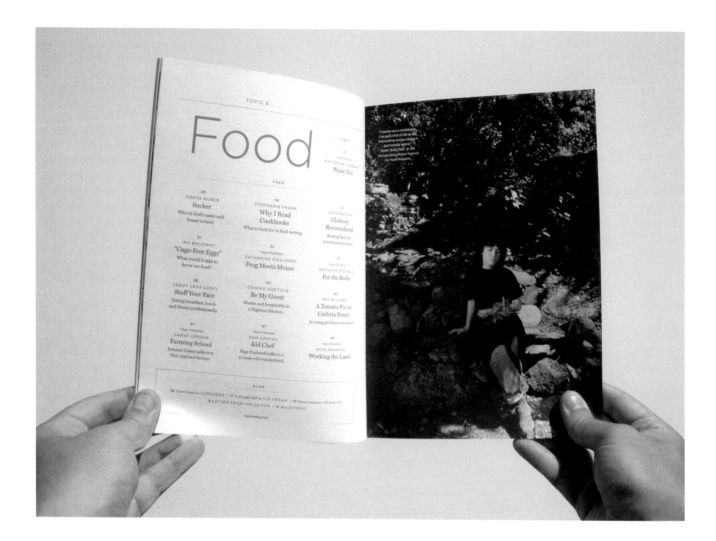

CREATIVE DIRECTION . . . Stella Bugbee, Robert Giampietro, and Kevin Smith
. *New York, New York*
STUDIO Giampietro + Smith
CLIENT Topic magazine
PRINCIPAL TYPE HTF Gotham and Miller
DIMENSIONS 7.2 x 9.75 IN. (18.3 x 24.8 CM)

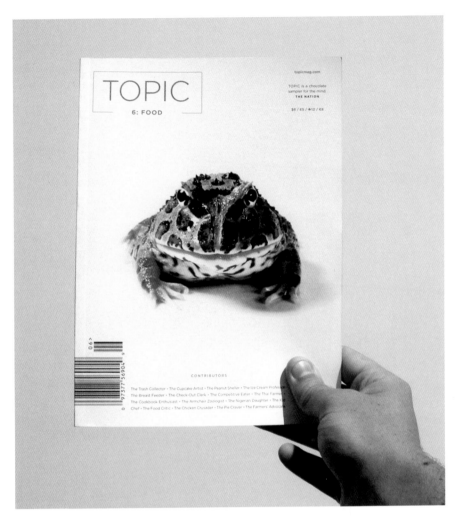

"...you will choose the crystal, because everything about it is calculated to reveal rather than to hide the beautiful thing which it was meant to contain."

Beatrice Warde, in *The Crystal Goblet*, describes one approach to typography in its service to content. In reviewing entrants to TDC51, I searched for examples that supported Warde's position but that further contributed meaning through the execution of formal decisions.

One project that exemplifies the typographer's role as author is "Freedom of the Press" (illustrated on page 54). By sampling basic elements of the newspaper medium as leverage, the designer compels the reader to take a critical view of the newspaper industry and to question what is otherwise considered "factual."

TOPIC magazine similarly operates within the conventions of the established typology of the academic journal. The format, layout, and typography exist as a highly stylized, self-conscious design that underscores the ironic tone and irreverence of the magazine's content.

Both of these projects are not only examples of excellent design but of the designer's role in lending shape and meaning to content. I am pleased to cite these two projects as my shared selection for judge's choice.

DESIGNERS STELLA BUGBEE, ROBERT GIAMPIETRO, AND KEVIN SMITH

Creative direction and editorial design for a New York-based quarterly magazine of first-person writing. With themes changing from issue to issue, *TOPIC 6: Food* aimed at unsettling food's comfortable role in our lives and showing it as a sometimes revolting, painful, sinful, or even violent subject. As a blend of the personal and the editorial, the design of *TOPIC* straddles the line between a literary journal and a youthful magazine, blending the crisp lines of Hoefler & Frere-Jones's Gotham with Matthew Carter's classic scotch roman Miller. There's an offbeat classicism in the air, paired with smart art, smart writing, and a very individual take on the world. Contributors to this issue included an internationally ranked competitive eater, a failed breast-feeder, and a pie thief.

DESIGN Alice Chung and Karen Hsu
. *New York, New York*
ART DIRECTION Rachel Wixom
CREATIVE DIRECTION . . . Chrissie Iles, Shamim M. Momin, and Debra Singer
PUBLISHER Whitney Museum of American Art
PRINCIPAL TYPE Clarendon, FF Din, Egyptienne,
. Berthold Akzidenz Grotesk, and Trade Gothic
DIMENSIONS 11.5 x 11.5 IN. (29.2 x 29.2 CM)

JUDGE GABRIELE WILSON

Tactile materials get me every time. The simple gray cover, with its suedelike surface and debossed silver-foil type, was begging to be picked up.

Materials aside, I chose this book as my favorite because the designers were able to showcase an incredibly diverse group of experimental artists in a controlled, sophisticated, and fun environment—an ambitious task given the breadth of the work involved.

The strict grid system, limited type choices, and pure colors allow the work of over one hundred very different artists to breath. The design moves at an exciting pace due to the varying column widths, type sizes, and full-bleed images.

The book is accompanied by a special box full of original projects contributed by each artist. That was especially appealing to me as someone who loves to collect things. The projects range in formats: postcards, posters, zines, and even bumper stickers in varying sizes, colors, and paper stocks. Sifting through the box is like discovering an unmediated view of the future of American art.

The designers have solved the problem of condensing the energy and vibrance of the biennial into a mini take-home exhibition, a perfect solution for someone who wants to revisit the show.

DESIGNERS ALICE CHUNG AND KAREN HSU

The 2004 Whitney Biennial was organized by three co-curators. Working in close collaboration, we developed a catalog comprised of a more traditional book and a box containing artwork created by each of the 107 featured artists. Each artist worked within one of eight prescribed formats–rectangular poster, square poster, eight-page zine, round sticker, bumper sticker, uncoated square card, glossary postcard, or filmstrip–to create an original contribution for the box.

41

To complement this eclectic collection, the book was also a container of controlled chaos. The three curators' essays were designed with a limited array of typefaces within a strict grid system, while commissioned and reprinted texts broke out of those constraints, reflecting their diverse origins. A third entity, the individual artist entries, was uniform in typeface and grid structure to counterbalance the eclectic range of work.

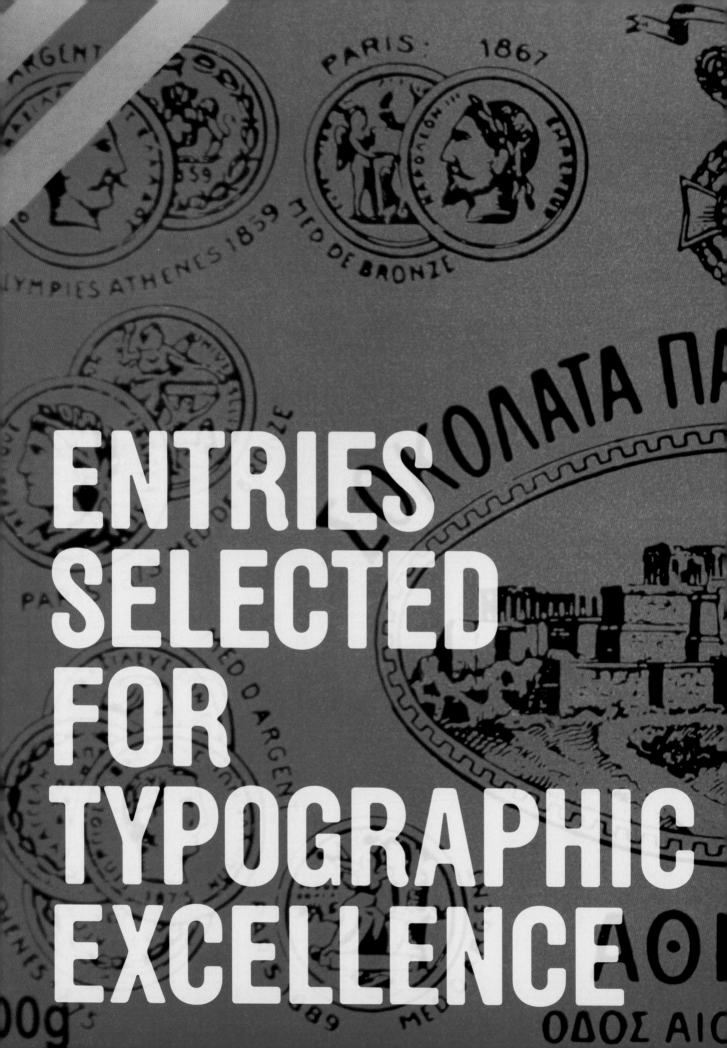

ENTRIES SELECTED FOR TYPOGRAPHIC EXCELLENCE

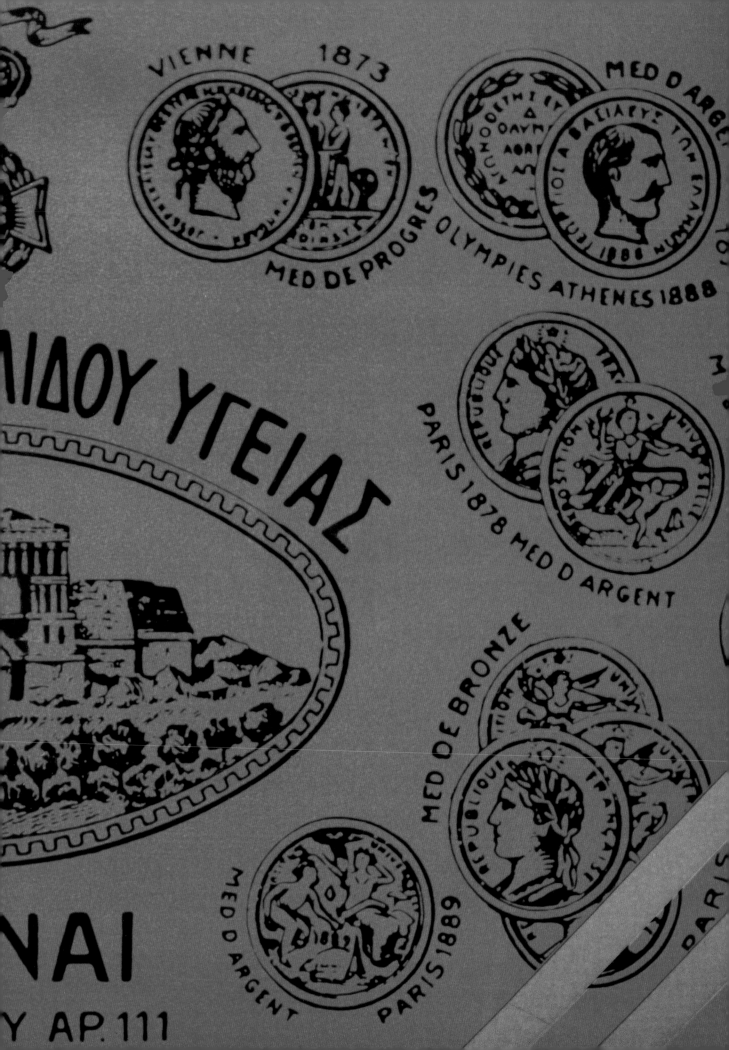

A

INVITATION

DESIGN Christine Celic Strohl and Eric Janssen Strohl
. *Brooklyn, New York*
DESIGN OFFICE A. Pomeroy Dakota & Co.
PRINCIPAL TYPE Trade Gothic and Farao
DIMENSIONS 5 x 7 IN. (12.7 x 17.8 CM)

POSTER

DESIGN Michihito Sasaki
. *Osaka, Japan*
ART DIRECTION Michihito Sasaki
CREATIVE DIRECTION . . . Michihito Sasaki
LETTERING Michihito Sasaki
DESIGN OFFICE Ad Seven Co.
CLIENT Graves Co.
PRINCIPAL TYPE Hiragana
DIMENSIONS 28.7 x 40.6 IN. (72.8 x 103 CM)

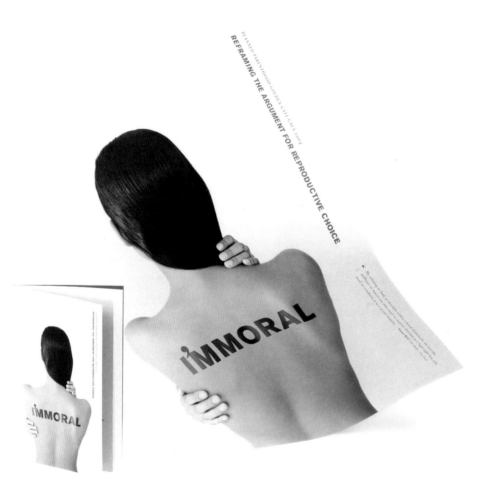

PLANNED PARENTHOOD GOLDEN GATE GALA 2004
REFRAMING THE ARGUMENT FOR REPRODUCTIVE CHOICE

IMMORAL

DESIGN Monica Schlaug
. *Berkeley, California*
CREATIVE DIRECTION . . . John Creson
AGENCY Addis Group Inc.
CLIENT Planned Parenthood Golden Gate
PRINCIPAL TYPE Akzidenz Grotesk, Adobe Garamond, Helvetica,
. and Neue Helvetica
DIMENSIONS Various

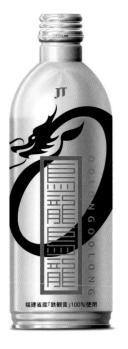
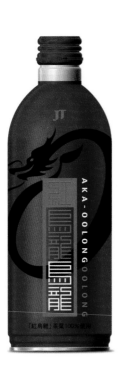

PACKAGING

DESIGN Alan Chan and Peter Lo
. *Hong Kong, China*
ART DIRECTION Alan Chan
CREATIVE DIRECTION . . . Alan Chan
LETTERING Peter Lo
DESIGN OFFICE Alan Chan Design Company
AGENCY Hakuhodo, Inc
CLIENT Japan Tobacco Inc.
PRINCIPAL TYPE Handlettering
DIMENSIONS 2.6 x 7.9 IN. (6.5 x 20 CM)

47

48 POSTER

DESIGN Alan Chan and Peter Lo
. *Hong Kong, China*
ART DIRECTION Alan Chan
CREATIVE DIRECTION . . . Alan Chan
LETTERING Peter Lo
DESIGN OFFICE Alan Chan Design Company
PRINCIPAL TYPE Handlettering
DIMENSIONS 27.6 x 39.4 IN. (70 x 100 CM)

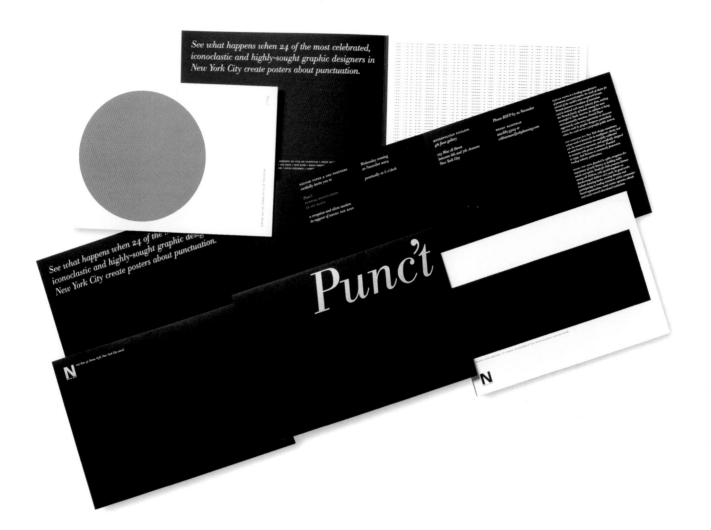

POSTER AND INVITATION

DESIGN Michael Bierut, Steven Brower, Marcos Chin,
. Seymour Chwast, Roberto de Vicq de Cumptich,
. Steff Geisbuhler, Alexander Gelman,
. Carin Goldberg, Kent Hunter, Mirko Ilić,
. Alexander Isley, Michael Ian Kaye, Chip Kidd,
. Emily Oberman, Woody Pirtle, Sam Potts,
. Stefan Sagmeister, Paula Scher, David Schimmel,
. Aimee Sealfon-Eng, Bonnie Siegler, Todd St. John,
. Scott Stowell, Robert Valentine, and James Victore
. *New York, New York*
CREATIVE DIRECTION . . . David Schimmel
AGENCY And Partners NY
CLIENT Neenah Paper
PRINCIPAL TYPE Bodoni Antiqua
DIMENSIONS Various

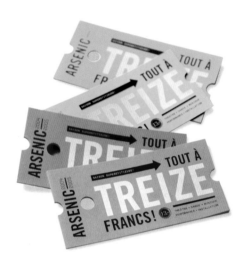

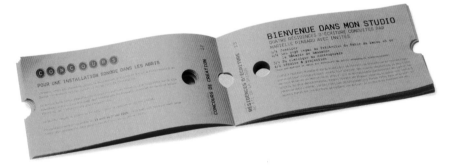

50 BROCHURE

DESIGN Giorgio Pesce
. *Lausanne, Switzerland*
ART DIRECTION Giorgio Pesce
CREATIVE DIRECTION . . . Giorgio Pesce
AGENCY Atelier Poisson
CLIENT Theatre Arsenio, *Lausanne*
PRINCIPAL TYPE Courier Sans, Normetica, and Trade Gothic
DIMENSIONS 8.3 x 4.1 IN. (21 x 10.5 CM)

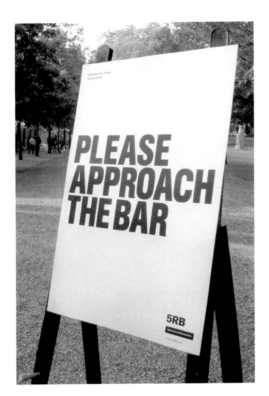

POSTER AND INVITATION

DESIGN Joseph Luffman
. *London, England*
ART DIRECTION Ian Chilvers
OFFICE Atelier Works
CLIENT Five Raymond Buildings (5RB)
PRINCIPAL TYPE AG Book
DIMENSIONS 3.9 x 8.3 IN. (9.9 x 21 CM)

DESIGN Danielle Aubert and Karel Martens
. *Detroit, Michigan*
CLIENT Yale School of Art
PRINCIPAL TYPE Gothic No. 13 and Akzidenz Grotesk
DIMENSIONS 22 x 34 IN. (55.9 x 86.4 CM)

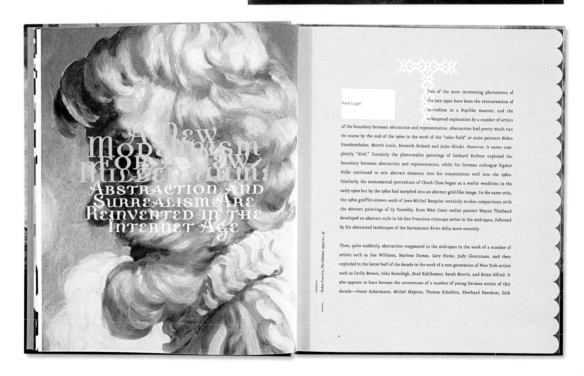

BOOK

DESIGN Bob Aufuldish
. *San Anselmo, California*
DESIGN OFFICE Aufuldish & Warinner
CLIENT The Logan Collection, *Vail*
PRINCIPAL TYPE Dalliance, Eureka, and RoarType
DIMENSIONS 8 x 9.25 IN. (20.3 x 23.5 CM)

B

This vote decided an election

Each circle represents 537 votes, the same amount that decided the 2000 Presidential election. In 2000, 100 million people didn't vote.

DESIGN Brian Ponto and Lindsay Ballant
. *Brooklyn, NY*
ART DIRECTION Brian Ponto and Lindsay Ballant
CREATIVE DIRECTION . . . Lindsay Ballant and Brian Ponto
ORGANIZATION Passthison.org
PRINCIPAL TYPE Imperial BT Roman and Neue Helvetica
DIMENSIONS Various

An analysis by the Center for Responsive Politics, shows media companies spent more than $82 million on federal lobbying efforts *between 1999 and 2002* and another $26 million on political contributions.

CO
MMU
N ME
E SURE?

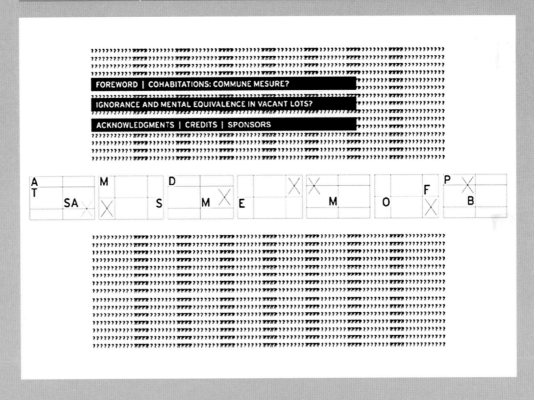

WEB SITE

DESIGN Mike Teixeira
. *Gatineau, Canada*
ART DIRECTION Mike Teixeira
CREATIVE DIRECTION . . . Stéphane Bertrand
. *Ottawa, Canada*
PROGRAMMER Charles Whalen
CLIENT Centre D'Artistes Axenéo7
PRINCIPAL TYPE Interstate

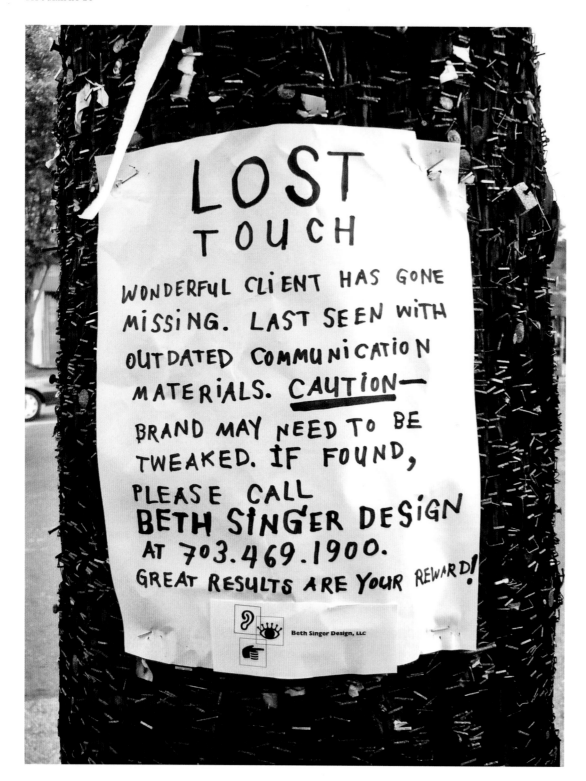

DESIGN Sucha Snidvongs
. *Arlington, Virginia*
ART DIRECTION Beth Singer
LETTERING Sucha Snidvongs
PHOTOGRAPHY Sucha Snidvongs
DESIGN OFFICE Beth Singer Design, LLC
PRINCIPAL TYPE Handlettering
DIMENSIONS 4.75 x 6.5 IN. (12.1 x 16.5 CM)

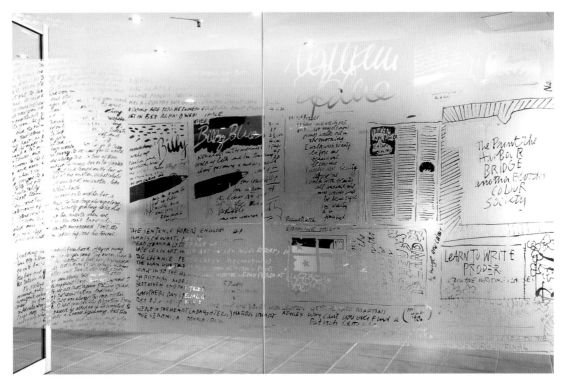

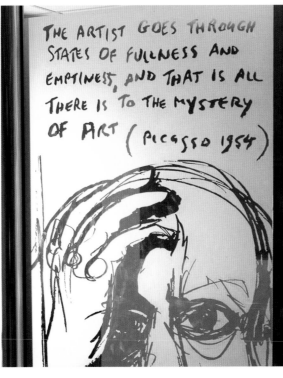

DESIGN Justin Smith
. *North Sydney, Australia*
ART DIRECTION Justin Smith
CREATIVE DIRECTION . . . Mick Thorp
CALLIGRAPHY Ross Renwick and Justin Smith
DESIGN OFFICE Billy Blue Creative
CLIENT Billy Blue Group
PRINCIPAL TYPE Handlettering

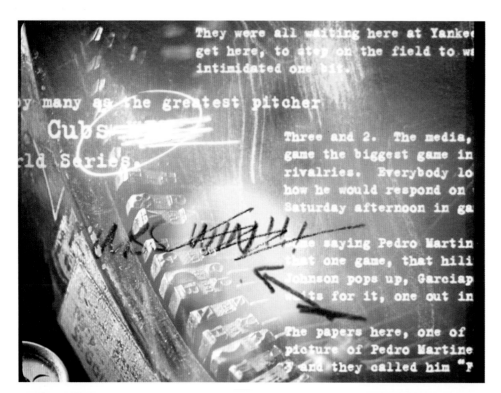

DESIGN Chris Do, Atsushi Ishizuka, and Steve Pacheco
. *Santa Monica, California*
CLIENT ART DIRECTION . . Dave Mellott
CREATIVE DIRECTION . . . Chris Do
CLIENT CREATIVE
DIRECTION Robert Gottlieb
EXECUTIVE PRODUCER . . Ellen Stafford
PRODUCERS Melissa Hagman and Ian Dawson
DIGITAL PRODUCERS . . . Russ Harper and Larry Dolkart
ANIMATION Wonhee Lee and Atsushi Ishizuka
PHOTOGRAPHY Rick Spitznass
DESIGN OFFICE Blind, Inc
CLIENT Fox Sports
PRINCIPAL TYPE Typeka, ITC Machine, and custom fonts

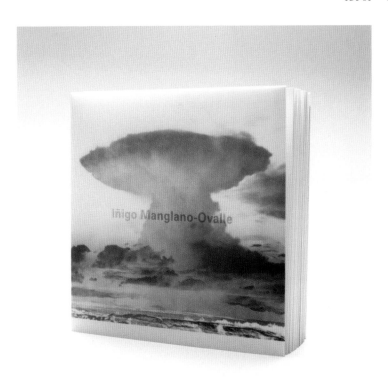

CATALOG

DESIGN Vanessa Eckstein and Mariana Contegni
. *Mexico City, Mexico*
CREATIVE DIRECTION . . . Vanessa Eckstein
PRINTER Artes Graficas Panorama, *Timbrart*
DESIGN OFFICE bløk design
CLIENT Museo Masco, Museo Tamayo
PRINCIPAL TYPE Meta, Trade Gothic, and Univers
DIMENSIONS 8.7 x 8.7 IN. (22 x 22 CM)

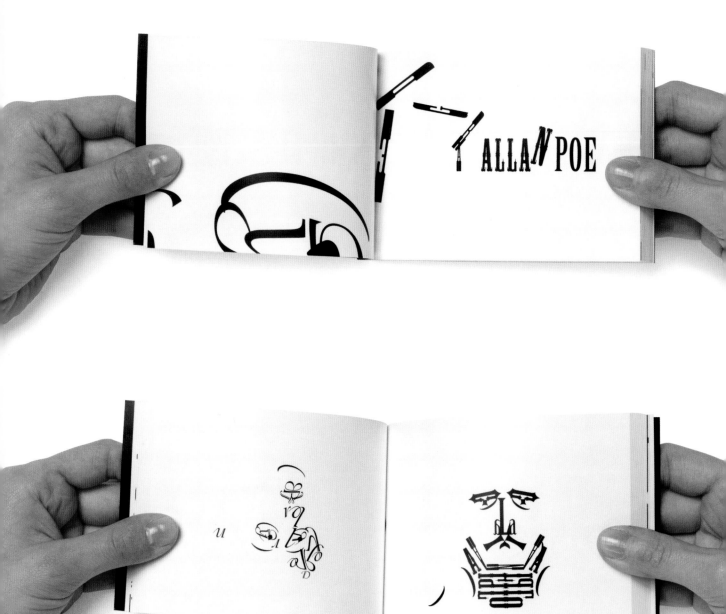

DESIGN Roberto de Vicq de Cumptich and Matteo Bologna
. *New York, New York*
ART DIRECTION Roberto de Vicq de Cumptich and Matteo Bologna
CREATIVE DIRECTION . . . Matteo Bologna, Roberto de Vicq de Cumptich, and
. Ashwini Jambotkar
. *New York, New York* and *San Jose, California*
ANIMATION Steve Holmes
CLIENT Adobe Systems Incorporated
PRINCIPAL TYPE Adobe Birch, Adobe Ironwood, ITC Isadora,
. Adobe Juniper, Adobe Mesquite, and
. Adobe Ponderosa
DIMENSIONS 3.5 x 5 IN. (8.9 x 12.7 CM)

**Break the monotony
at the table!**

**Set the table in
nature!**

ANNUAL REPORT

DESIGN Maja Bagic
. *Zagreb, Croatia*
ART DIRECTION Maja Bagic
CREATIVE DIRECTION . . . Maja Bagic
PHOTOGRAPHY Marin Topic
AGENCY BRUKETA & ZINIC
CLIENT Podravka d.d.
PRINCIPAL TYPE Fobia
DIMENSIONS 9.1 x 4.9 IN. (23 x 12.5 CM)

62 BOOK JACKET

DESIGN	Lynn Buckley
	New York, New York
ART DIRECTION	Lynn Buckley and Susan Mitchell
LETTERING	Lynn Buckley
PUBLISHER	Farrar, Straus and Giroux
PRINCIPAL TYPE	Rockwell, Trade Gothic, and handlettering
DIMENSIONS	5.5 x 8.25 IN. (14.2 x 21 CM)

C

Since 1949, Lubri-Loy has been producing products that handle the spectrum of situations—from the most extreme conditions to the very basic, everyday maintenance. Lubri-Loy can lower your operating costs, maximize efficiency, increase power and decrease mainte-nance downtime.

From engines to gear boxes to all mechanical parts, machinery requires ongoing lubrication, fortification and enhancement to survive and continue working to maximum capacity. But a basic lubricant, fortifier or fuel enhancer simply won't accomplish your needs over the short or long term.

In this, our sixth decade, Lubri-Loy— a blend of the terms lubricant and alloy— distributes an array of superior lubricant, fortifier and fuel enhancing products in more than 35 countries on five continents.

Headquartered in St. Louis, Missouri, Lubri-Loy's technology serves a wide range of markets including the industrial, metal fabrication, railroad agriculture, construc-tion, automotive, utility, trucking and marine industries.

BROCHURE

DESIGN Michael Braley
. *San Francisco, California*
ART DIRECTION Bill Cahan and Michael Braley
CREATIVE DIRECTION . . . Bill Cahan
STUDIO Cahan & Associates
CLIENT Lubri-Loy
PRINCIPAL TYPE Akzidenz Grotesk
DIMENSIONS 11.25 x 13.6 IN. (28.6 x 34.5 CM)

DESIGN Kirsten Sorton
. *New York, New York*
ART DIRECTION Kirsten Sorton
LETTERING Davide
STUDIO Carrotshy Design
CLIENT Valeri Lucks
PRINCIPAL TYPE Engravers Std Bold and Adobe Garamond Semibold
DIMENSIONS 5.25 x 7.75 IN. (13.3 x 19.7 CM)

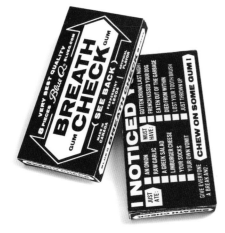

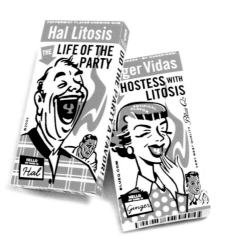

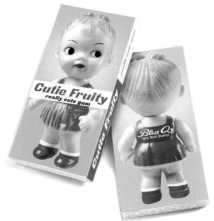

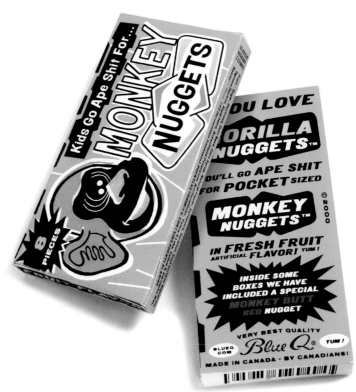

PACKAGING

DESIGN Todd Piper-Hauswirth and Aaron Dimmel
. *Minneapolis, Minnesota*
ART DIRECTION Charles S. Anderson and Todd Piper-Hauswirth
DESIGN OFFICE Charles S. Anderson Design Co.
CLIENT Blue Q
PRINCIPAL TYPE Various
DIMENSIONS 1.4 x 2.6 x .4 IN. (3.6 x 6.6 x 1 CM)

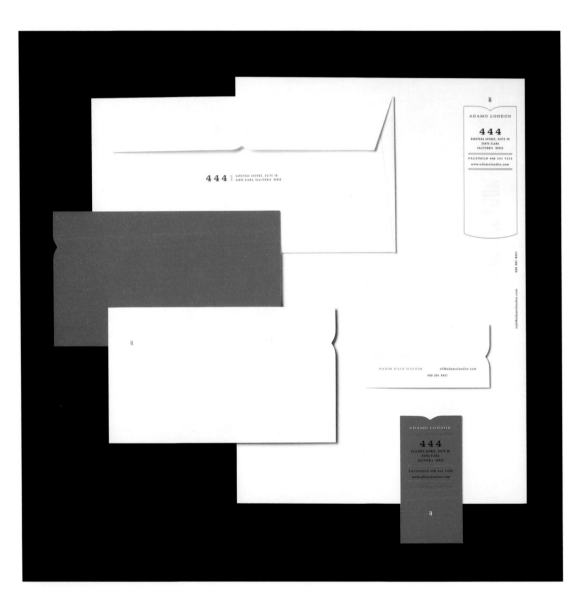

DESIGN Max Spector and Jennifer Tolo Pierce
. *San Francisco, California*
ART DIRECTION Joshua C. Chen
CREATIVE DIRECTION . . . Joshua C. Chen
DESIGN OFFICE Chen Design Associates
CLIENT Adamo London
PRINCIPAL TYPE Akzidenz Grotesk Condensed, Alaric SSL,
. Melior Italic and Medium,
. and AT Sackers English Script
DIMENSIONS Various

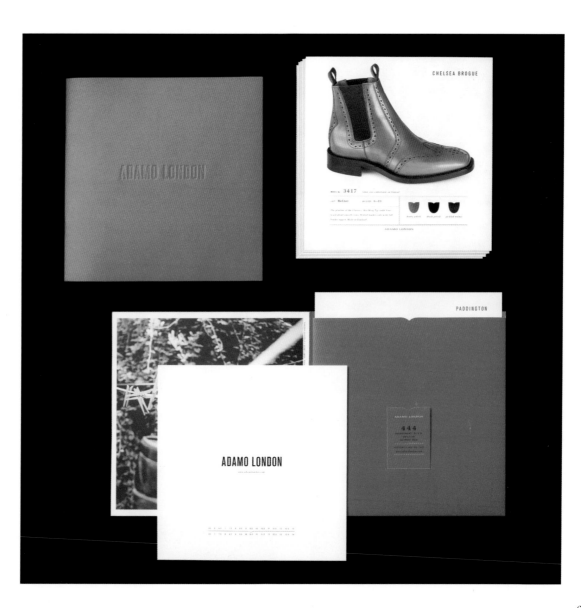

BROCHURE

67

DESIGN Jennifer Tolo Pierce
. *San Francisco, California*
ART DIRECTION Joshua C. Chen and Jennifer Tolo Pierce
CREATIVE DIRECTION . . . Joshua C. Chen
PHOTOGRAPHY Jessica Robinson and Karl Hedner
. *San Francisco, California*, and *London, England*
DESIGN OFFICE Chen Design Associates
CLIENT Adamo London
PRINCIPAL TYPE Akzidenz Grotesk Condensed, Alaric SSL,
. Melior Italic and Medium,
. and AT Sackers English Script
DIMENSIONS 8 x 8 IN. (20.3 x 20.3 CM)

ADVERTISEMENT

DESIGN Yukichi Takada and Chiaki Okuno
. *Osaka, Japan*
ART DIRECTION Shinnoske Sugisaki and Yukichi Takada
CREATIVE DIRECTION . . . seneca
LETTERING Yukichi Takada
STUDIO CID Lab
AGENCY Chuden Kogyo
CLIENT CHUBU Electric Power
PRINCIPAL TYPE Handlettering
DIMENSIONS 40.6 x 14.3 IN. (103 x 36.4 CM)

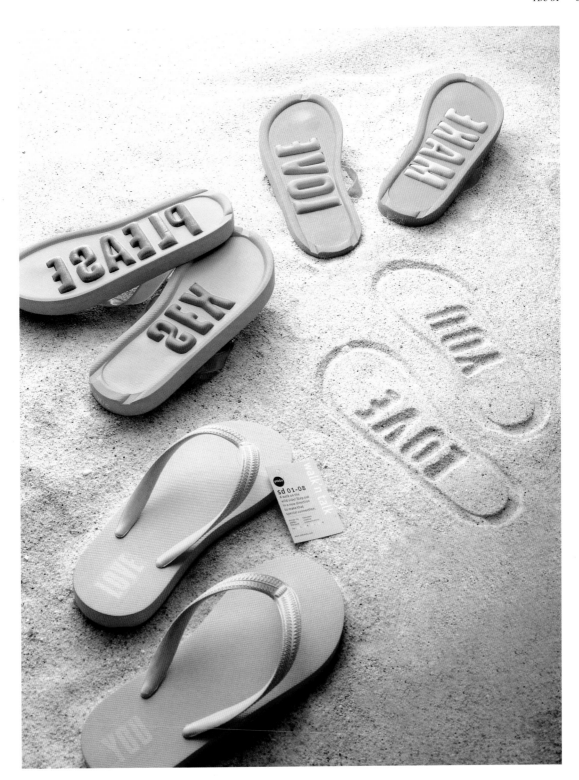

BEACH SLIPPERS

DESIGN Porntip Trimungklayon
. *Bangkok, Thailand*
CREATIVE DIRECTION . . . Punlarp Punnotok and Adul Adulyanukosol
DESIGN OFFICE Color Party Object
PRINCIPAL TYPE Compacta
DIMENSIONS 4.1 x 10.4 x .7 IN. (10.5 x 26.5 x 1.9 CM)

DESIGN Angela DuBois, Jean-Paul Leonard,
. and Michael Murphy
. *Los Angeles, California*
CREATIVE DIRECTION . . . Jean-Paul Leonard
VIDEO/MOTION
GRAPHICS DIRECTOR . . . Michael Murphy
LETTERING Angela DuBois
DESIGN OFFICE Company Wide Shut
CLIENT 20th Century Fox Home Entertainment
PRINCIPAL TYPE Sign Painter, Dymo Label Tape, and handlettering

CALENDAR

DESIGN Corps
. *The Hague, The Netherlands*
ART DIRECTION Allard van Basten-Batenburg
CREATIVE DIRECTION . . . Errol Konat and Edwin Rozendal
AGENCY Corps
CLIENT Ando bv
PRINCIPAL TYPE FF Dax
DIMENSIONS 7.9 x 9.6 IN. (20 x 24.5 CM)

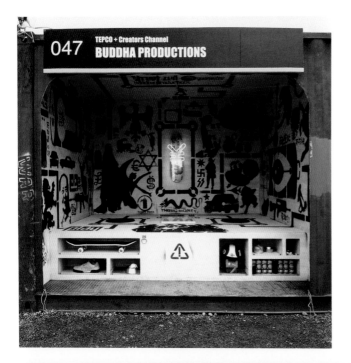

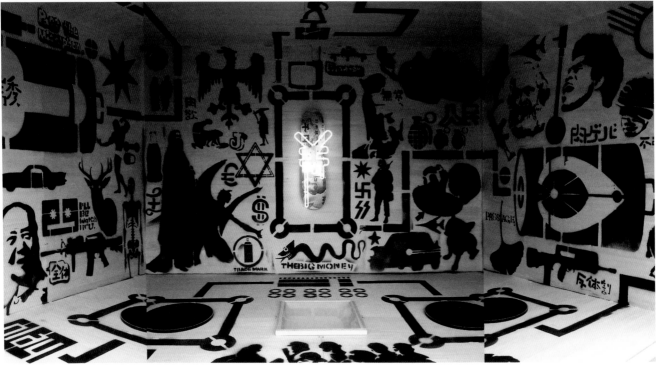

DESIGN Kei Saito
. *Tokyo, Japan*
ART DIRECTION Kei Saito
CALLIGRAPHY Kei Saito
PHOTOGRAPHY Koichi Moriya
STYLIST Masato Okamura
AGENCY Creators Channel
CLIENT Tokyo Electric Power Company (TEPCO)
PRINCIPAL TYPE Revolution and custom
DIMENSIONS 114.2 x 98.4 IN. (290 x 250 CM)

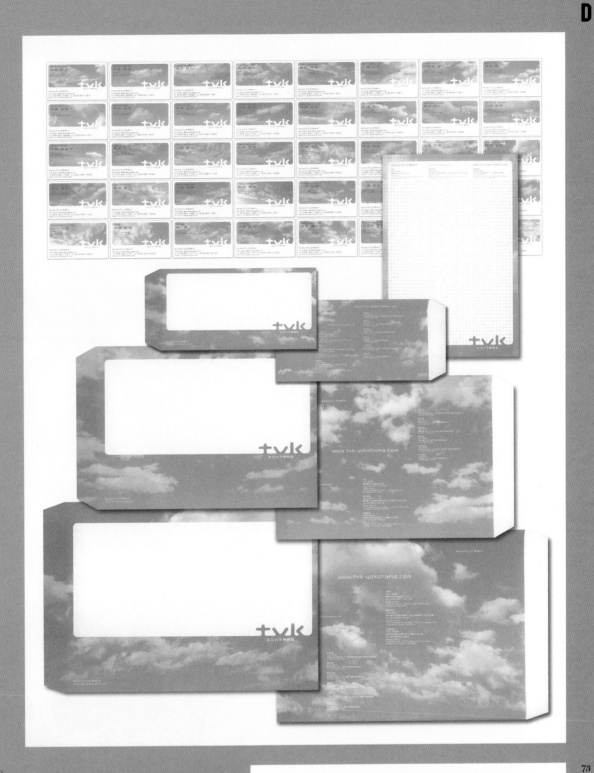

CORPORATE IDENTITY

DESIGN Jun Takechi
. *Tokyo, Japan*
ART DIRECTION Jun Takechi
CREATIVE DIRECTION . . . Tom Uemura and Kojiro Tanoue
PHOTOGRAPHY Hiroshi Noguchi
AGENCY Dentsu Inc.
CLIENT Television Kanagawa Inc.
PRINCIPAL TYPE Custom
DIMENSIONS Various

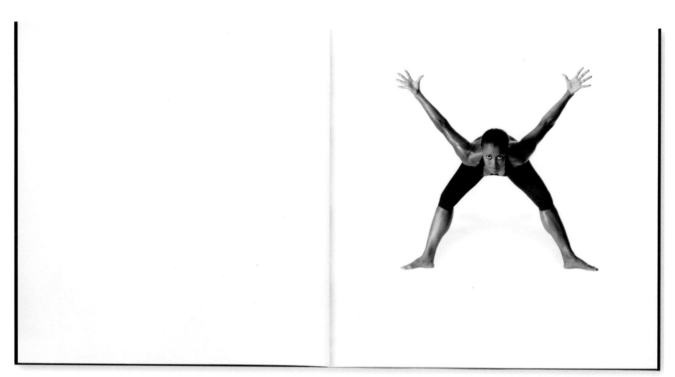

74 BROCHURE

DESIGN Stewart Devlin and Sahar El-Hage
. *New York, New York*
ART DIRECTION Stewart Devlin
CREATIVE DIRECTION . . . Phyllis Aragaki
PHOTOGRAPHY Steve Vaccariello and James Worrell
DESIGN OFFICE Desgrippes Gobé Group
CLIENT Meadowlands Xanadu
PRINCIPAL TYPE Adobe Neue Helvetica
DIMENSIONS 14 x 14 IN. (35.6 x 35.6 CM)

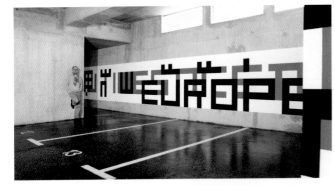
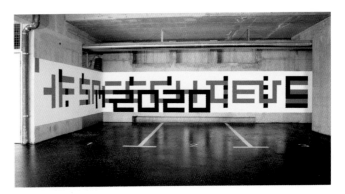

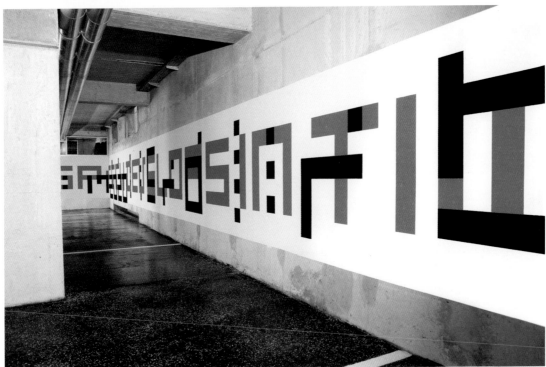

ARCHITECTURAL DESIGN

DESIGN Eduard Cehovin
. *Ljubljana, Slovenia*
ART DIRECTION Eduard Cehovin
CREATIVE DIRECTION . . . Eduard Cehovin
DESIGN STUDIO Design Center: Slovenia
CLIENT IEDC, Bled School of Management
PRINCIPAL TYPE Van Doesburg

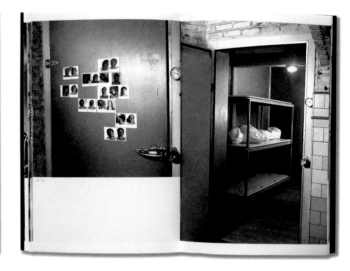

DESIGN Yael Eisele
. *New York, New York*
CREATIVE DIRECTION . . . J.P. Williams
PHOTOGRAPHY Grant Peterson
PRINTER Lithographix
. *Los Angeles, California*
DESIGN OFFICE Design: MW
CLIENT Grant Petersen
PRINCIPAL TYPE HTF Gotham and Mrs. Eaves
DIMENSIONS 5.75 x 8.5 IN. (14.6 x 21.6 CM)

BOOK 77

DESIGN Jean-Marc Durviaux and John Wiese
. *Los Angeles, California*
ART DIRECTION Jean-Marc Durviaux and John Wiese
DESIGN OFFICE Distinc Design
CLIENT Balcony Press
PRINCIPAL TYPE Akzidenz Grotesk, Bureau Grotesque, and
. Foundry Form Serif
DIMENSIONS 6.9 x 9 IN. (17.5 x 22.9 CM)

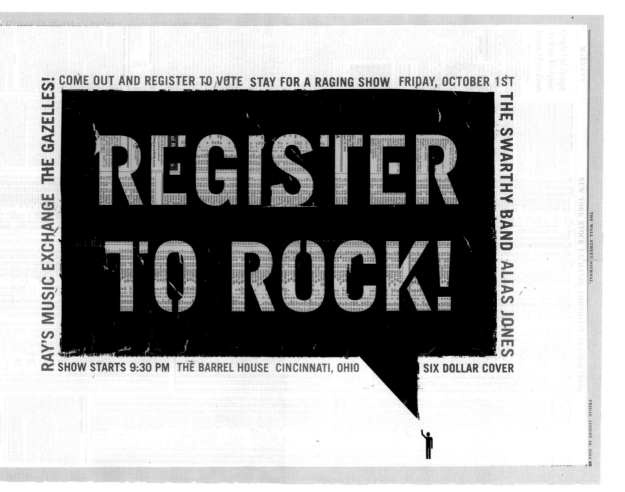

78 POSTER

DESIGN Andre Andreev and G. Dan Covert
. *New York, New York*
CREATIVE DIRECTION . . . Andre Andreev and G. Dan Covert
PROJECT MANAGER Alison Bailey
STUDIO dress code
CLIENT Joe Jahnigen
PRINCIPAL TYPE Trade Gothic (altered)
DIMENSIONS 21.5 x 15 IN. (54.6 x 38.1 CM)

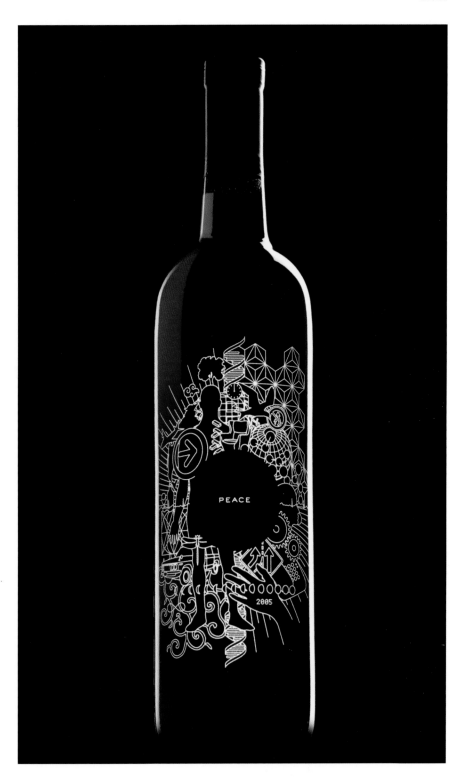

GREETING CARD

DESIGN Ken Sakurai
. *Minneapolis, Minnesota*
EXECUTIVE CREATIVE
DIRECTION Joe Duffy
CREATIVE DIRECTION . . . Dan Olson
DESIGN FIRM Duffy & Partners
PRINCIPAL TYPE AT Sackers Gothic Sans (altered)
DIMENSIONS 5.75 x 3.75 IN. (14.6 x 9.5 CM)

E

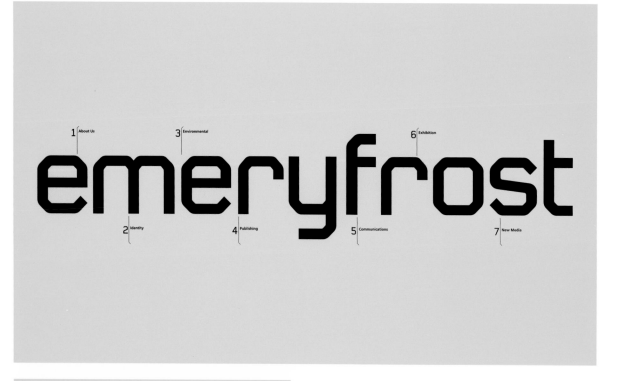

80 WEB SITE

DESIGN Matthew Willis
. *Sydney, Australia*
CREATIVE DIRECTION . . . Vince Frost
STUDIO emeryfrost
PRINCIPAL TYPE Frutiger Light and Foundry Gridnik (modified)

LOGOTYPE

DESIGN Joseph Michael Essex and Nancy Essex
. *Chicago, Illinois*
LETTERING Joseph Michael Essex
DESIGN OFFICE Essex Two
CLIENT Indiana Health for All and
. Hetrick Communications

F

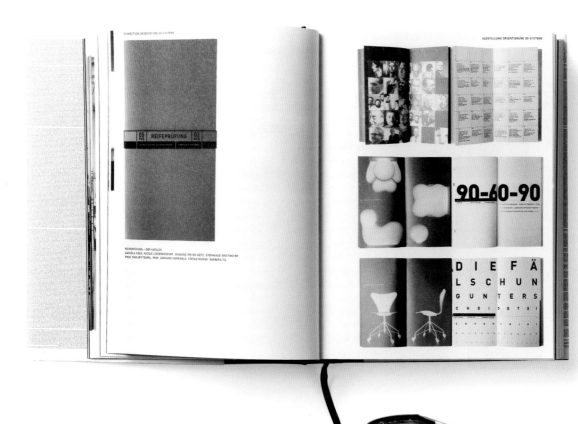

BOOK

DESIGN Hendrik Bruning, Alexander Gialouris,
. Bettina Knoth, Markus Kremer, Thomas Meyer,
. Nils Mengedoth, and Carola Rentz
. *Düsseldorf, Germany*
CREATIVE DIRECTION . . . Professor Wilfried Korfmacher,
. Professor Victor Malsy,
. Professor Philipp Teufel, and Gilmar Wendt
PHOTOGRAPHY Michael Lübke, Hendrik Bruning,
. Alexander Gialouris, Markus Kremer,
. Thomas Meyer, Nils Mengedoth, and Carola Rentz
SCHOOL Fachhochschule Düsseldorf,
. University of Applied Sciences
CLIENT Fachbereich Design
PRINCIPAL TYPE Proforma and Bell Centennial
DIMENSIONS 7.1 x 9.5 IN. (18 x 24 CM)

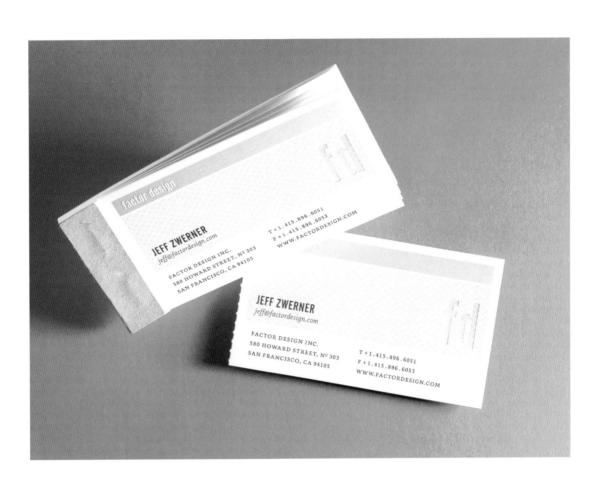

STATIONERY

DESIGN Alwin Mulyono
. *San Francisco, California*
CREATIVE DIRECTION . . . Jeff Zwerner and Gabe Campodonico
DESIGN OFFICE Factor Design
PRINCIPAL TYPE Alternate Gothic and Dolly
DIMENSIONS Various

DESIGN Jindrich Novotny
. *Hamburg, Germany*
ART DIRECTION Jindrich Novotny
CREATIVE DIRECTION . . . Johannes Erler
LETTERING Jindrich Novotny
DESIGN OFFICE Factor Design AG
PRINCIPAL TYPE Adobe Concorde and handlettering
DIMENSIONS 23.4 x 31.5 IN. (59.5 x 80 CM)

Wie Augsburg bei der
künstlerischen Gestaltung
des Stadtraumes auf die
Mitwirkung von Bürgerinnen
und Bürgern setzt.

BOOK

DESIGN Jindrich Novotny and Christian Tönsmann
. *Hamburg, Germany*
ART DIRECTION Jindrich Novotny and Christian Tönsmann
CREATIVE DIRECTION . . Johannes Erler
DESIGN OFFICE Factor Design AG
CLIENT Kulturreferat der Stadt Augsburg
PRINCIPAL TYPE Courier, Adobe Garamond,
. and Berthold Garamond Italic
DIMENSIONS 8.7 x 10.8 IN. (21 x 27.5 CM)

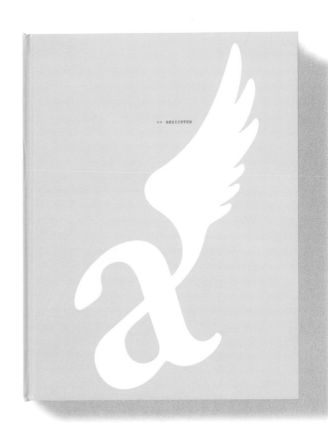

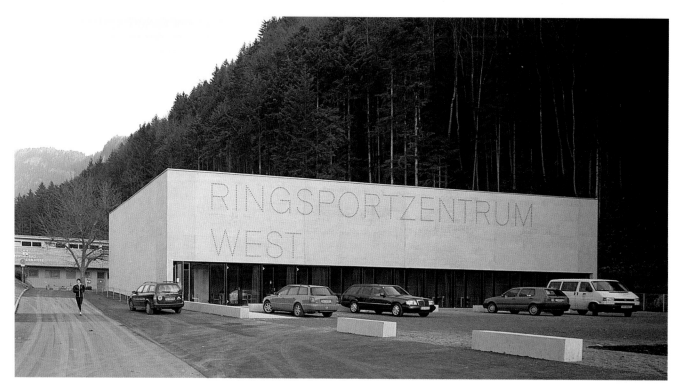

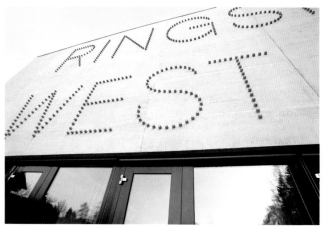

86 ARCHITECTURAL AND DIMENSIONAL DISPLAY

DESIGN Peter Felder
. *Rankweil, Austria*
ART DIRECTION Peter Felder
PHOTOGRAPHY Albrecht Schnabel
ARCHITECTURE Cukrowicz + Nachbaur
DESIGN OFFICE Felder Grafikdesign
CLIENT Ringsportzentrum West
PRINCIPAL TYPE Helvetica Ultra Light and Neue Helvetica

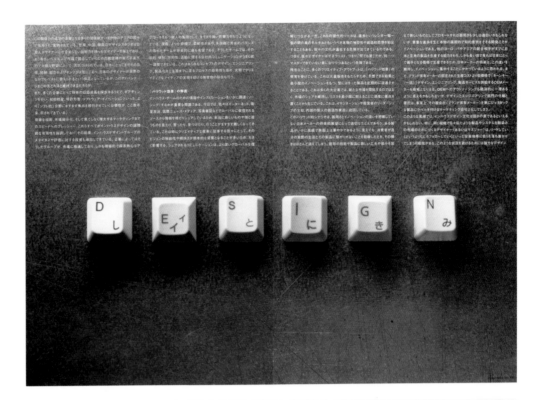

MAGAZINE SPREAD

DESIGN Masayoshi Kodaira
. *Tokyo, Japan*
ART DIRECTION Masayoshi Kodaira
PHOTOGRAPHY Kozo Takayama
STUDIO. FLAME, Inc.
CLIENT Japan Industrial Design Promotion Organization
PRINCIPAL TYPE Handlettering
DIMENSIONS 16.5 x 11.7 IN. (42 x 29.7 CM)

DESIGN Masayoshi Kodaira and Namiko Otsuka
. *Tokyo, Japan*
ART DIRECTION Masayoshi Kodaira
IMAGES Archigram Archives
STUDIO FLAME, Inc.
CLIENT Art Tower Mito
PRINCIPAL TYPE Trade Gothic and Clarendon
DIMENSIONS 20.3 x 28.7 IN. (51.5 x 72.8 CM)

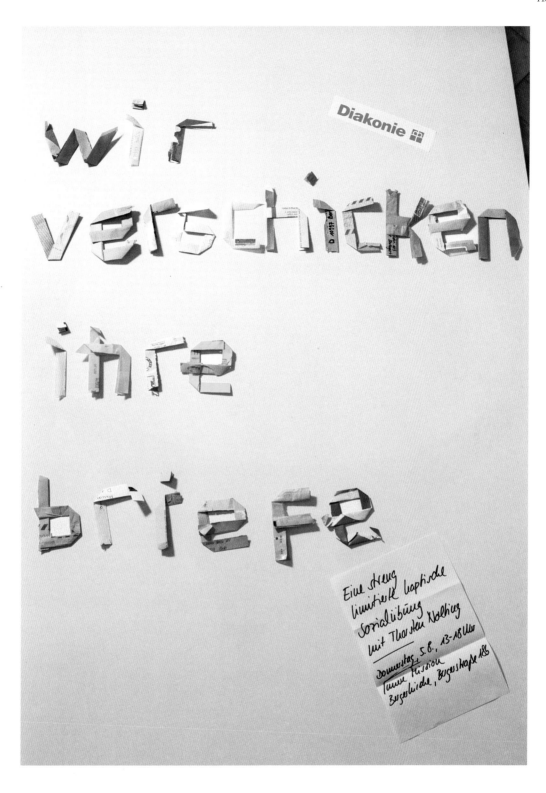

DESIGN Barbara Baettig and Fons Hickmann
. *Berlin, Germany*
ART DIRECTION Fons Hickmann
PHOTOGRAPHY Simon Gallus
DESIGN OFFICE Fons Hickmann m23
CLIENT Diakonie
PRINCIPAL TYPE m23_paper
DIMENSIONS 23.6 x 33.1 IN. (60 x 84 CM)

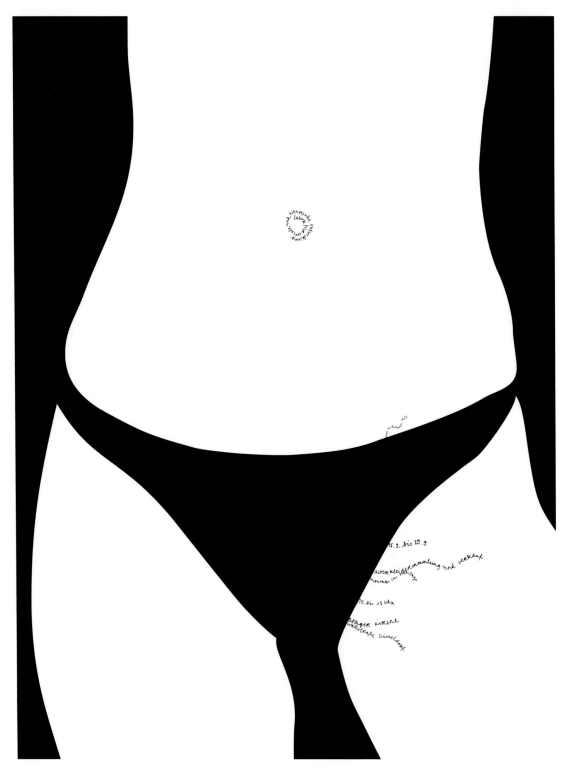

DESIGN Fons Hickmann
. *Berlin, Germany*
ART DIRECTION Fons Hickmann
ILLUSTRATION Gesine Grotrian-Steinweg
DESIGN OFFICE Fons Hickmann m23
CLIENT Labor
PRINCIPAL TYPE m23_Anaïs
DIMENSIONS 33.1 x 47.2 IN. (84 x 120 CM)

Abb. 001

VORNAME / NAME
Edgar Endress

ARBEIT / TITEL
Bon Dieu Bon, 2003

«Bon Dieu Bon» ist eine Gemeinschaftsarbeit von
Edgar Endress und der Anthropologin Lori Lee.
Sie thematisiert die häufige, zunächst illegale
Einwanderung von Haitianern, Dominikanern und
Chinesen auf die zu den US-amerikanischen
Virgin Islands (Jungferninseln, Kleine Antillen)
gehörende Insel St. John.

Wenn ein illegaler Einwanderer aufgegriffen
wird, erscheint eine kurze Notiz in der lokalen
Tageszeitung; wenn nicht, zeugen nur noch die
am Strand zurückgelassenen Kleidungsstücke -
Beutel, Schwimmwesten und andere Habseligkeiten
- davon, dass wieder ein Neuankömmling auf der
«Einwanderungswelle» hierher geschwommen ist.
Diese Form der Migration hat eine Art Ritual
hervorgebracht, bei dem die Einwanderer am Ufer
mit einem Müllsack ankommen, in dem sie einen
Satz Kleidung mitbringen.

Die Flüchtlinge kommen mit Booten und schwimmen
die letzten Seemeilen an Land. Hier ziehen sie
die trockenen Kleidungsstücke an und lassen
ihre nassen Sachen und Rucksäcke am Strand
zurück, bevor sie sich in die Stadt aufmachen.
Die meisten Neuankömmlinge bleiben nur so lange
auf St. John, bis sie nach St. Thomas aufbre-

VISA / ENDRESS / BON DIEU BON / 024 **VISA / ENDRESS / BON DIEU BON / 025**

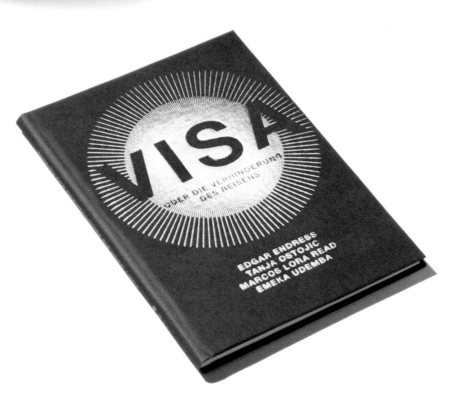

CATALOG

DESIGN Fons Hickmann, Barbara Baettig, and Simon Gallus
. *Berlin, Germany*
ART DIRECTION Fons Hickmann
DESIGN OFFICE Fons Hickmann m23
CLIENT IFA Gallery
PRINCIPAL TYPE Helvetica
DIMENSIONS 3.9 x 5.9 IN. (10 x 15 CM)

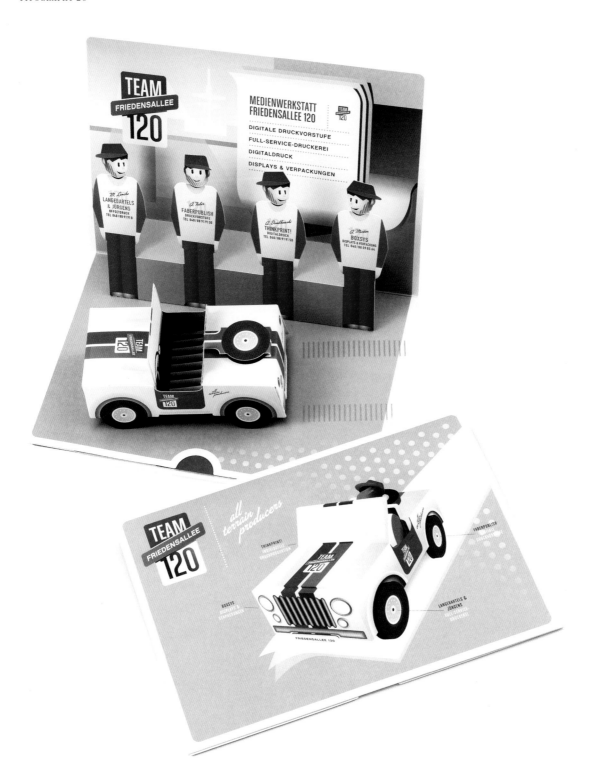

DESIGN Knut Ettling
. *Hamburg, Germany*
ILLUSTRATION Knut Ettling
STUDIO Format Design
CLIENT Langebartels & Jürgens GmbH
PRINCIPAL TYPE Chalet and Las Vegas Fabulous
DIMENSIONS 7.9 x 11.2 IN. (20 x 28.5 CM)

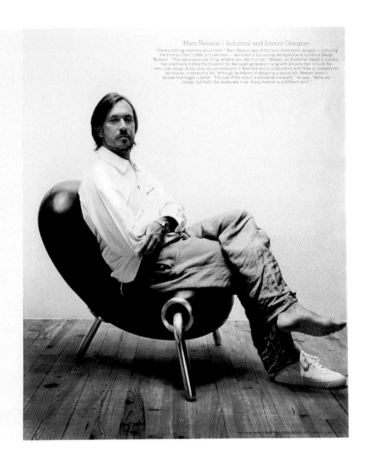

NOW
MORE THAN EVER,
DESIGN IS SUBJECT TO
THE WINDS AND
WHIMS OF FASHION.
WHICH MEANS
THAT FOR ARCHITECTS
AND DESIGNERS,
BEING THEMSELVES IS
NO SMALL FEAT

The Originals

THESE MEN AND
WOMEN DON'T DESIGN
LIKE EVERYONE ELSE.
SO WHY IN THE WORLD
WOULD THEY
WANT TO LOOK LIKE
EVERYONE ELSE?
PHOTOGRAPHS
BY ROBERT MAXWELL

MAGAZINE SPREAD

DESIGN Janet Froelich and David Sebbah
. *New York, New York*
ART DIRECTION David Sebbah
CREATIVE DIRECTION . . . Janet Froelich
PHOTOGRAPHY Robert Maxwell
PUBLICATION The New York Times Style Magazine
PRINCIPAL TYPE Stymie and Fraktur
DIMENSIONS 9.5 x 11.5 IN. (24.1 x 29.2 CM)

Gramm celebrated the shutdown. "Have you really noticed a difference?" he reportedly asked.

The public did notice, as it turned out, and they didn't like it. Within a few years the Republicans were backtracking so furiously they were proposing to spend more money on the Department of Education than the Clinton administration thought to ask for.

III. Muddling Toward a Governing Philosophy

So now we have two sorts of Republicans. The first group is made up of people who still mouth the words about reducing the size of government but don't even pretend to live according to their creed. These Republicans, mostly in Congress, go home to their states and districts and rail against Washington and big government. Then when they get back to Capitol Hill they behave like members of any majority party. They try to use their control over the federal purse to buy votes. They embrace appropriations and champion pork with an enthusiasm that makes your eyes pop.

For them, the old anti-statist governing philosophy exists in the airy-fairy realm of ideals. When it actually comes time to make some decisions about priorities and spending, they have no governing philosophy and hence no discipline. The money just splurges out. "The current version of the Republican Party is engaged in an outrageous spending binge, and they're being steadied and encouraged by Democrats," John McCain observed recently.

The money is appropriated in increments large and small — a $180 billion corporate tax bill one week, a steady stream of pork projects all the rest. In 1994, there were 4,126 "earmarks" — special spending provisions — attached to the 13 annual appropriations bills. In 2004, there were around 14,000. Real federal spending on the Departments of Education, Commerce and Health and Human Services has roughly doubled since the Republicans took control of the House in 1994. This is a governing majority without shape, coherence or discipline.

The second group of Republicans is at least trying to come up with a governing philosophy that applies to the times. It understands the paradox that if you don't have a positive vision of government, you won't be able to limit the growth of government. If you can't offer people a vision of what government should do, you won't be able to persuade them about the things it shouldn't do. If the Republican Party is going to evolve into a principled majority party, members of this group are going

to have to build a governing philosophy based on this insight.

To his credit, George Bush falls into this latter category. By the time he began his campaign for president in 1999, Bush understood that the simple government-is-the-problem philosophy of the older Republicans was obsolete. During that campaign, Bush criticized what he called the "destructive mind-set: the idea that if government would only get out of our way, all our problems would be solved. An approach with no higher goal, no nobler purpose, than 'Leave us alone.'" Instead, Bush argued, "government must be carefully limited but strong and active."

In another speech, Bush noted, "Too often, my party has confused the need for limited government with a disdain for government itself." He continued: "Our founders rejected cynicism and cultivated a noble love of country. That love is undermined by sprawling, arrogant, aimless government. It is restored by focused and effective and energetic government."

Compassionate conservatism was his attempt to come up with a new governing philosophy, a set of beliefs to guide Republicans as they tried to figure out what to do with power. Unfortunately, compassionate conservatism turned out to be a pretty thin tissue, and it was incinerated by the events of Sept. 11.

Since then, the Bush administration, while focusing on the war on terror, has been muddling toward a more appropriate governing philosophy. As Daniel Casse observed recently in Commentary magazine, "It is impossible to ignore the ways in which the sometimes surprising and unorthodox policies [Bush] has been advancing, albeit unevenly, have created a new type of conservative agenda."

On domestic policy, Casse writes, the Bush administration has agreed to greater federal spending in exchange for the seeds of market reform — a tax prescription drug benefit in exchange for the hint of a new approach to Medicare that emphasizes choice and accountability. This is not traditional big government, nor is it small government. It is strong government, Casse writes, which provides services while giving individuals choice about how they want them delivered.

This sort of conservatism measures its success not by how big or small government is but by the habits it encourages in its citizens. Does it encourage dependence or self-reliance? Does it tap individual initiative or give it new forums to exert itself? As Jonathan Rauch wrote in The National Journal: "Conservatives have been obsessed with reducing the supply of government when instead they should reduce the demand for it; and the way to do that is by repudiating the Washington-knows-best legacy of the New Deal. Republicans will empower people, and the people will empower Republicans."

Bush himself seems to agree. On July 21 he noted that while "government should never try to control or dominate the lives of our citizens," nonetheless, "government can and should help citizens gain the tools to make their own choices."

This is not yet a governing philosophy. It is not yet a new identity for American conservatism. It is not yet an updated conservative agenda. But it is a glimmer of these things. It is the first glimpse of the sort of Republican Party we could see when the convention rolls around again in 2008.

Nobody knows who the nominee will be that year. It could be Bill Frist, Chuck Hagel, Rudy Giuliani, Gov. Bill Owens of Colorado or somebody else — maybe even Arnold Schwarzenegger. But if the party is going to offer a positive, authoritative vision for the post-9/11 world, which is a world of conflict and anxiety, then it is going to have to develop a strong-government philosophy consistent with Republican principles. It will have to embrace a progressive conservative agenda more ambitious and fully developed than anything the Bush administration has so far articulated.

A candidate who does that would not need to launch an insurgency campaign against the Republican establishment, the way Goldwater did in 1964 or the way Reagan did in 1976. The fact is the Republican Party no longer has a coherent establishment left to inveigh against. Instead, a progressive conservative candidate would have to play a more constructive role. He would have to lay out a vision that would rebuild the bonds among free-market conservatives, who dream of liberty; social conservatives, who dream of decency; middle-class suburbanites, who dream of opportunity; and foreign-policy hawks, who dream of security and democracy. He would have to revive and update the governing philosophy that did bind these groups, and did offer such hope, in the early days of the G.O.P. Long before it was the party of Tom DeLay, the G.O.P. was a strong government/progressive conservative party. It was the party of Lincoln, and thus of Hamilton. Today, in other words, the Republican Party doesn't need another revolution. It just needs a revival. It needs to learn from the ideas that shaped the party when it was born.

IV. What Would Hamilton Do?

Today we have one political tradition, now housed in the Democratic Party, which believes in using government in the name of equality and social justice. We have another tradition, recently housed in the Republican Party, which believes, or says it believes, in restricting the size of government in the name of freedom and personal responsibility. But through much of American history there has always been a third tradition, now dormant, which believes in limited but energetic government in the name of social mobility and national union.

This third tradition was founded by Alexander Hamilton, embraced by Henry Clay and the Whig Party, taken up by Abraham Lincoln and the early Republican Party and brought into the 20th century by Theodore Roosevelt. It withered during the great 20th-century debate over the size of government (its philosophy was confusedly crossways to this debate), but it is this tradition that Republicans must embrace if they are to become the majority party for the next few decades.

This progressive conservative tradition is built on an admiration for a certain sort of individual: the young, ambitious striver, who works hard, makes something of himself, creates opportunities for others and then goes on to advance America's unique mission in the world. Alexander Hamilton was the first embodiment and definer of this creed. Hamilton came from nothing and spent his political career trying to create a world in which as many people as possible could replicate his amazing success.

Hamilton looked around after independence and saw a country destined to become the greatest empire of the earth (as he put it) but burdened with institutions that retarded social mobility and stifled development. The American economy was still mainly an agricultural economy, which trapped talented young people on the farm, where they could not cultivate the full range of their talents. Then there were the aristocratic families like Thomas Jefferson's, which exercised stranglehold control over the country's economic life.

Hamilton sought to smash all that, to liberate and stir Americans to exploit the full range of their capacities. As he wrote in his "Report on Manufactures," "To cherish and stimulate the activity of the human mind, by multiplying the objects of enterprise, is not among the least considerable of the expedients, by which the wealth of a nation may be promoted. … Every new scene, which is opened to the busy nature of man to rouse and exert itself, is the addition of a new energy to the general stock of effort." Hamilton believed that people had inside them vast wells of untapped resources, and that it was the job of government to open up opportunities, to arouse, stimulate and cultivate an energetic populace so citizens could compete with one another.

First Hamilton had to break up the vested interests that encrusted American life. He did this, in part, by nationalizing the Revolutionary War debt. This, he said, would fuse the many insular local economies into one dynamic national economy. It would also lead to thriving credit markets. It would shift power away from the local landowners to commercial traders, who would move capital around looking for investment opportunities. Hamilton also created the Bank of the United States, to finance investments. He organized what we would now call federal scientific research.

He believed, in other words, in using government to enhance market dynamism by fostering more equitable competition. He believed government could usefully promote social revolutions, in his case the move from an agricultural to a commercial economy. In short, he rejected the

Illustrations by Michael Ian Kaye 35

THE PROBLEM:
AMERICANS ARE NOT OF ONE RELIGIOUS FAITH.
AMERICANS ARE NOT TRADITION-DRIVEN.
AMERICANS LIKE CHANGE.

MAGAZINE

DESIGN	Kristina DiMatteo
	New York, New York
ART DIRECTION	Arem Duplessis
CREATIVE DIRECTION	Janet Froelich
ILLUSTRATION	Michael Ian Kaye
PUBLICATION	The New York Times Magazine
PRINCIPAL TYPE	Stymie, Cheltenham, and Garamond
DIMENSIONS	9.6 x 11.75 IN. (24.4 x 29.8 CM)

THE ERA OF SMALL GOVERN-MENT IS OVER*

The New York Times Magazine

Republicans 2008 | The case for a new progressive conservatism. By David Brooks

*MAYBE

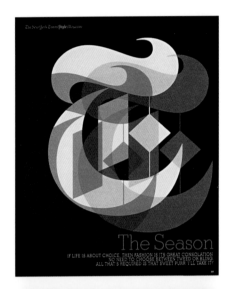

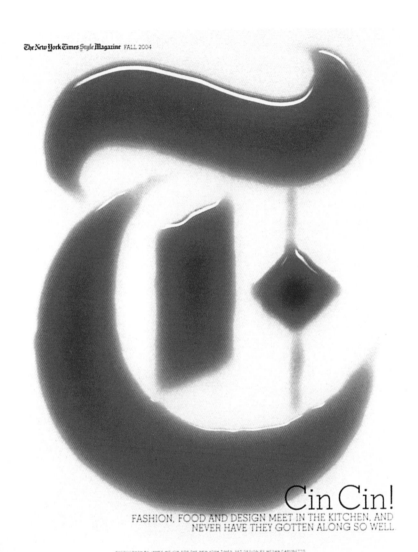

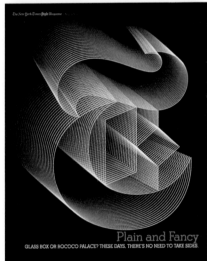

MAGAZINE

DESIGN Janet Froelich and David Sebbah
. *New York, New York*
ART DIRECTION David Sebbah
CREATIVE DIRECTION . . . Janet Froelich
PHOTOGRAPHY James Wojcik
PUBLICATION The New York Times Style Magazine
PRINCIPAL TYPE Stymie and Cheltenham
DIMENSIONS 9.6 x 11.75 IN. (24.4 x 29.8 CM)

G

DESIGN Go Takahashi
. *Tokyo, Japan*
ART DIRECTION Manabu Mizuno
CREATIVE DIRECTION . . . Manabu Mizuno
DESIGN OFFICE good design company, inc.
CLIENT Twinkle Co., Ltd.
PRINCIPAL TYPE Custom
DIMENSIONS 20.3 x 28.7 IN. (51.5 x 72.8 CM)

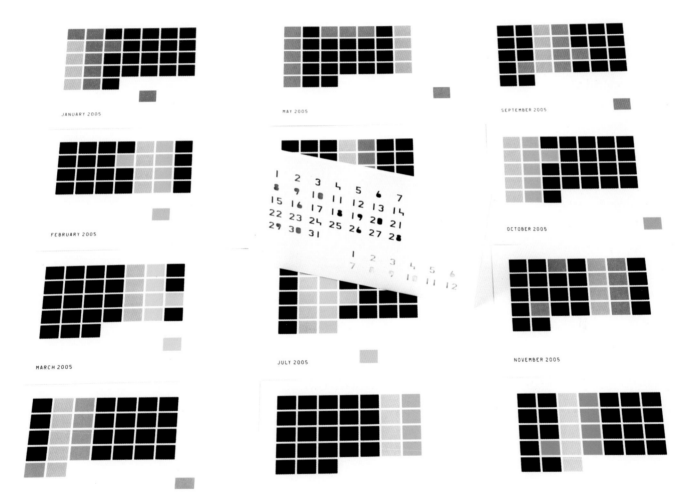

JANUARY 2005

MAY 2005

SEPTEMBER 2005

FEBRUARY 2005

OCTOBER 2005

MARCH 2005

JULY 2005

NOVEMBER 2005

CALENDAR

97

DESIGN Kohei Miyasaka
. *Tokyo, Japan*
ART DIRECTION Katsumi Tamura
DESIGN OFFICE good morning inc.
PRINCIPAL TYPE Custom lettering
DIMENSIONS 6.7 x 4.3 IN. (17 x 11 CM)

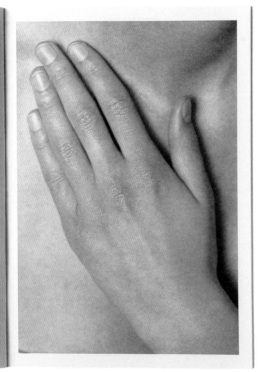

Pini starrte seine Hand an, als bitte er sie, ihre närrischen Eigenwilligkeiten, ihre unnötig komplizierten Extratouren endlich und endgültig sein lassen zu wollen – und schloss und öffnete sie dabei so mechanisch, als probiere er die Funktionstüchtigkeit eines eben erst an sein Gelenk montierten künstlichen Apparates aus, bei dem man nicht sicher sein konnte, ob sein Erfinder nicht doch gepfuscht hatte. Sie verweigert den Dienst. Sie streikt. Das ist es, was ich weiß. Sagen Sie, Doktor ...

Wolf Wondratschek

DESIGN Ulli Neutzling and Sandra Ost
. *Hamburg, Germany*
ART DIRECTION Ulli Neutzling
CREATIVE DIRECTION . . . Ulli Neutzling
PHOTOGRAPHY Wolfgang Steche
PRODUCTION Ralf Schnarrenberger
REPRODUCTION Susanne Kreher
PRINT Christians-partner in media
AGENCY Groothuis, Lohfert, Consorten
CLIENT Lohfert & Lohfert AG
PRINCIPAL TYPE Minion and Myriad MM
DIMENSIONS 8.3 x 11.7 IN. (21 x 29.7 CM)

HERBSTLICHER VERZICHT

Das Wetter ist heut schon so herbstlich kalt,
daß Dich das eigne Heim erheblich freut.
Im allgemeinen wirst Du gut betreut
und bist damit zufrieden: man wird alt.

Lügst Du Dir eine zweite Jugend vor,
so weißt Du doch, daß Dir nichts mehr gelingt,
daß keines Wunsches Zauber wiederbringt,
was man dereinst versäumte und verlor.

Verzichtet hast Du schon auf soviel Lust,
zuletzt sogar auf manchen guten Trunk:
nun zehrst Du nur von der Erinnerung,
und es genügt, daß Du nicht hungern mußt.

Doch wenn Du Dich ganz unbeachtet weißt,
gedenkst Du zärtlich der verflossnen Zeit,
als Du noch warst zur Meuterei bereit
und opferwillig dem Rebellengeist.

Erfüllt ist nichts, was Du zuvor erstrebt,
und schließlich wahrst Du nicht einmal den Schein.
Nur schlaflos nachts mit Deiner Angst allein
gestehst Du Dir: »Mein Leben ist verlebt.«

Der Nebel sinkt, das Beste ist vorbei:
was fürder kommt, kann nur noch Abschied sein,
und jedes Lächeln, jedes Gläschen Wein
vergällt die Furcht, daß es das letzte sei.

64

Bevor Du ganz verzweifelst, nimmst Du feig
mit einem halbwegs warmen Raum vorlieb,
beseelt allein vom Selbsterhaltungstrieb,
mit einem Nest auf herbstlich morschem Zweig.

Vom Fenster sieht Dein welkes Angesicht
als Spiegelbild den Herbst des Parkes an,
und sinnt dem nach, wann der Verfall begann.
Denn wenn Du ehrlich bist: Längst lebst Du nicht.

65

BOOK

DESIGN Rainer Groothuis
. *Hamburg, Germany*
ART DIRECTION Rainer Groothuis
CREATIVE DIRECTION . . . Rainer Groothuis
SETTING Tobias Wantzen
PRODUCTION Ralf Schnarrenberger
REPRODUCTION Frische Grafik
PRINTER Clausen & Bosse
BINDER real Lachenmaier
AGENCY Groothuis, Lohfert, Consorten
CLIENT Offizin Bertelsmann
PRINCIPAL TYPE Dolly
DIMENSIONS 5.7 x 8.9 IN. (14.5 x 22.5 CM)

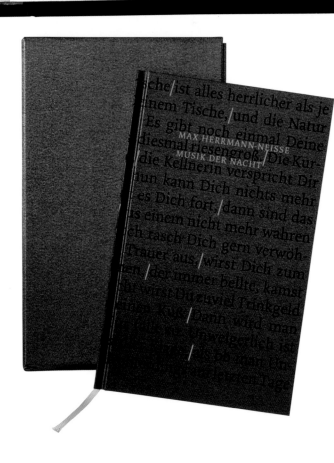

99

H

DESIGN Kurt Steinebrunner and Martina Lothes
. *Munich, Germany*
ART DIRECTION Kurt Steinebrunner
CREATIVE DIRECTION . . . Frank Wagner
DESIGN OFFICE Häfelinger & Wagner Design
PRINCIPAL TYPE Syntax Roman and Berthold City Bold
DIMENSIONS 4.9 x 6.5 IN. (12.5 x 16.5 CM)

Die BMW Group wächst in eine neue Größenordnung. Vom Automobilhersteller mit einer Marke und drei Produktlinien ist das Unternehmen im Jahr 2003 zum Premium-Anbieter mit drei Marken geworden – und im Jahr 2004 wird sich die Zahl der Produktlinien auf zehn erweitern. Entsprechend dynamisch wird sich auch das Absatzvolumen der BMW Group in den nächsten Jahren entwickeln. Bis zum Jahr 2008 wird das Unternehmen ein jährliches Absatzvolumen von mehr als 1,4 Millionen Automobilen erreichen. Ein Ziel, das sich nicht nur mit der Entwicklung der bereits bestehenden Märkte verwirklichen lässt. Diese ist zwar die unabdingbare Basis für das angestrebte Wachstum. Zusätzlich gilt es jedoch, sich konsequent neue Chancen zu erschließen und damit neue Kundengruppen zu gewinnen.

Wo immer sich ein Segment mit entsprechendem Potenzial für Premium-Produkte definiert und die BMW Group mit ihren Marken BMW, MINI oder Rolls-Royce ein authentisches Angebot machen kann, wird sie dies tun. Kompromisse in Sachen Premium gibt es dabei nicht. Denn ein entscheidender Erfolgsfaktor der BMW Group ist das klare und scharf abgegrenzte Profil ihrer Marken. Voraussetzung für die Expansion in neue Segmente ist daher stets der authentische Charakter der Fahrzeuge. Sie müssen zur Marke passen und – vor allem – eine hundertprozentige Lösung für die Ansprüche der Kunden darstellen. Aktuelle Beispiele für diese Expansionsstrategie sind etwa die neuen Modelle BMW X3 und BMW 6er. Oder der Rolls-Royce Phantom, der Anfang 2003 an den Start ging und mit dem die BMW Group ihr Angebot in das absolute Top-Segment der internationalen Automobilmärkte ausgebaut hat.

Das umfassendste Beispiel für die Erschließung neuer Segmente bietet jedoch die Marke MINI. Mit MINI hat die BMW Group den Premium-Begriff im Kleinwagensegment etabliert – mit einem Erfolg, der seinesgleichen sucht. MINI belegt, dass Premium keine Frage der Größe eines Fahrzeugs ist, sondern eine Frage des richtigen Konzepts. Selbst in den USA, wo das Kleinwagensegment bisher nur eine untergeordnete Rolle spielte, ist der MINI erfolgreich. So erfolgreich, dass die USA inzwischen zum zweitgrößten Markt für MINI Automobile weltweit wurden, knapp hinter Großbritannien, dem Mutterland des MINI.

Potenziale erkennen. Wachstum gestalten.

Segmente erschließen

22 23

101

ANNUAL REPORT

DESIGN	Andrea Mönch
	Munich, Germany
ART DIRECTION	Kerstin Weidemeyer
CREATIVE DIRECTION	Frank Wagner and Kerstin Weidemeyer
DESIGN OFFICE	Häfelinger & Wagner Design
CLIENT	BMW Group
PRINCIPAL TYPE	BMW Type
DIMENSIONS	8.3 x 11 IN. (21.2 x 28 CM)

CATALOG

DESIGN Thomas Tscherter
. *Munich, Germany*
ART DIRECTION Thomas Tscherter
CREATIVE DIRECTION . . . Frank Wagner
DESIGN OFFICE Häfelinger & Wagner Design
CLIENT Linda Schwarz
PRINCIPAL TYPE Berthold City, Clarendon, Medici Script,
. and Meridien
DIMENSIONS 8.7 x 11.2 IN. (22 x 28.5 CM)

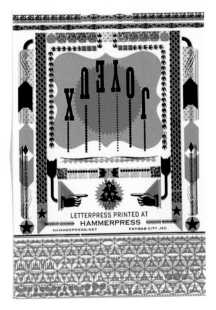

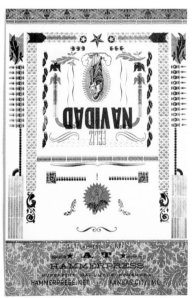

103

GREETING CARD

DESIGN Brady Vest
. *Kansas City, Missouri*
STUDIO Hammerpress
PRINCIPAL TYPE Various lead ornaments, rules, wood and lead type
DIMENSIONS 6 x 9 IN. (15.2 x 22.9 CM)

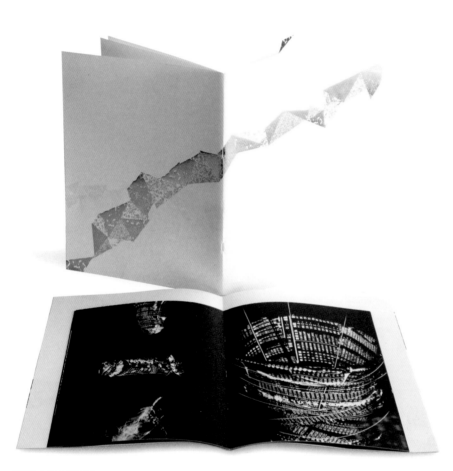

DESIGN Han Jiaying
. *Shenzhen, China*
ART DIRECTION Han Jiaying
CREATIVE DIRECTION . . . Han Jiaying
LETTERING Han Jiaying
DESIGN OFFICE Han Jiaying Design & Associates Ltd.
PRINCIPAL TYPE Handlettering
DIMENSIONS 27.6 x 39.4 IN. (70 x 100 CM)

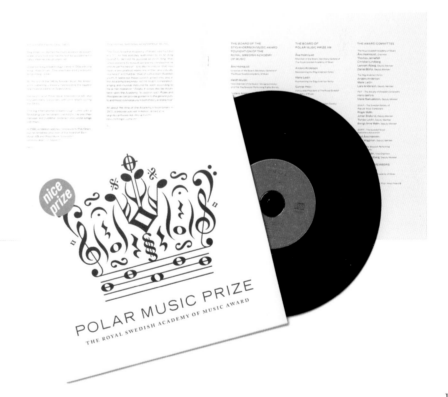

CATALOG

DESIGN	Andreas Kittel
	Gothenburg, Sweden
ART DIRECTION	Andreas Kittel
CREATIVE DIRECTION	Anders Kornestedt
AGENCY	Happy Forsman & Bodenfors
CLIENT	Polar Music Prize
PRINCIPAL TYPE	Trade Gothic Extended
DIMENSIONS	11.8 x 11.8 IN. (30 x 30 CM)

now here's a funny thing...

BROCHURE

DESIGN Jim Sutherland and Gareth Howat
. *London, England*
CREATIVE DIRECTION . . . Gareth Howat, David Kimpton, and Jim Sutherland
AGENCY hat-trick design
CLIENT Scott Perry
PRINCIPAL TYPE Clarendon
DIMENSIONS6 x 7.4 IN. (1.5 x 18.7 CM)

POSTER

DESIGN Jianping He
. *Berlin, Germany*
ART DIRECTION Jianping He
CREATIVE DIRECTION . . . Jianping He
STUDIO Hesign Studio Berlin
PRINCIPAL TYPE Square Slabserif
DIMENSIONS 66.1 x 94.5 IN. (168 x 240 CM)

DESIGN Klaus Hesse
. *Erkrath, Germany*
DESIGN OFFICE Hesse Design GmbH
CLIENT Museum of Modern Art Frankfurt
. and HfG Offenbach
PRINCIPAL TYPE Corporate S
DIMENSIONS 27.6 x 39.4 IN. (70 x 100 CM)

**THE
GHETTO
FILM
SCHOOL**

DESIGN Steven Fabrizio
. *New York, New York*
AGENCY Hill/Holliday Inc.
CLIENT Ghetto Film School
PRINCIPAL TYPE Interstate Bold Condensed

BOOK

DESIGN Anton Huber
. *Munich, Germany*
ART DIRECTION Anton Huber
CREATIVE DIRECTION . . . Anton Huber
LETTERING Anton Huber
DESIGN OFFICE Huber & Co. Design
PRINCIPAL TYPE Garamond and Amsterdam
DIMENSIONS 6.5 x 9.1 IN. (16.5 x 23 CM)

Octel Corp.
2009 Annual Report

07

Eq

Equilibrium

TEL + Specialty Chemicals

Balance is at the heart
of our business strategy.

Our carefully calibrated
business mix of Lead Alkyls
(TEL) and Specialty Chemicals
allows us to optimise
our strategy for long-term
shareholder value.

Fulfilling our mission
of being a global, profitable,
growing specialty chemicals
company hinges on managing
this equilibrium. So we
maintain our sensible
approach to spending.

While seeking the right
acquisition opportunities,
we have invested in integration,
restructuring, and rightsizing;
research and development;
and organic growth. On one
hand our Specialties
business is growing steadily,
and on the other we've
achieved excellent cash
generation in TEL.

At the same time, we have
met our debt obligations, paid
dividends, and continued with
our share buyback program.

On balance, we're *in* balance.

DESIGN Darren Namaye
. *New York, New York*
ART DIRECTION Darren Namaye
CREATIVE DIRECTION . . . Darren Namaye
DESIGN OFFICE Ideas on Purpos e
CLIENT Octel Corporation
PRINCIPAL TYPE Neue Helvetica
DIMENSIONS 7.25 x 7.25 IN. (18.4 x 18.4 CM)

DESIGN Ryan Glendening
. *Kansas City, Missouri*
CREATIVE DIRECTION . . . Ryan Hembree
PHOTOGRAPHY Chris Dennis
PRINTER Sterling Screen Printing
. *Merriam, Kansas*
DESIGN STUDIO Indicia Design, Inc.
CLIENT The Buckley Group, LLC
PRINCIPAL TYPE Mrs. Eaves and Benton
DIMENSIONS 26.75 x 11.25 IN. (67.9 x 28.6 CM)

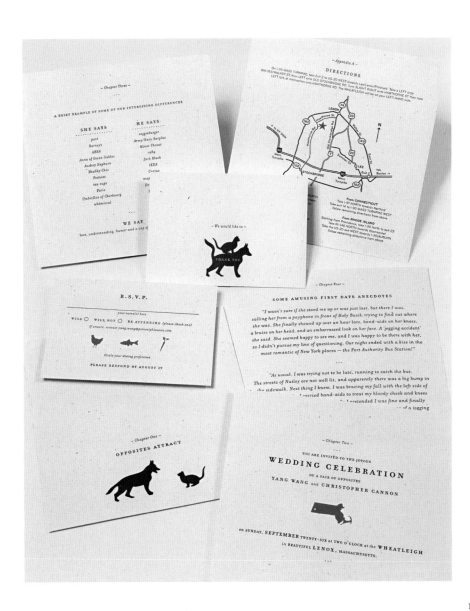

INVITATION

113

DESIGN Christopher Cannon
. *Brooklyn, New York*
ART DIRECTION Christopher Cannon
CREATIVE DIRECTION . . . Christopher Cannon
LETTERPRESS PRINTING . Milk Row Press
STUDIO Isotope 221
CLIENT Yang Wang and Christopher Cannon
PRINCIPAL TYPE Filosofia and Bryant
DIMENSIONS Various

J

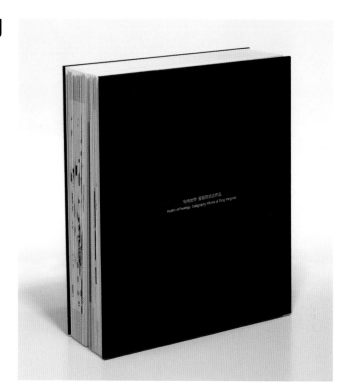

DESIGN Carol Lu
. *Taipei, Taiwan*
CREATIVE DIRECTION . . . Van So
CALLIGRAPHY Tong Yang-tze
DESIGN OFFICE JRV International Company Limited
PRINCIPAL TYPE Handlettering
DIMENSIONS 12.6 x 8.3 IN. (32 x 21 CM)

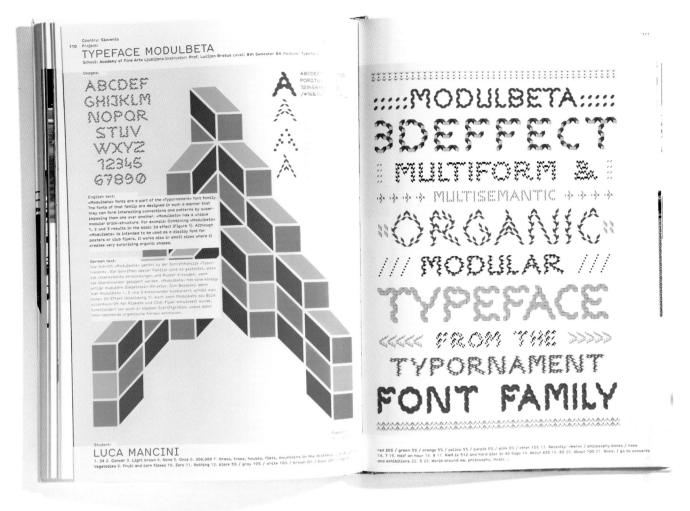

BOOK

DESIGN Ole Kaleschke, Petra Michel, and Florian Pfeffer
. *Bremen, Germany*
DESIGN OFFICE jung und pfeffer
CLIENT :output foundation
PRINCIPAL TYPE Hermes Regular
DIMENSIONS 9.1 x 13 IN. (23 x 33 CM)

DESIGN Florian Pfeffer
. *Bremen, Germany*
DESIGN OFFICE jung und pfeffer
CLIENT Bremen Marketing, Projektbüro Kulturhauptstadt
PRINCIPAL TYPE Cachet and Dolly
DIMENSIONS 9.5 x 11.2 IN. (24 x 28.5 CM)

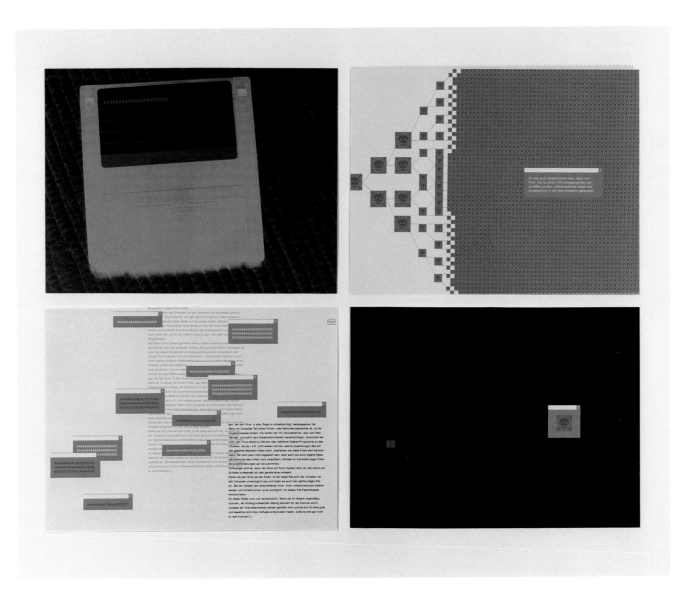

STUDENT PROJECT

DESIGN Ronny Karoussiotis
. *Krefeld, Germany*
PROFESSOR Monika Hagenberg
SCHOOL Hochschule Niederrhein Krefeld
PRINCIPAL TYPE Arial, Keyboard, and Russell Square
DIMENSIONS 7.5 x 10.8 IN. (19 x 27.5 CM)

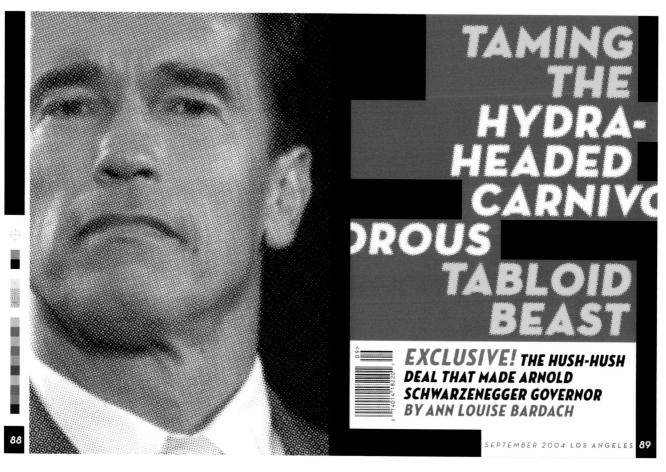

DESIGN Joe Kimberling
. *Los Angeles, California*
ART DIRECTION Joe Kimberling
PUBLICATION Los Angeles Magazine
PRINCIPAL TYPE Neutra
DIMENSIONS 16 x 10.5 IN. (40.6 x 26.7 CM)

BOOK

ART DIRECTION Liane Zimmermann
. *Munich, Germany*
CREATIVE DIRECTION . . . Martin Summ and Gabriele Werner
LETTERING Ulrike Paul
. *Augsburg, Germany*
TEXT Sandra Hachmann, Ulrich Mueller,
. and Martin Rasper
AGENCY Kochan & Partner GmbH
CLIENT Studiosus Reisen Muenchen GmbH
PRINCIPAL TYPE Corporate A, Corporate E, and Univers
DIMENSIONS 8.3 x 12.2 IN. (21 x 31 CM)

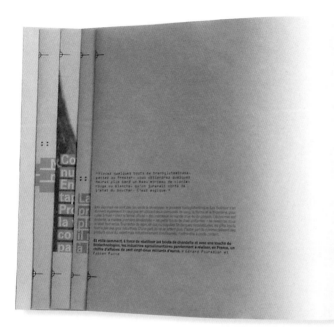

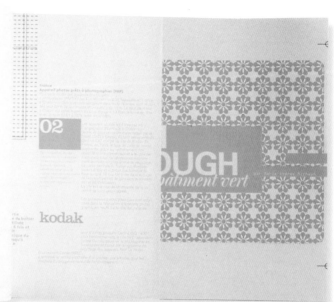

STUDENT PROJECT

DESIGN Anne-Lise Kyling
. *Saint-Armand, Canada*
INSTRUCTOR Judith Poirier
SCHOOL École de design UQAM
PRINCIPAL TYPE Akzidenz Grotesk, LoRes Nine, Microscan,
. Poppl, and Univers
DIMENSIONS 11.75 x 9 in. (29.8 x 22.9 cm)

L

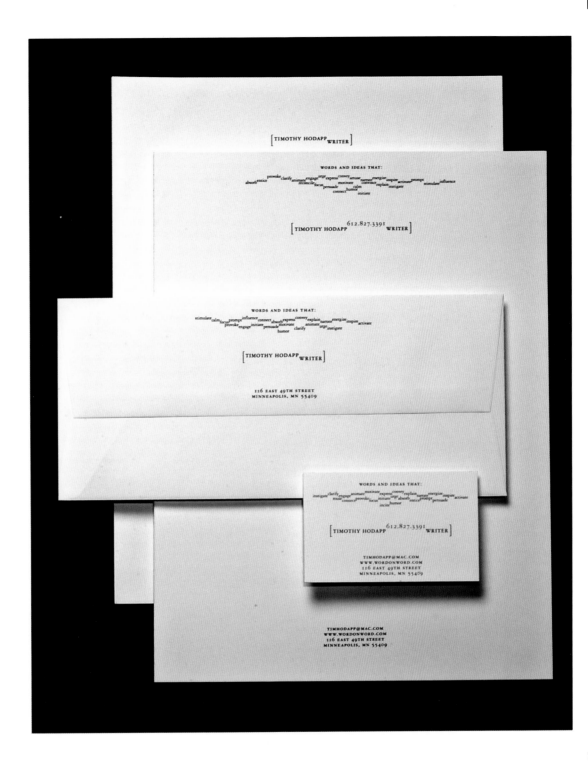

STATIONERY

DESIGN Jo Davison
. *Minneapolis, Minnesota*
CREATIVE DIRECTION . . . Jo Davison
DESIGN OFFICE Larsen Design + Interactive
CLIENT Tim Hodapp
PRINCIPAL TYPE Garamond 3
DIMENSIONS Various

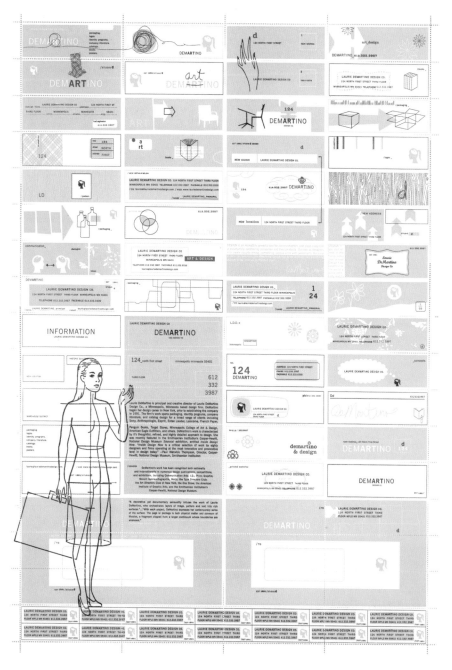

DESIGN Laurie DeMartino
. *Minneapolis, Minnesota*
ART DIRECTION Laurie DeMartino
DESIGN OFFICE Laurie DeMartino Design Co.
PRINCIPAL TYPE Clarendon, Faxfont, News Gothic,
. and handlettering
DIMENSIONS Various

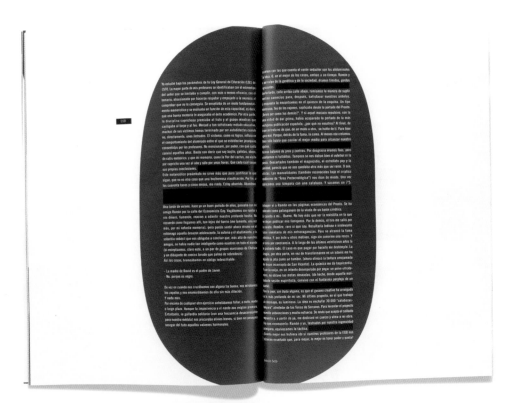

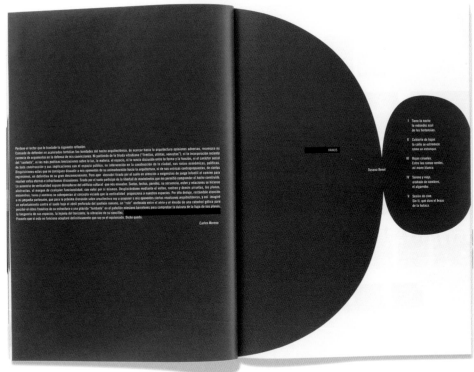

MAGAZINE

DESIGN Nacho Lavernia and Alberto Cienfuegos
. *Valencia, Spain*
CREATIVE DIRECTION . . . Nacho Lavernia and Alberto Cienfuegos
DESIGN OFFICE Lavernia y Cienfuegos
CLIENT Galeria "Color Elefante"
PRINCIPAL TYPE Trade Gothic Condensed Eighteen
DIMENSIONS 8.6 x 12.2 IN. (22 x 31 CM)

124 STUDENT PROJECT

DESIGN Min Kyong Lew
. *New York, New York*
INSTRUCTOR Linda Van Deursen
SCHOOL Yale School of Art
PRINCIPAL TYPE Helvetica
DIMENSIONS 17 x 22 IN. (43.2 x 55.9 CM)

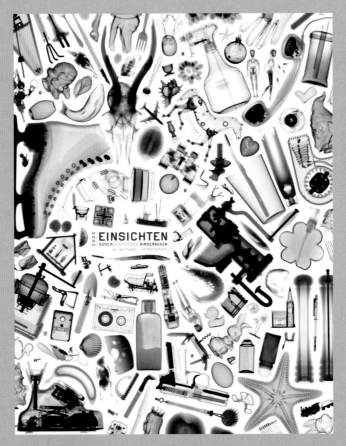

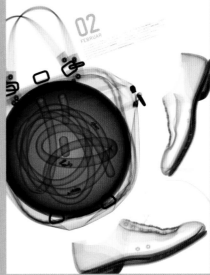

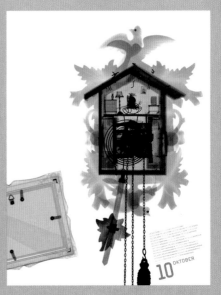

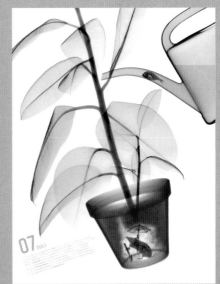

CALENDAR

DESIGN Guido Bender, Alexandra Ehrenklau, Lars Herzig,
. Christina Rüffer, Jasmin Siddiqui,
. and Helge Wagner
. *Wiesbaden, Germany*
ART DIRECTION Guido Bender, Alexandra Ehrenklau, Lars Herzig,
. Christina Rüffer, Jasmin Siddiqui,
. and Helge Wagner
CREATIVE DIRECTION . . . Professor Volker Liesfeld
PROFESSOR Volker Liesfeld
SCHOOL University of Applied Sciences,
. Fachhochschule Wiesbaden
PRINCIPAL TYPE FF Magda Clean
DIMENSIONS 23.4 x 30.3 IN. (59.4 x 77 CM)

DESIGN Domenic Lippa
. *London, England*
ART DIRECTION Domenic Lippa
CREATIVE DIRECTION . . . Domenic Lippa
EDITORS James Alexander, Domenic Lippa, Bruno Maag,
. and Sallyanne Theddosiou
DESIGN STUDIO Lippa Pearce Design
CLIENT The Typographic Circle
PRINCIPAL TYPE Interface and Lexia
DIMENSIONS 17.5 x 12.5 IN. (44.5 x 31.8 CM)

opthalmia nivialis
snow blindness

POSTER

DESIGN Harry Pearce
. *London, England*
ART DIRECTION Harry Pearce
CREATIVE DIRECTION . . . Harry Pearce
TYPOGRAPHY Harry Pearce and Nicky Perkins
DESIGN STUDIO Lippa Pearce Design
PRINCIPAL TYPE Rockwell Bold Condensed and Bespoke
DIMENSIONS 23 x 32 IN. (58.4 x 81.3 CM)

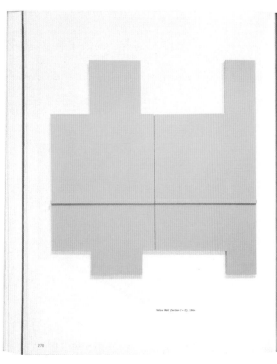

DESIGN Robert Ruehlman, Stuart Smith, and Lorraine Wild
. *Los Angeles, California*
ART DIRECTION Lorraine Wild
SENIOR DESIGNER Robert Ruehlman
DESIGN OFFICE Lorraine Wild Design/Green Dragon Office
PUBLISHER The Museum of Contemporary Art, Los Angeles
PRINCIPAL TYPE ITC Officina Sans
DIMENSIONS 8.5 X 11 IN. (22.6 X 27.9 CM)

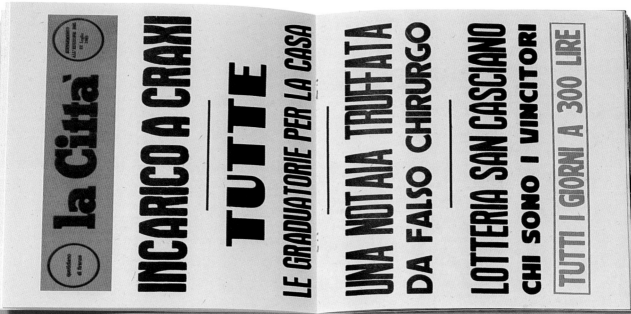

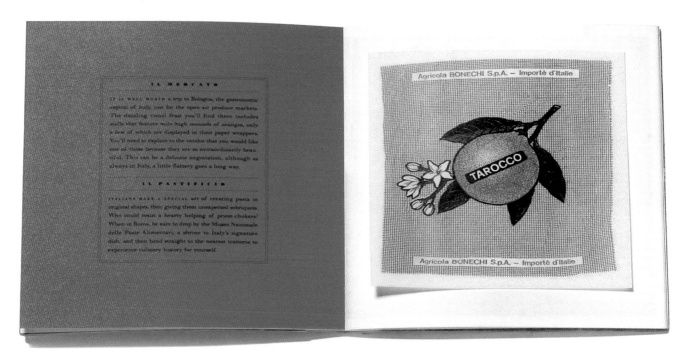

BOOK

DESIGN Louise Fili and Mary Jane Callister
. *New York, New York*
ART DIRECTION Louise Fili
CREATIVE DIRECTION . . . Louise Fili
STUDIO Louise Fili Ltd.
CLIENT Louise Fili Ltd. and Darby Litho
PRINCIPAL TYPE Walbaum MT and Bodoni Chancery
DIMENSIONS 6.5 x 7.25 IN. (16.5 x 18.4 CM)

M

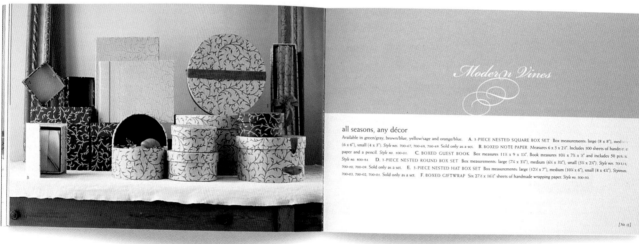

DESIGN Melanie Lowe
. *Cambridge, Massachusetts*
ART DIRECTION Melanie Lowe
DESIGN OFFICE M Space Design
CLIENT Moonrock Paper Company
PRINCIPAL TYPE Weiss and Bickman Script
DIMENSIONS 9 x 6 IN. (22.9 x 15.2 CM)

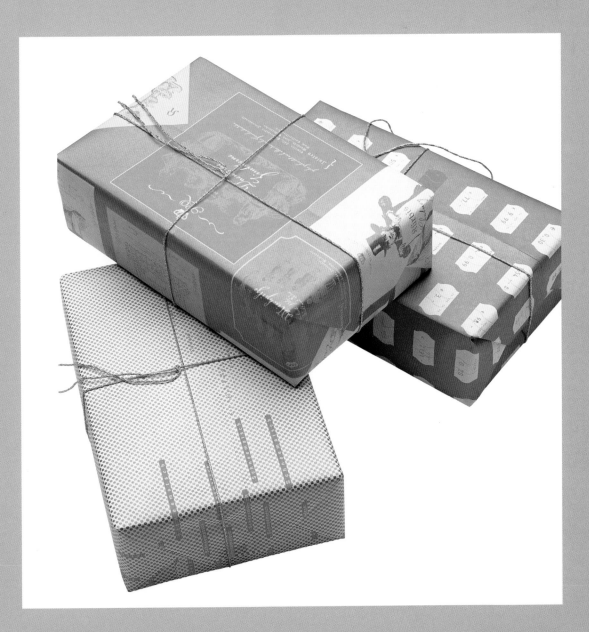

WRAPPING PAPER

DESIGN Isabel Bach, Patrick Bittner, and Sabine Wilhelm
. *Saarbrücken, Germany*
ART DIRECTION. Isabel Bach, Patrick Bittner, and Sabine Wilhelm
CREATIVE DIRECTION . . . Ivica Maksimovic
DESIGN OFFICE Maksimovic & Partners
PRINCIPAL TYPE Isanorm, Univers, Voluta Script,
. and Wittenberger-Fraktur
DIMENSIONS 16.5 x 23.4 IN. (42 x 59.4 CM)

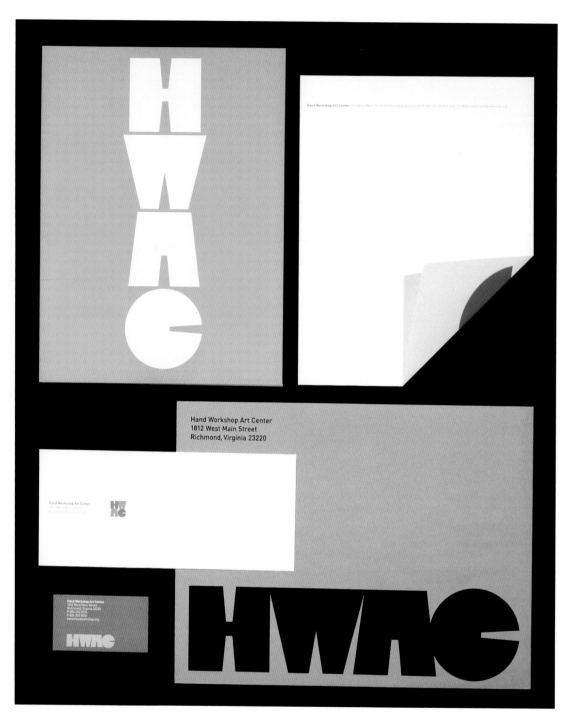

DESIGN John Malinoski
. *Richmond, Virginia*
CLIENT Hand Workshop Art Center
PRINCIPAL TYPE HWAC Identity Display
DIMENSIONS 20 x 24 IN. (50.8 x 61 CM)

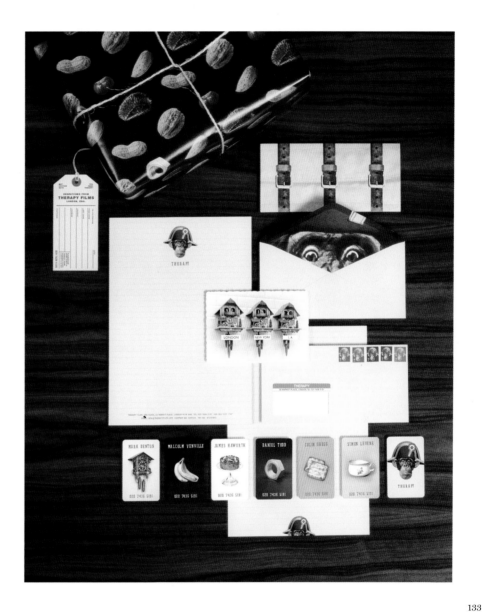

STATIONERY

DESIGN Mark Denton
. *London, England*
ART DIRECTION Mark Denton
CREATIVE DIRECTION . . . Mark Denton
LETTERING Andy Dymock
DESIGN OFFICE Mark Denton Design
CLIENT Therapy Films
PRINCIPAL TYPE Flyer Straight and Checkout
DIMENSIONS Various

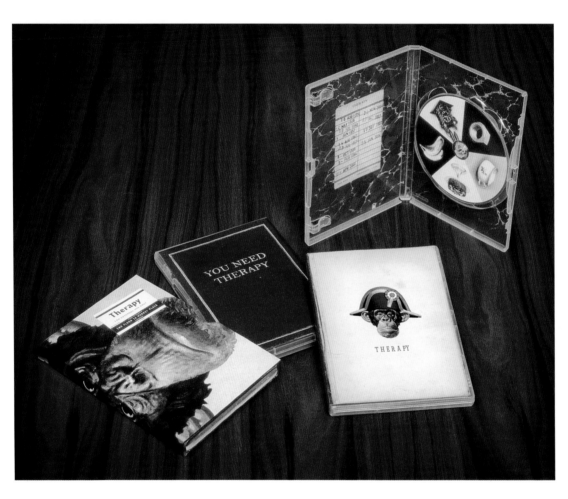

DESIGN Mark Denton
. *London, England*
ART DIRECTION Mark Denton
CREATIVE DIRECTION . . . Mark Denton
LETTERING Andy Dymock
DESIGN OFFICE Mark Denton Design
CLIENT Therapy Films
PRINCIPAL TYPE Bell Gothic, Flyer Straight, and handlettering
DIMENSIONS Various

kevin estimates

kevin writes

kevin invoices

kevin promotes

kevin networks

kevin compliments

CORPORATE IDENTITY

DESIGN Mark Lester
. *Manchester, England*
ART DIRECTION Mark Lester
CREATIVE DIRECTION . . . Mark Lester
STUDIO Mark Design Consultants
CLIENT Kevin Leighton
PRINCIPAL TYPE Helvetica
DIMENSIONS Various

The Fabric Workshop and Museum
1315 Cherry Street, 5ᵗʰ Floor
Philadelphia, PA 19107

The Fabric Workshop and
1315 Cherry Street, 5ᵗʰ Floor
Philadelphia, PA 19107

Margaret Baird
Administrative Assistant

The Fabric Workshop and Museum
1315 Cherry Street, 5ᵗʰ Floor
Philadelphia, PA 19107
[T] 215.568.1111 ext. 10 [F] 215.568.8211
meg@fabricworkshopandmuseum.org
www.fabricworkshopandmuseum.org

DESIGN Takaaki Matsumoto
. *New York, New York*
ART DIRECTION Takaaki Matsumoto
CREATIVE DIRECTION . . . Takaaki Matsumoto
LETTERING Takaaki Matsumoto
STUDIO Matsumoto Incorporated
CLIENT The Fabric Workshop and Museum
PRINCIPAL TYPE Univers and handlettering
DIMENSIONS Various

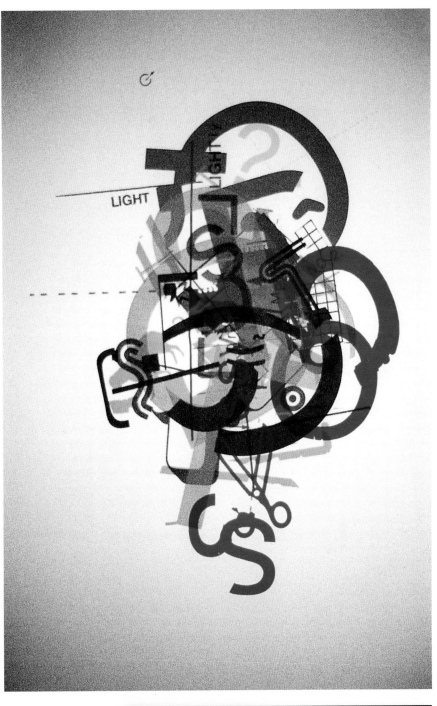

BOOK AND POSTER

137

DESIGN Rick Griffith
. *Denver, Colorado*
CREATIVE DIRECTION . . . Rick Griffith
PRINTERS Chad Bratten, Rick Griffith, and George Hententa
DESIGN OFFICE Matter
PRINCIPAL TYPE Various
DIMENSIONS 5.5 x 8.5 IN. (14 x 21.6 CM) and
. 26 x 40 IN. (66 x 101.6 CM)

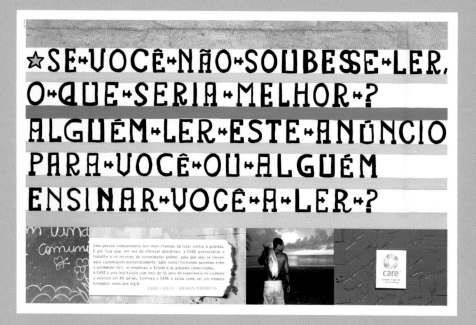

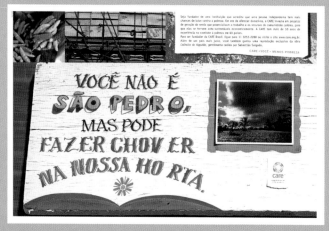

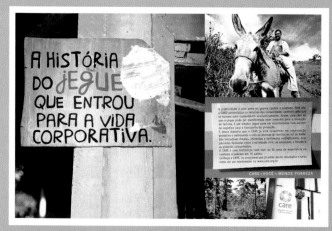

DESIGN Ricardo Aguiar and Ricardo Sciammarella
. *São Paolo, Brazil*
ART DIRECTION Ricardo Aguiar
CREATIVE DIRECTION . . . Percival Caropreso and Glen Martins
LETTERING Ricardo Aguiar
AGENCY McCann-Erickson Advertising
CLIENT Care Brazil
PRINCIPAL TYPE Handlettering
DIMENSIONS 16.5 x 11 IN. (42 x 28 CM)

STUDENT PROJECT

DESIGN Kristy McKoy
. *San Francisco, California*
INSTRUCTOR Emily McVarish
SCHOOL California College of Arts
PRINCIPAL TYPE Scala and Scala Sans
DIMENSIONS 8.1 x 10 IN. (20.6 x 25.4 CM)

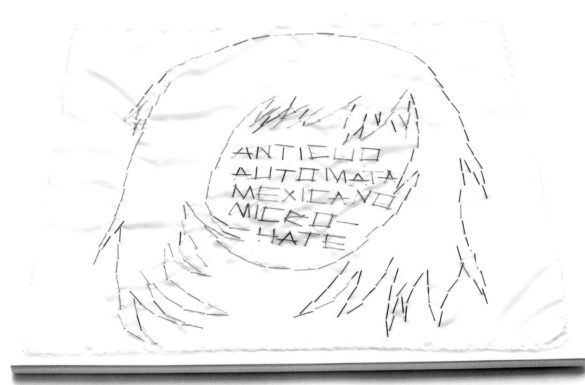

DESIGN Mario Lombardo
. *Cologne, Germany*
ART DIRECTION Mario Lombardo
LETTERING Mario Lombardo
TEXT Andy Vaz
DESIGN OFFICE MEM
CLIENT Background Records
PRINCIPAL TYPE Staple and FF Din
DIMENSIONS 12.5 x 12.5 IN. (31.8 x 31.8 CM)

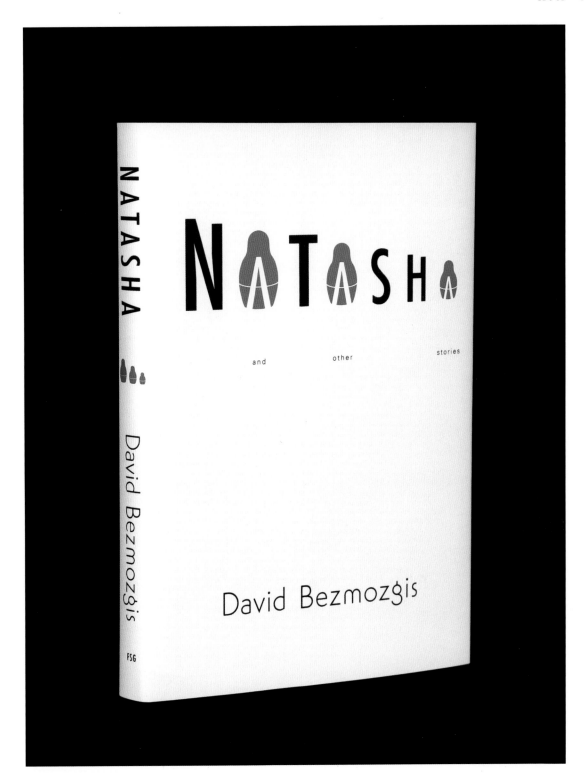

BOOK JACKET

DESIGN Dean Nicastro
. *New York, New York*
ART DIRECTION Susan Mitchell
PUBLISHER Farrar, Straus and Giroux
PRINCIPAL TYPE Futura Condensed and Naniara
DIMENSIONS 5.6 x 8.5 IN. (14.2 x 21.6 CM)

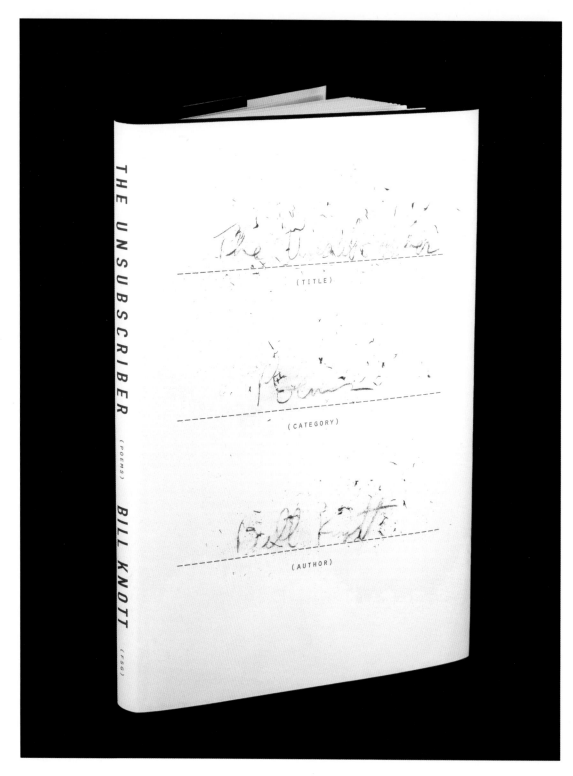

142 BOOK JACKET

DESIGN Dean Nicastro
. *New York, New York*
ART DIRECTION Susan Mitchell
LETTERING Steve Brown
PUBLISHER Farrar, Straus and Giroux
PRINCIPAL TYPE DIN Engschrift, Orator, and handlettering
DIMENSIONS 5.6 x 8.5 IN. (14.2 x 21.6 CM)

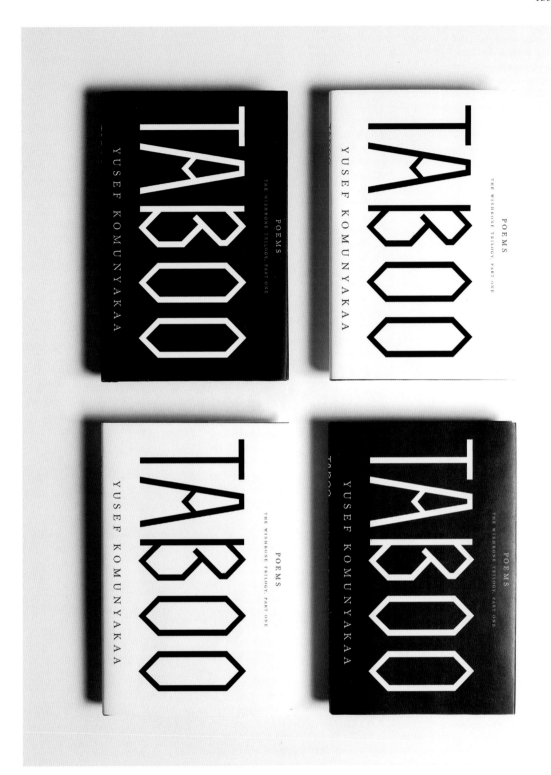

BOOK JACKET

DESIGN Dean Nicastro
. *New York, New York*
ART DIRECTION Susan Mitchell
PUBLISHER Farrar, Straus and Giroux
PRINCIPAL TYPE Basque and Esprit
DIMENSIONS 5.6 x 8.5 IN. (14.2 x 21.6 CM)

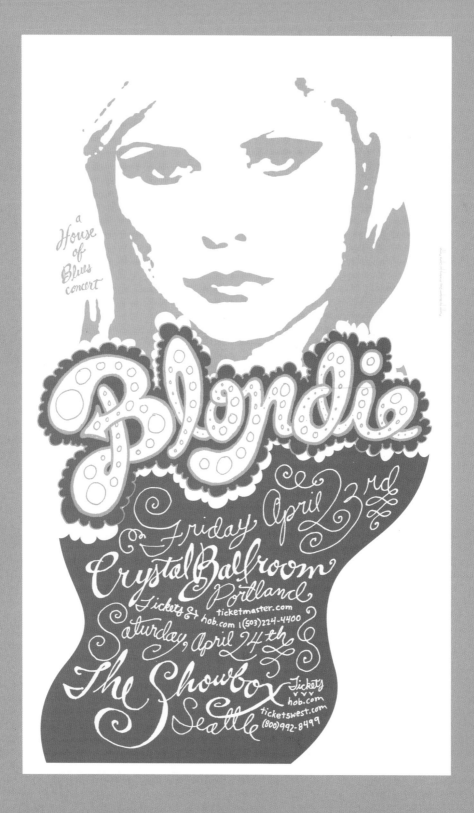

DESIGN Michael Strassburger
. *Seattle, Washington*
ART DIRECTION Michael Strassburger
CREATIVE DIRECTION . . . Adam Zacks
LETTERING Michael Strassburger
STUDIO Modern Dog Design Company
CLIENT House of Blues Concert
PRINCIPAL TYPE Handlettering
DIMENSIONS 13 x 22 IN. (33 x 55.9 CM)

STUDENT PROJECT

DESIGN Lauren Monchik
. *New York, New York*
INSTRUCTOR James Victore
SCHOOL School of Visual Arts
PRINCIPAL TYPE Handlettering
DIMENSIONS 17 x 22 IN. (43.2 x 55.9 CM)

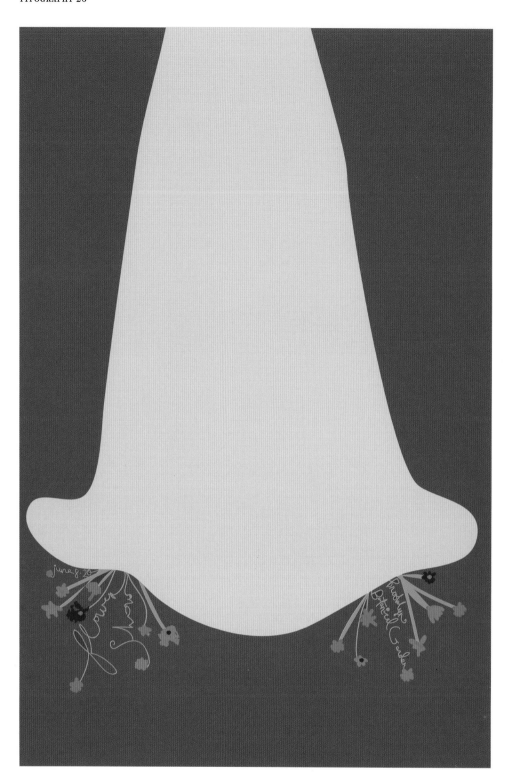

STUDENT PROJECT

DESIGN Lauren Monchik
. *New York, New York*
INSTRUCTOR James Victore
SCHOOL School of Visual Arts
PRINCIPAL TYPE Handlettering
DIMENSIONS 10 x 15 IN. (25.4 x 38.1 CM)

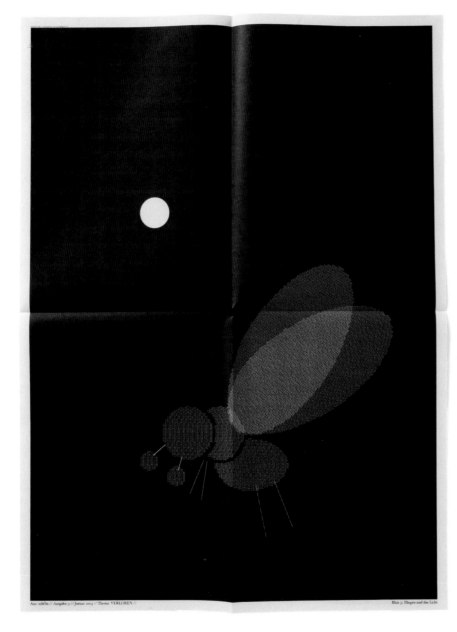

STUDENT PROJECT

147

DESIGN Michael Moser and Anne Piesln
. *Kornwestheim, Germany*
ART DIRECTION Michael Moser and Julian Alexander Melzig
CREATIVE DIRECTION . . . Michael Moser
PROFESSORS Andrea Rauschenbusch and Volker Erhard
SCHOOL University of Applied Sciences, Münster
CLIENT mlein press
PRINCIPAL TYPE Baskerville
DIMENSIONS 16.9 x 22 IN. (43 x 56 CM)

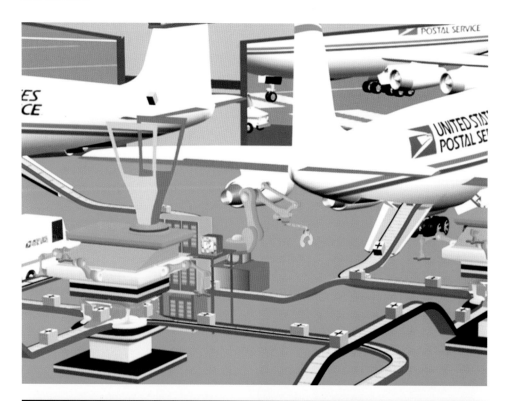

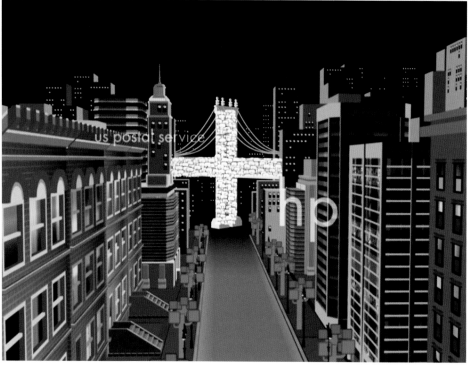

TELEVISION COMMERCIAL

DESIGN Kaan Atilla, Tom Bruno, John Clark,
. Paulo DeAlmada, Mark Kudsi, Irene Park, and
. Shihlin Wu
. *Venice, California*
ART DIRECTION Paulo DeAlmada
CREATIVE DIRECTION . . . Mathew Cullen
EXECUTIVE PRODUCER . . Javier Jimenez
VISUAL FX SUPERVISOR . . John Clark
DESIGN OFFICE Motion Theory
CLIENT Hewlett Packard
PRINCIPAL TYPE Futura Book HP

MHS Class of 1992 **Reunion**

Be a part of an event so cool,
it took 2 years to plan:

Mamaroneck High School's
Class of 1992 10-Year Reunion

Saturday, April 3rd, 2004
VFW at Flint Park
7:00-11:00pm
$40 per person, $45 after 3/15

For more information contact Jim McBride
703-867-5070 jamesemcb@yahoo.com

INVITATION

149

DESIGN Marc S. Levitt and Sheri L. Koetting
. *Long Island City, New York*
DESIGN OFFICE MSLK
CLIENT Mamaroneck High School
. Class of 1992 Reunion Committee
PRINCIPAL TYPE Chalet–New York 1960
DIMENSIONS 8.75 x 6.1 IN. (22.2 x 15.5 CM)

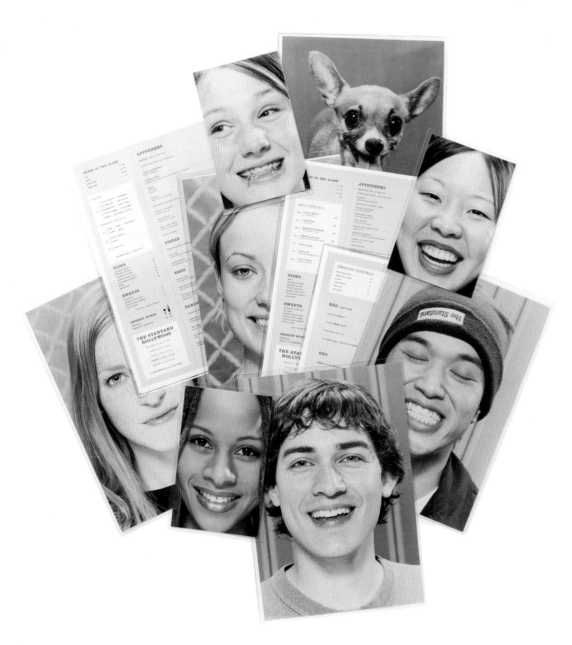

DESIGN Christine Celic Strohl
. *New York, New York*
CREATIVE DIRECTION . . . Matteo Bologna
PHOTOGRAPHY Ramona Rosales
. *Los Angeles, California*
DESIGN OFFICE Mucca Design
CLIENT André Balazs Properties
PRINCIPAL TYPE Clarendon and Trade Gothic
DIMENSIONS 10 x 14 IN. (25.4 x 35.6 CM)

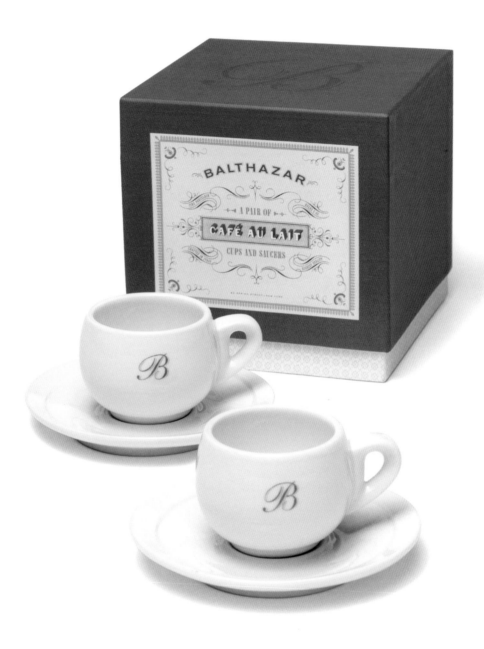

PACKAGING

DESIGN Christine Celic Strohl
. *New York, New York*
CREATIVE DIRECTION . . . Matteo Bologna
DESIGN OFFICE Mucca Design
CLIENT Keith McNally
PRINCIPAL TYPE Muccatypo Decora, Rockwell, and handlettering
DIMENSIONS 6.75 x 6.75 x 6.75 IN. (17.1 x 17.1 x 17.1 CM)

WEB SITE

DESIGN Christine Celic Strohl
. *New York, New York*
ART DIRECTION Christine Celic Strohl
CREATIVE DIRECTION . . . Matteo Bologna
PROGRAMMER Alex Smoller Design
DESIGN OFFICE Mucca Design
CLIENT Niccolò Carpani Glisenti
PRINCIPAL TYPE Tribute

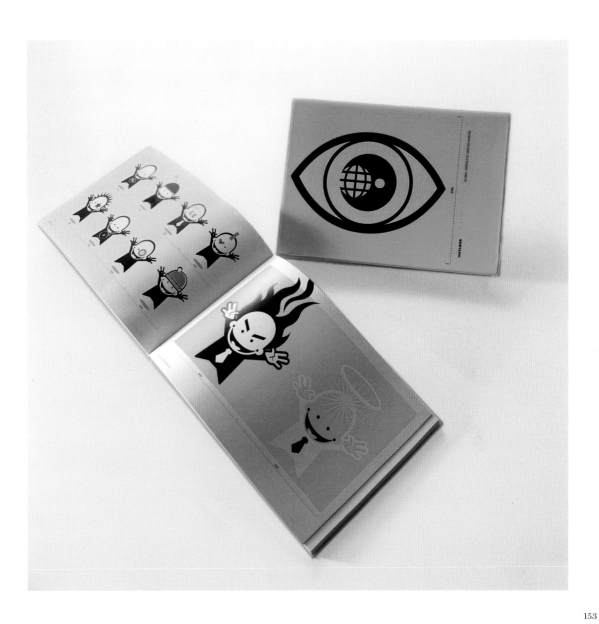

BOOK 153

DESIGN Beatrice de Joncheere, Anna Linder,
. and Carsten Raffel
. *Hamburg, Germany*
ART DIRECTION Johannes Plass and Carsten Raffel
CREATIVE DIRECTION . . . Johannes Plass
TYPOGRAPHY Anna Linder
ADMINISTRATION AND
ORGANIZATION Barbara Stolley-Rögels
DESIGN OFFICE Mutabor Design GmbH
PRINCIPAL TYPE Conduit
DIMENSIONS 7.9 x 5.7 IN. (20 x 14.5 CM)

N

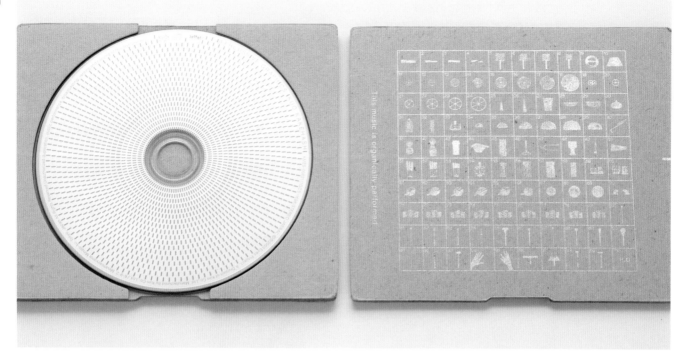

DESIGN Hiroaki Nagai and Yuki Iwata
. *Tokyo, Japan*
ART DIRECTION Hiroaki Nagai
CREATIVE DIRECTION . . . Hiroaki Nagai
PHOTOGRAPHY Katsuhiro Ichikawa
DESIGN OFFICE N.G. Inc.
CLIENT Ikuo Kakehashi
PRINCIPAL TYPE Pixel Regular and Helvetica
DIMENSIONS 5.5 x 4.8 IN. (14 x 12.3 CM)

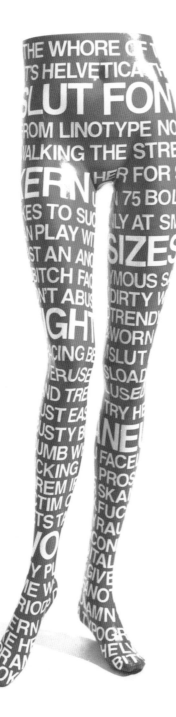

DESIGN Lenny Naar
. *New York, New York*
PHOTOGRAPHY David Miao
INSTRUCTOR Mike Joyce
SCHOOL School of Visual Arts
PRINCIPAL TYPE Neue Helvetica
DIMENSIONS 24 x 36 IN. (61 x 91.4 CM)

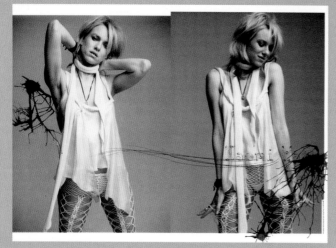

DESIGN Hideki Nakajima
. *Tokyo, Japan*
ART DIRECTION Hideki Nakajima
LETTERING Hideki Nakajima
PHOTOGRAPHY Various
DESIGN OFFICE Nakajima Design
CLIENT CUT magazine and Rockin' on Inc.
PRINCIPAL TYPE Custom
DIMENSIONS 18.7 x 13 IN. (47.6 x 33 CM)

Ryuichi Sakamoto /04

DESIGN Hideki Nakajima
. *Tokyo, Japan*
ART DIRECTION Hideki Nakajima
PHOTOGRAPHY Various
DESIGN OFFICE Nakajima Design
CLIENT Warner Music Japan
PRINCIPAL TYPE Custom

LETTER TO SHAREHOLDERS

SOMETIMES THINGS JUST CLICK — IN 2003 THINGS CLICKED FOR PROGRESSIVE.

THE PROFITABLE GROWTH PHASE OF THE INSURANCE CYCLE, HIGHLIGHTED IN MY LETTER LAST YEAR, CONTINUED FOR PROGRESSIVE IN 2003 AND, REMARKABLY, GOT BETTER. OUR MARKET POSITIONING AND ONGOING EFFORTS TO CULTIVATE COMPETITIVE ADVANTAGES IN PRICING, CLAIMS HANDLING AND BRAND DEVELOPMENT ARE WORKING WELL AND CONTINUE TO PLAY OUT AS PLANNED. FORTUITOUSLY, AUTOMOBILE ACCIDENT FREQUENCY FELL TO THE LOWEST LEVEL IN RECENT HISTORY. AS A RESULT, NET INCOME INCREASED 88% OVER LAST YEAR TO $1.26 BILLION AND NET WRITTEN PREMIUMS GREW 26% TO $11.9 BILLION.

SETTING ASIDE THE TAIL WIND PROVIDED BY REDUCED ACCIDENT FREQUENCY, 2003 WAS BY ANY MEASURE ANOTHER GREAT YEAR FOR PROGRESSIVE.

ANNUAL REPORT

DESIGN Joyce Nesnadny, Michelle Moehler,
. and Keith Pishnery
. *Cleveland, Ohio*
ART DIRECTION Mark Schwartz and Joyce Nesnadny
CREATIVE DIRECTION . . . Mark Schwartz and Joyce Nesnadny
ARTIST Carlos Vega
. *New York, New York*
DESIGN OFFICE Nesnadny + Schwartz
CLIENT The Progressive Corporation
PRINCIPAL TYPE Perpetua Expert and Bell Gothic
DIMENSIONS 8.5 x 11 IN. (21.6 x 27.9 CM)

0

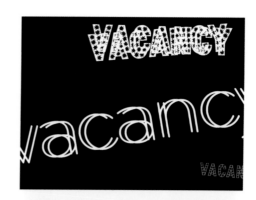

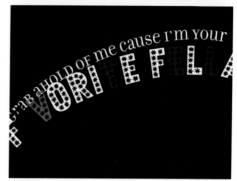

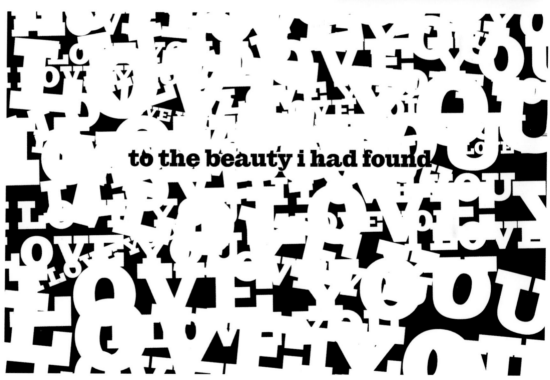

STUDENT PROJECT

159

DESIGN Megan Oiler
. *New York, New York*
INSTRUCTOR Gail Anderson
SCHOOL School of Visual Arts
PRINCIPAL TYPE Bryant, Filosofia, Giza, and Showtime

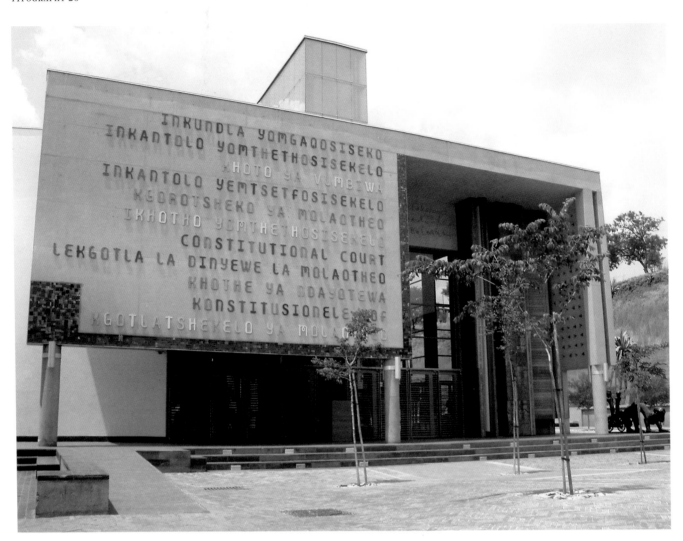

ENVIRONMENTAL DESIGN

DESIGN Garth Walker
. *Durban, South Africa*
ART DIRECTION Garth Walker
CREATIVE DIRECTION . . . Garth Walker
LETTERING Garth Walker
ARCHITECTS OMM Design Workshop + Urban Solutions
DESIGN OFFICE Orange Juice Design
CLIENT Constitutional Court of South Africa
PRINCIPAL TYPE Handlettering

#BXBDJGH***** 5-DIGIT 11
|..||...||.|.||.|.||||.|.....|..||..||||...|.|||
#OTR17451094 0#580632 Z2P48
THE 13TH ST REPERTORY
NY NY 10011
212-806-1745

STUDENT PROJECT

DESIGN Anna Ostrovskaya
. *New York, New York*
INSTRUCTOR Carin Goldberg
SCHOOL School of Visual Arts
PRINCIPAL TYPE Found type
DIMENSIONS Various

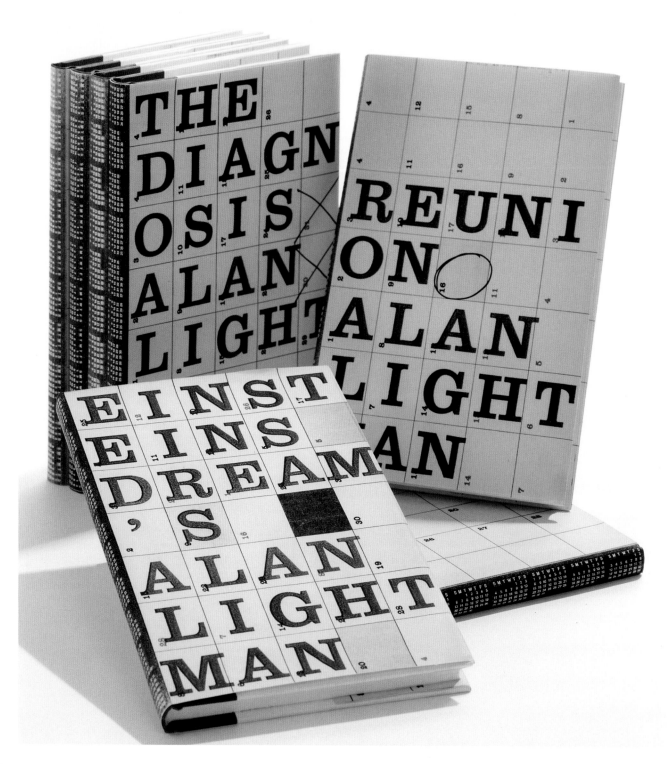

162

DESIGN Anna Ostrovskaya
. *New York, New York*
INSTRUCTOR Carin Goldberg
SCHOOL School of Visual Arts
PRINCIPAL TYPE Clarendon
DIMENSIONS 5.75 X 9 IN. (14.6 X 22.9 CM)

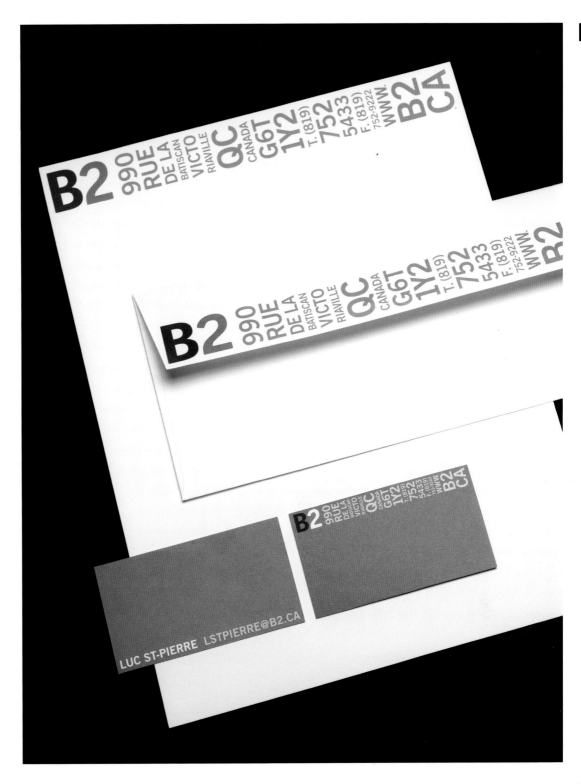

CORPORATE IDENTITY

DESIGN Rene Clement
. *Montreál, Canada*
ART DIRECTION Rene Clement
CREATIVE DIRECTION . . . Louis Gagnon
AGENCY Paprika
CLIENT B2
PRINCIPAL TYPE ITC Officina Sans and Trade Gothic
DIMENSIONS Various

DESIGN Paul Lam and Patrick Chan
. *Hong Kong, China*
ART DIRECTION Paul Lam
CREATIVE DIRECTION . . . Paul Lam
DESIGN OFFICE Paul Lam Design Associates
CLIENT CO1 School of Visual Arts
PRINCIPAL TYPE Monotype CHei 3 Bold, MHei Bold, Medium, Light,
and handlettering
DIMENSIONS 20 x 29 IN. (50.8 x 73.7 CM)

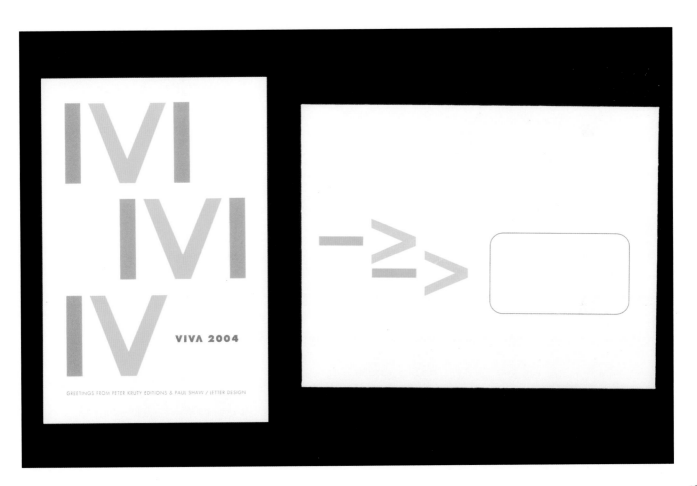

GREETING CARD

DESIGN Paul Shaw
. *New York, New York*
PRODUCTION Sayre Gaydos
PRINTING Peter Kruty Editions
DESIGN OFFICE Paul Shaw/Letter Design
CLIENT Paul Shaw/Letter Design and Peter Kruty Editions
PRINCIPAL TYPE Futura
DIMENSIONS 3.6 X 5.4 IN. (9.1 X 13.7 CM)

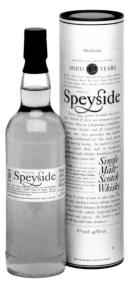
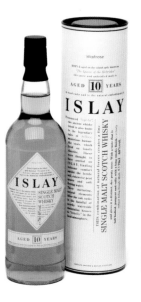
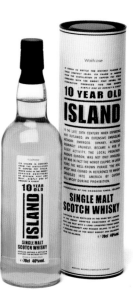

166 PACKAGING

DESIGN Mark Christou
. *London, England*
CREATIVE DIRECTION . . . Jonathan Ford
ACCOUNT DIRECTOR Kerry Bolt
DESIGN OFFICE Pearlfisher
CLIENT Waitrose
PRINCIPAL TYPE Caslon family, Century family, Impact,
. Neue Helvetica, wood type ornaments,
. and other fonts
DIMENSIONS Various

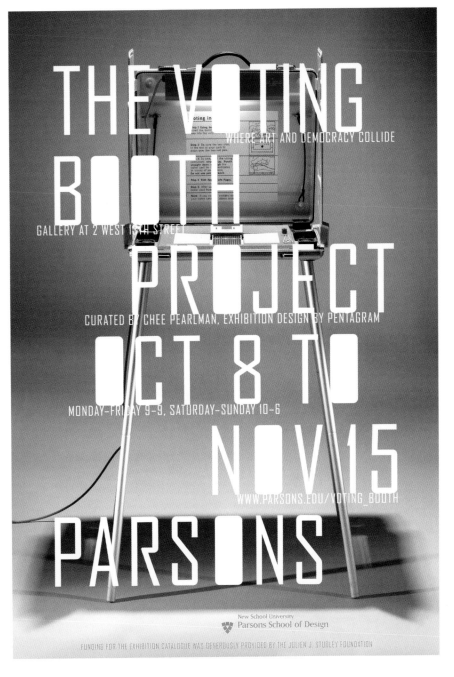

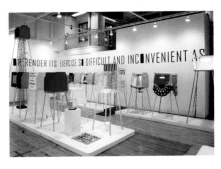

EXHIBITION

DESIGN Jena Sher
. *New York, New York*
ART DIRECTION Michael Bierut
PHOTOGRAPHY Michael Moran
CURATOR Chee Pearlman
DESIGN OFFICE Pentagram Design Inc.
CLIENT Parsons School of Design
PRINCIPAL TYPE FB Agency

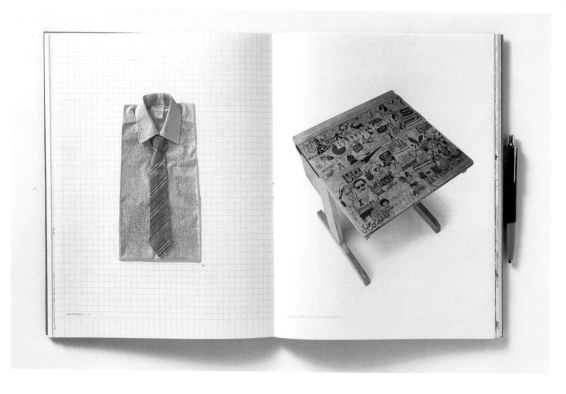

DESIGN Charlie Hanson
. *London, England*
ART DIRECTION Angus Hyland
AGENCY Pentagram Design Ltd.
CLIENT The Gallery at Pentagram
PRINCIPAL TYPE Helvetica Light and Typewriter Light
DIMENSIONS 9.25 x 11.8 IN. (23.5 x 30 CM)

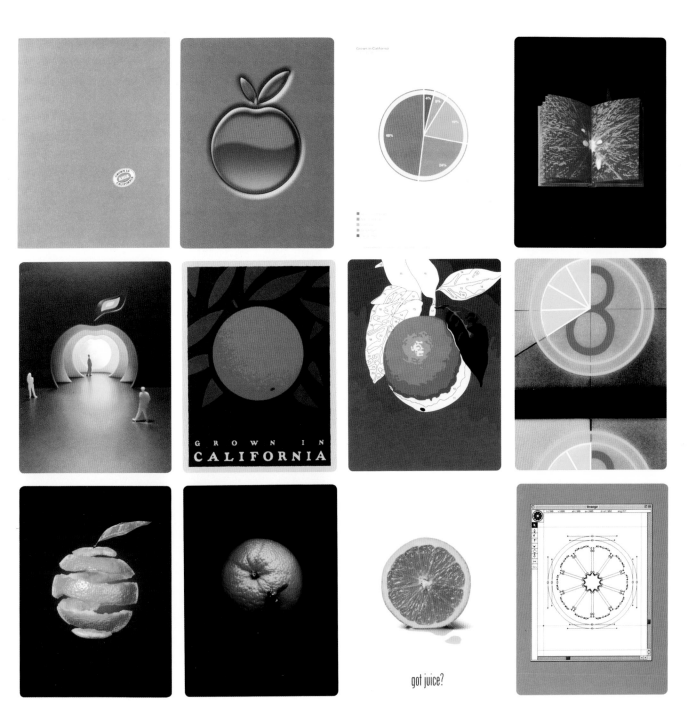

got juice?

DESIGN Rob Duncan, Judy Hsu, and Brian Jacobs
. *San Francisco, California*
ART DIRECTION Brian Jacobs
PHOTOGRAPHY Jeanne Carley, Terry Heffernan, Barry Robinson,
. and Ron Slenzak Associates
ARTISTS Karin Fong, Josh Levine, Zuzana Licko,
. Mitchell Mauk, Akio Morishima, Marty Neumeier,
. Al Quattrocchi, Michael Schwab, Jeff Smith,
. and Tornado Design
DESIGN OFFICE Pentagram Design Inc.
CLIENT The California American Institute of Graphic Arts
PRINCIPAL TYPE Rockwell
DIMENSIONS 6 x 8 IN. (15.2 x 20.3 CM)

DESIGN Rob Duncan, Brian Jacobs, Charles Mastin,
. and Douglas McDonald
. *San Francisco, California*
ART DIRECTION Brian Jacobs
DESIGN OFFICE Pentagram Design Inc.
CLIENT Muzak, LLC
PRINCIPAL TYPE Futura Bold

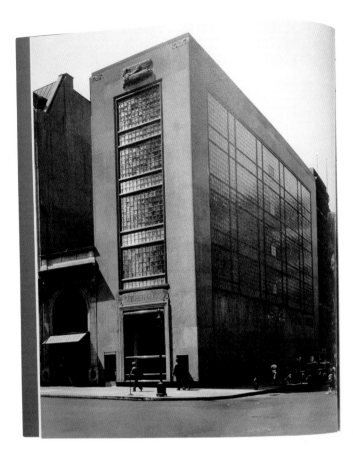

steuben's modern moment

Donald Albrecht

Light, transparent, and reflective, glass has come to represent the glamour of twentieth-century Modernism. As early as the 1920s and 1930s, houses made of glass in Paris, Berlin, Los Angeles, and Chicago promised an exciting new form of residential life by blurring the distinction between indoors and outdoors, machine and nature. After World War II, International Style steel-and-glass towers such as Lever House and the Corning Building rose in midtown Manhattan, captivating the public and forever redefining city skylines around the world. But the allure of glass was not confined to architecture. From studios in Austria, Finland, Italy, and other aesthetic centers, artists and industrial designers passionately embraced the challenge to create in the modern idiom. In the field of American glass that modern idiom was

The glass block Corning-Steuben Building at 718 Fifth Avenue — housing Steuben's shop, offices, and design studio — opened in 1937.

BOOK

DESIGN J. Abbott Miller and Johnschen Kudos
. *New York, New York*
ART DIRECTION. J. Abbott Miller
DESIGN OFFICE Pentagram Design Inc.
CLIENT Museum of the City of New York
. and Harry Abrams Publishers
PRINCIPAL TYPE Neutraface
DIMENSIONS 10 x 12 in. (25.4 x 30.5 cm)

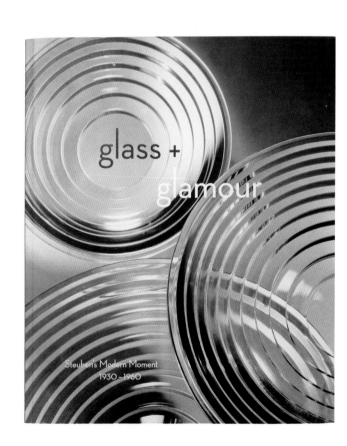

glass +
glamour

Steuben's Modern Moment
1930 – 1960

FORMAL

From debutantes and brides, to ballerinas and dandies, formality is expressed through clothing as much as behavior. The rituals and artifacts that we refer to as "formal" share an element of theatricality, an attitude that encourages us to be our most dignified, civilized selves. This sense of theater can reach extremes, as Andrew Solomon describes in his essay on the extravagant fashions of the dandy. Formal clothing can also become a kind of masquerade, as evidenced by Catherine Smith and Cynthia Greig in their contribution on the recurrence of women in taxedos over the last century. In the realm of dance, ballet represents the height of formality. In our photographic portfolios we represent this tradition as it is passed down from one generation to the next. Bart Cook and Maria Calegari, former members of the New York City Ballet and now répétiteurs for the Balanchine Trust, are followed by Albert Evans, Janie Taylor and Sébastien Marcovici, three current members of the New York City Ballet. Finally, photographer Tina Barney's stately group portraits show how traditions persist, despite the cultural changes that root us in the present. Our goal with this issue was to represent how our ideas of formality—while rooted in history—continue to inform the way we represent ourselves through fashion, dance, photography, and art. PATSY TARR AND ABBOTT MILLER

JANIE TAYLOR AND SEBASTIEN MARCOVICI, PHOTOGRAPH BY CHRISTIAN WITKIN

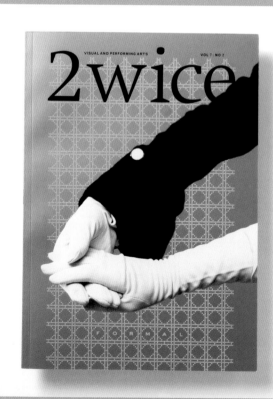

MAGAZINE

DESIGN J. Abbott Miller and Jeremy Hoffman
. *New York, New York*
ART DIRECTION J. Abbott Miller
DESIGN OFFICE Pentagram Design Inc.
CLIENT 2wice Arts Foundation
PRINCIPAL TYPE Monotype Walbaum and Sackers Gothic
DIMENSIONS 8.25 x 11.5 IN. (21 x 29.2 CM)

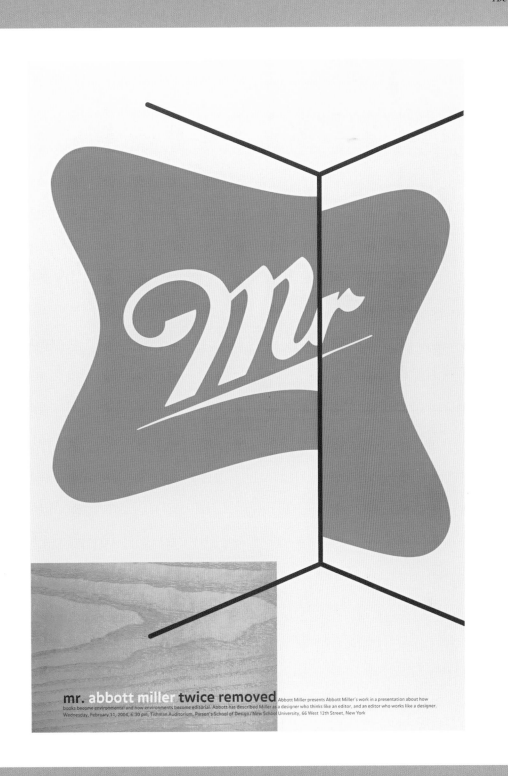

DESIGN J. Abbott Miller and Jeremy Hoffman
. *New York, New York*
ART DIRECTION J. Abbott Miller
DESIGN OFFICE Pentagram Design Inc.
CLIENT American Institute of Graphic Arts New York
PRINCIPAL TYPE Balance
DIMENSIONS 24 x 36 IN. (61 x 91.4 CM)

(Grafía callada) **Pepe Gimeno**. Del 3 de Junio al 4 de Julio de 2004. IVAM *///* [Institut Valencià d'Art Modern] [GENERALITAT VALENCIANA CONSELLERIA DE CULTURA, EDUCACIÓ I ESPORT]

DESIGN Pepe Gimeno
. *Valencià, Spain*
ART DIRECTION Pepe Gimeno
CREATIVE DIRECTION . . . Pepe Gimeno
DESIGN OFFICE Pepe Gimeno Proyecto Gráfico
CLIENT IVAM, Institut Valencià d'Art Modern
PRINCIPAL TYPE Syntax
DIMENSIONS 26.4 x 38.6 IN. (67 x 98 CM)

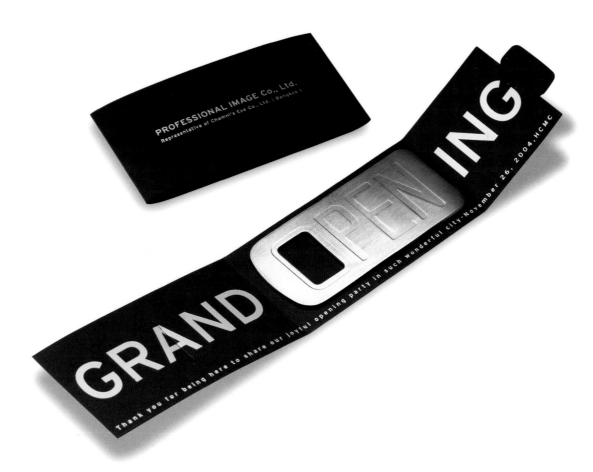

ANNOUNCEMENT

DESIGN Patsuda Rochanaluk and Porntip Trimungklayon
. *Bangkok, Thailand*
CREATIVE DIRECTION . . . Punlarp Punnotok and Siam Attariya
DESIGN OFFICE Pink Blue Black & Orange (Color Party)
CLIENT Professional Image and Chamni's Eye
PRINCIPAL TYPE Interstate
DIMENSIONS 4.1 x 2.2 IN. (10.5 x 5.5 CM)

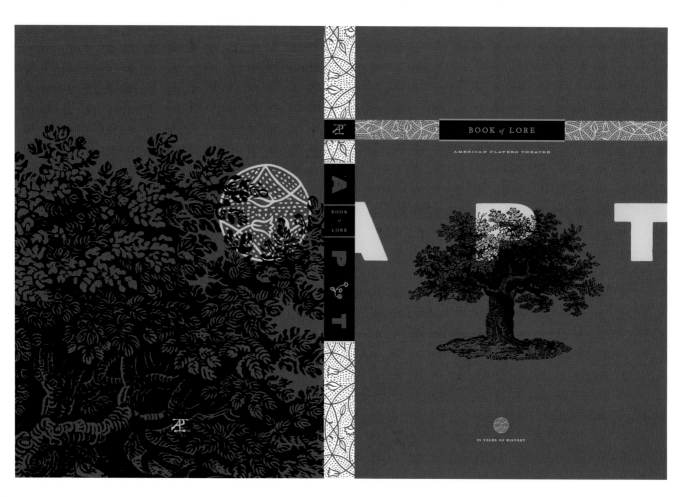

176 BROCHURE

DESIGN Kevin Wade
. *Madison, Wisconsin*
DESIGN OFFICE Planet Propaganda
CLIENT Uppercut Images
PRINCIPAL TYPE HTF Gotham
DIMENSIONS 5.75 x 8.25 IN. (14.6 x 21 CM)

BOOK

DESIGN Geoff Halber
. *Madison, Wisconsin*
CREATIVE DIRECTION . . . Dana Lytle
PRODUCTION DESIGN . . . Angie Medenwaldt
WRITER John Anderson
DESIGN OFFICE Planet Propaganda
CLIENT American Players Theatre
PRINCIPAL TYPE Tribute and Zurich
DIMENSIONS 9.5 x 13 IN. (24.1 x 33 CM)

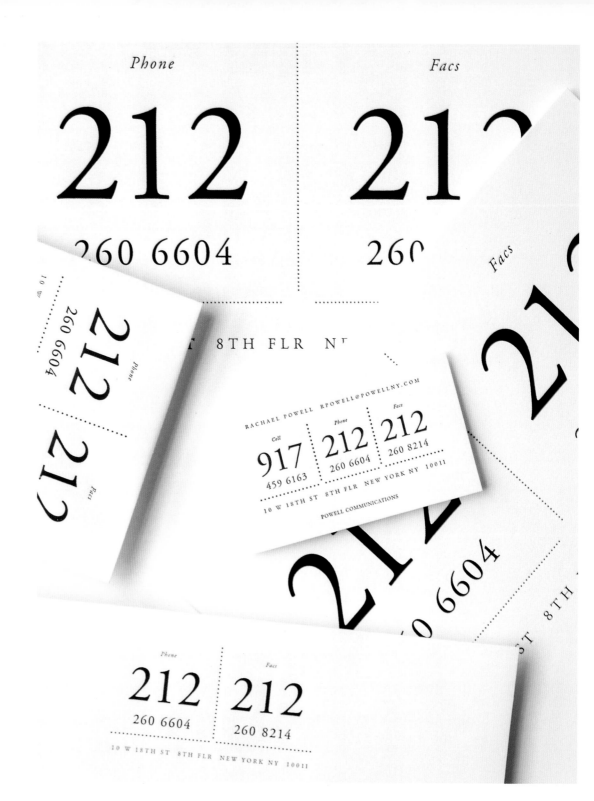

DESIGN Neil Powell
. *New York, New York*
ART DIRECTION Rachael Powell
CREATIVE DIRECTION . . . Neil Powell
AGENCY Powell
CLIENT Powell Communications
PRINCIPAL TYPE Adobe Garamond Regular
. and Italic
DIMENSIONS Various

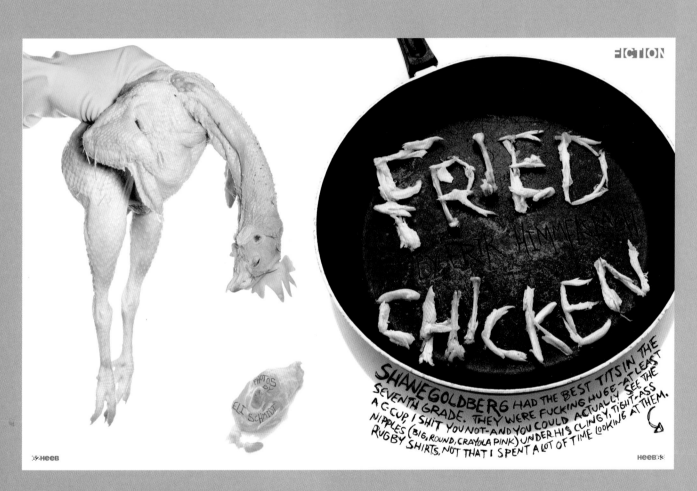

MAGAZINE SPREAD

DESIGN Omar Mrva
. *New York, New York*
CREATIVE DIRECTION . . . Omar Mrva
DESIGN OFFICE Pressure Point Studios
CLIENT Heeb Magazine
PRINCIPAL TYPE Custom fonts and handlettering
DIMENSIONS 16.5 x 11 IN. (41.9 x 27.9 CM)

CORPORATE IDENTITY

DESIGN Tessa Lee, Nancy Thomas, and Lindsay Wheeler
. *San Francisco, California*
ART DIRECTION Todd Foreman
DESIGN OFFICE Public
CLIENT Cafe Lo Lubano
PRINCIPAL TYPE Engravers (modified), Fenway Park, and Filosofia
DIMENSIONS Various

R

CORPORATE IDENTITY

DESIGN Claas Blüher and Robert Siegmund
. *Hamburg, Germany*
AGENCY Revorm
CLIENT Onkologische Versorgung Oldenburger
. Münsterland (OVOM)
PRINCIPAL TYPE Melior and Avenir
DIMENSIONS 8.3 x 11.7 IN. (21 x 29.7 CM)

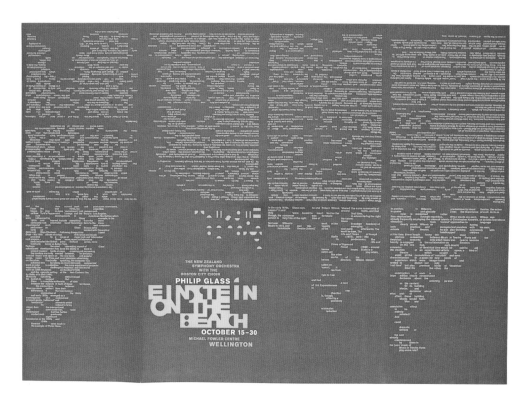

STUDENT PROJECT

DESIGN Claudia Riedel
. *Wellington, New Zealand*
INSTRUCTORS Mark Geard and Lee Jensen
SCHOOL Massey University Wellington
PRINCIPAL TYPE Akzidenz Grotesk and handlettering
DIMENSIONS Various

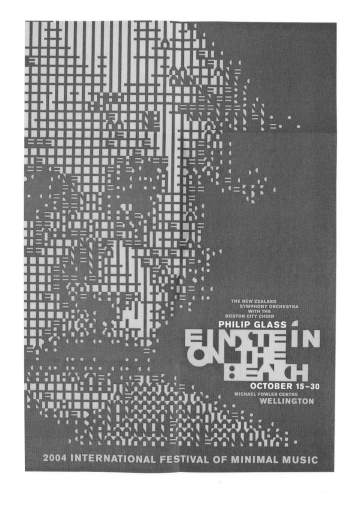

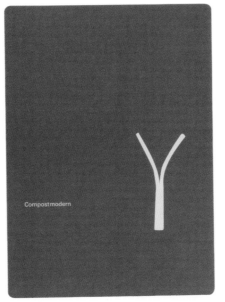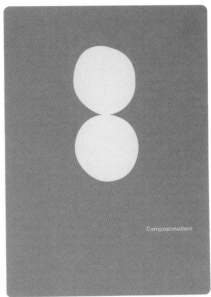

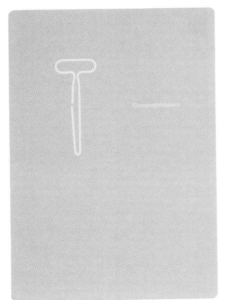

INVITATION

DESIGN Robert Williams and Gary Williams
. *San Francisco, California*
DESIGN OFFICE/STUDIO . . Robert & Gary
CLIENT American Institute of Graphic Arts San Francisco
PRINCIPAL TYPE Univers and Bits
DIMENSIONS 4 x 6 IN. (10.2 x 15.2 CM)

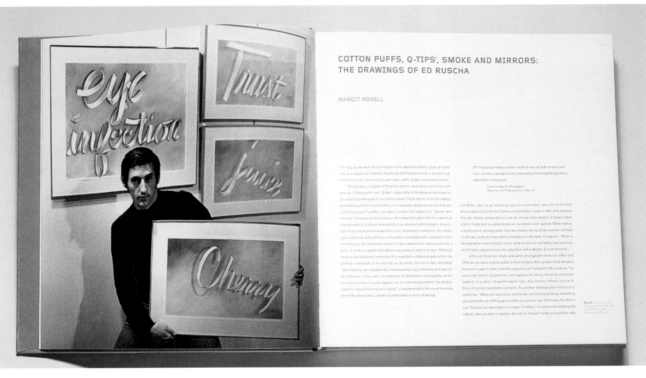

DESIGN Simon Johnston
. *Pacific Palisades, California*
ART DIRECTION Rachel Wixom
. *New York, New York*
CREATIVE DIRECTION/
CURATOR Margit Rowell
PUBLISHER Whitney Museum of American Art
PRINCIPAL TYPE Foundry Gridnik and Monotype Grotesque
DIMENSIONS 11 x 11 IN. (27.9 x 27.9 CM)

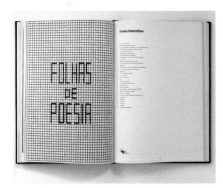

BOOK

DESIGN Nuno Bastos, Artur Rebelo, and Lizá Ramalho
. *Matosinhos, Portugal*
AGENCY. R2 Design
CLIENT Museu Serralues
PRINCIPAL TYPE Jannon and DeSrito
DIMENSIONS 9.8 x 14 IN. (25 x 35.5 CM)

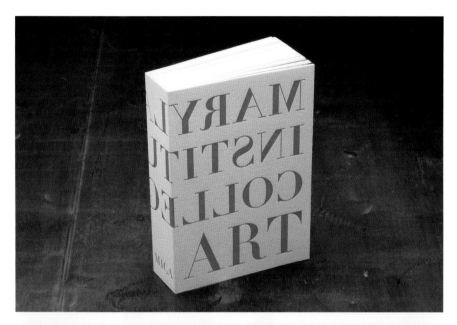

DESIGN Angelo Alcasabas, Allyson Gerson, and Hwa Lee
. *Baltimore, Maryland*
ART DIRECTION Anthony Rutka
CREATIVE DIRECTION . . . Anthony Rutka
DESIGN OFFICE Rutka Weadock Design
CLIENT Maryland Institute College of Art
PRINCIPAL TYPE Didot and Bauer Bodoni
DIMENSIONS 4.6 x 6.5 IN. (11.7 x 16.5 CM)

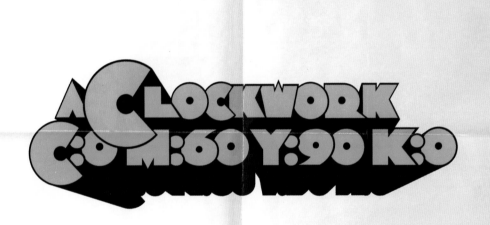

Not just color. Exact color. **Hudson Repro**

POSTER

ART DIRECTION Hamish McArthur and Adam Lewin
. *New York, New York*
EXECUTIVE CREATIVE
DIRECTOR Tony Granger
CHIEF CREATIVE OFFICER Tod Seisser
CREATIVE DIRECTION . . . Lee St. James
LETTERING Hamish McArthur and Adam Lewin
COPYWRITERS Jason Graff and Jeff Greenspan
AGENCY Saatchi & Saatchi
CLIENT Hudson Repro
PRINCIPAL TYPE Avenir and handlettering
DIMENSIONS 23.4 x 16.5 IN. (59.4 x 41.9 CM)

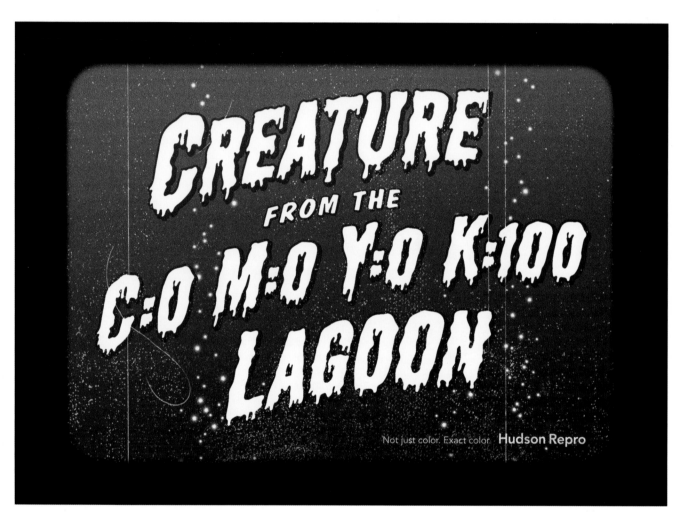

ART DIRECTION Hamish McArthur and Adam Lewin
. *New York, New York*
EXECUTIVE CREATIVE
DIRECTOR Tony Granger
CHIEF CREATIVE OFFICER Tod Seisser
CREATIVE DIRECTION . . . Lee St. James
LETTERING Hamish McArthur and Adam Lewin
COPYWRITERS Jason Graff and Jeff Greenspan
AGENCY Saatchi & Saatchi
CLIENT Hudson Repro
PRINCIPAL TYPE Avenir and handlettering
DIMENSIONS 23.4 x 16.5 IN. (59.4 x 41.9 CM)

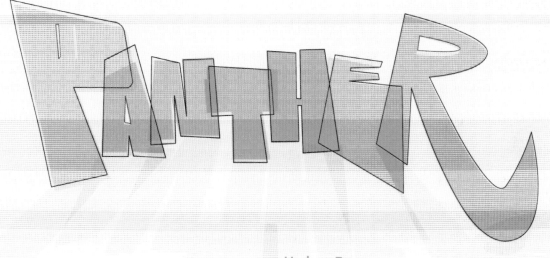

Not just color. Exact color. **Hudson Repro**

POSTER

ART DIRECTION	Hamish McArthur and Adam Lewin
	New York, New York
EXECUTIVE CREATIVE DIRECTOR	Tony Granger
CHIEF CREATIVE OFFICER	Tod Seisser
CREATIVE DIRECTION	Lee St. James
LETTERING	Hamish McArthur and Adam Lewin
COPYWRITERS	Jason Graff and Jeff Greenspan
AGENCY	Saatchi & Saatchi
CLIENT	Hudson Repro
PRINCIPAL TYPE	Avenir and handlettering
DIMENSIONS	23.4 x 16.5 IN. (59.4 x 41.9 CM)

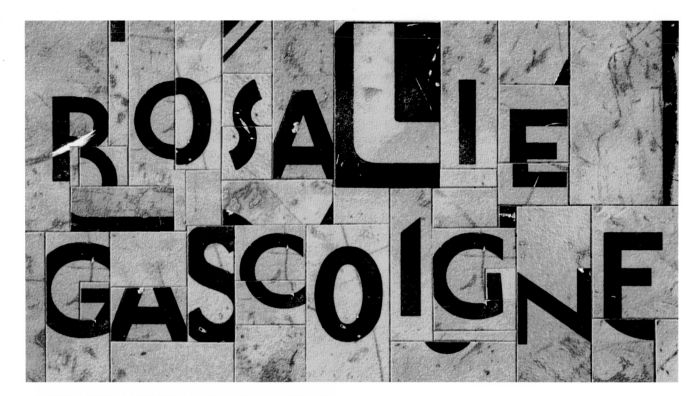

190 CINEMA COMMERCIAL

DESIGN Chris Bleackley and Len Cheeseman
. *Wellington, New Zealand*
ART DIRECTION Chris Bleackley, Len Cheeseman,
. and John Plimmer
CREATIVE DIRECTION . . . John Plimmer
LETTERING Hayden Doughty
ILLUSTRATION Andy Salisbury
ANIMATION Jason Bowden
AGENCY Saatchi & Saatchi New Zealand
CLIENT City Gallery
PRINCIPAL TYPE Cut-up and pasted road signage

You are

You wear

You prefer

TELEVISION COMMERCIAL

DESIGN Len Cheeseman, Jonny Kofoed,
. and Craig Speakman
. *Wellington, New Zealand*
ART DIRECTION Len Cheeseman
CREATIVE DIRECTION . . . John Plimmer
LETTERING Hayden Doughty
ANIMATION Oktobor: Jonny Kofoed and Craig Speakman
VFX PRODUCER Steen Bech
AGENCY Saatchi & Saatchi New Zealand
CLIENT TVNZ
PRINCIPAL TYPE FF Scala Jewel: Crystal, Diamond, Pearl,
. and Saphyr

192 DIRECT MAIL

DESIGN Birger Linke
. *Singapore*
ART DIRECTION Birger Linke
CREATIVE DIRECTION . . . Graham Kelly
LETTERING Birger Linke
WRITER Justine Lee
AGENCY Saatchi & Saatchi Singapore
CLIENT Republic of Singapore Navy
PRINCIPAL TYPE Trebuchet MS
DIMENSIONS Various

SUNSET STRIP

SUNSET STRIP

SUNSET STRIP

LOGOTYPE

DESIGN Kota Sagae
. *Tokyo, Japan*
CREATIVE DIRECTION . . . Kota Sagae
LETTERING Kota Sagae
DESIGN OFFICE SAGA
CLIENT Otonanomugicha
PRINCIPAL TYPE DIN

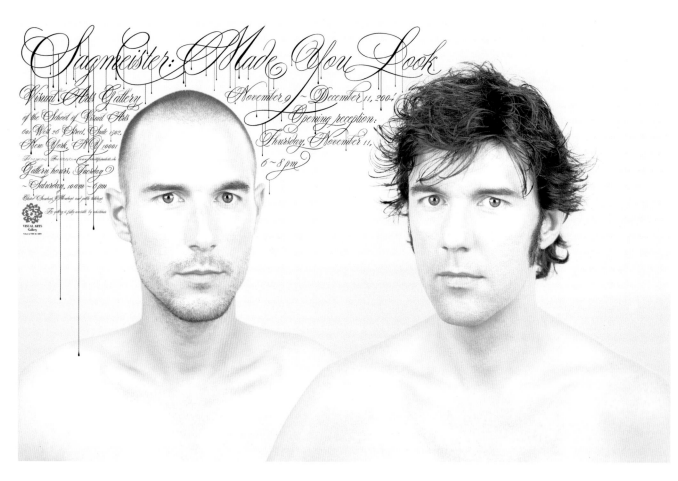

194 POSTER

DESIGN Stefan Sagmeister and Matthias Ernstberger
. *New York, New York*
ART DIRECTION Stefan Sagmeister
CREATIVE DIRECTION . . . Stefan Sagmeister
LETTERING Matthias Ernstberger
RETOUCHING Traian Stanescu
DESIGN OFFICE Sagmeister Inc.
CLIENT The Visual Arts Gallery
PRINCIPAL TYPE Custom based on Yves Script
DIMENSIONS 36 x 24 IN. (91.4 x 61 CM)

LOGOTYPE

DESIGN Stefan Sagmeister, Kiyoka Katahira,
. Sarah Noellenheidt, and Matthias Ernstberger
. *New York, New York*
ART DIRECTION Stefan Sagmeister
CREATIVE DIRECTION . . . Stefan Sagmeister
LETTERING Kiyoka Katahira
DESIGN OFFICE Sagmeister Inc.
CLIENT Sideshow, New York
PRINCIPAL TYPE Handlettering

196 CATALOG

DESIGN Stefan Sagmeister, Sarah Noellenheidt,
. and Matthias Ernstberger
. *New York, New York*
ART DIRECTION Stefan Sagmeister
CREATIVE DIRECTION . . . Stefan Sagmeister
LETTERING Stefan Sagmeister
WRITER Joan Young
DESIGN OFFICE Sagmeister Inc.
CLIENT The Guggenheim Museum, New York
PRINCIPAL TYPE Handlettering
DIMENSIONS 10.75 x 13.5 IN. (27.3 x 34.3 CM)

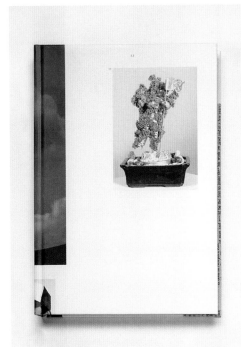

BOOK

DESIGN Paul Sahre
. *New York, New York*
ART DIRECTION Paul Sahre and Richard Wilde
CREATIVE DIRECTION . . . Silas H. Rhodes, Paul Sahre, and Richard Wilde
PRODUCTION Adam S. Wahler
CLIENT School of Visual Arts
PRINCIPAL TYPE Helvetica and Times
DIMENSIONS 7.25 x 10.25 IN. (18.4 x 26 CM)

198 BROCHURE

DESIGN Kevin Krueger, Beth May, and Dave Mason
. *Dundee, Illinois*
ART DIRECTION Dave Mason and Kevin Krueger
STRATEGIC DESIGN AGENCY SamataMason
PRINCIPAL TYPE Garamond 3 and ITC Franklin Gothic
DIMENSIONS 6.5 x 9.5 IN. (16.5 x 24.1 CM)

You shouldn't have
to pay a single dollar on
an unsubstantiated claim.

Fatality
Blamed On
Medication

The family of 18-year-old ■■■■
claims that the teenager developed
suicidal behavior after taking a popular
medication for the treatment of adolescent
skin conditions.

■■■■ took his life by driving his
late-model sports car into a bridge abutment
on Interstate 10 near San Antonio in
December 2002. While he had been
issued a prescription for the medication in
October 2002, the county medical examiner
found no trace of the substance in his
bloodstream following his death.

The parents of the victim have filed a
$40 million lawsuit against the maker of
the medication, ■■■■, which denies
any connection between the widely used
product and suicidal ideation.

Nevertheless, the parents contend that
there is no other possible explanation for
the behavior that caused a driver with a
perfect traffic record, showing no traces
of alcohol or illegal substances in his
bloodstream, to swerve unprovoked
across two lanes of interstate highway
under ideal driving conditions to strike the
only immovable object for miles around.

■■■■ was an honor student
and member of the swimming team with
no prior history of unstable behavior.
Several witnesses described the accident
as a sudden veering to the right for no
apparent reason, on a sunny afternoon
under light traffic conditions. The car
appeared to be going at or slightly below
the posted speed limit.

199

BROCHURE

DESIGN Goreth Kao and Kevin Krueger
. *Dundee, Illinois*
ART DIRECTION Kevin Krueger
STRATEGIC DESIGN AGENCY SamataMason
CLIENT Cambridge Integrated Services Group, Inc.
PRINCIPAL TYPE ITC Franklin Gothic Book and Demi,
. Adobe Garamond Regular and Italic
DIMENSIONS 7.5 x 9 IN. (19.1 x 22.9 CM)

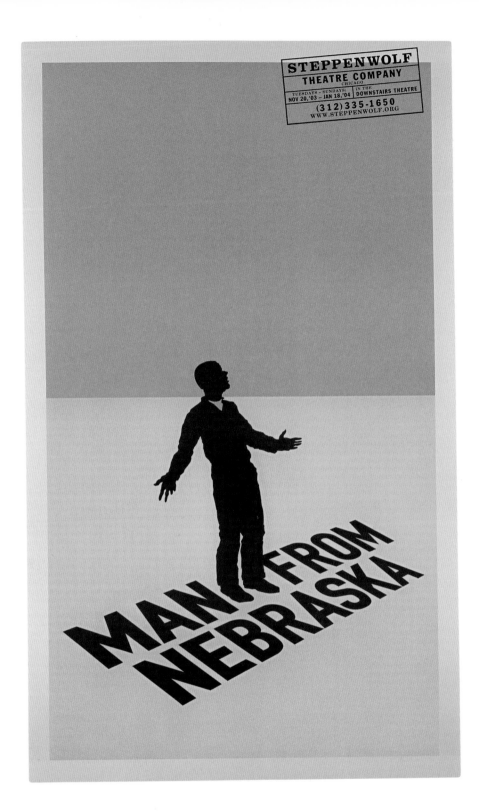

DESIGN Steve Sandstrom and Kristin Anderson
. *Portland, Oregon*
ART DIRECTION Steve Sandstrom
CREATIVE DIRECTION . . . Joe Sciarrotta, Ogilvy & Mather
. *Chicago, Illinois*
ILLUSTRATION Steve Sandstrom
DESIGN OFFICE Sandstrom Design
CLIENT Steppenwolf Theatre
PRINCIPAL TYPE Century Schoolbook, Franklin Gothic,
. and HTF Knockout
DIMENSIONS 24 x 36 IN. (61 x 91.4 CM)

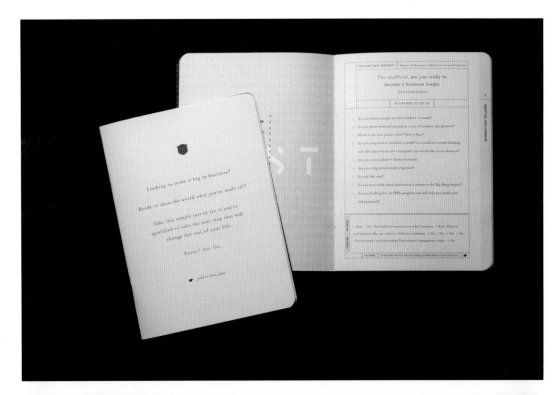

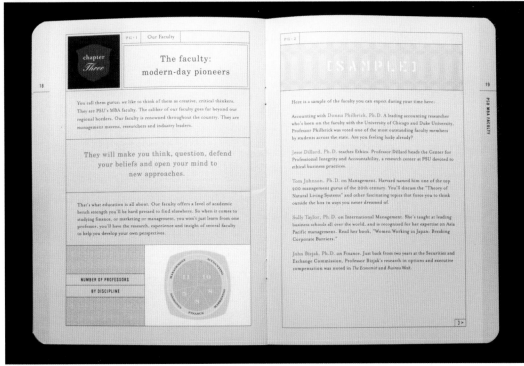

BROCHURE

DESIGN Sally Morrow and Shanin Andrew
. *Portland, Oregon*
ART DIRECTION Sally Morrow
CREATIVE DIRECTION . . . Sally Morrow
PHOTOGRAPHY David Emmite
COPYWRITER Leslee Dillon
DESIGN OFFICE Sandstrom Design
CLIENT Portland State University
PRINCIPAL TYPE Kuenstler Script, Mrs. Eaves,
. New Century Schoolbook,
. and Vinyl Warehouse
DIMENSIONS 7.1 x 9.5 IN. (18 x 24.1 CM)

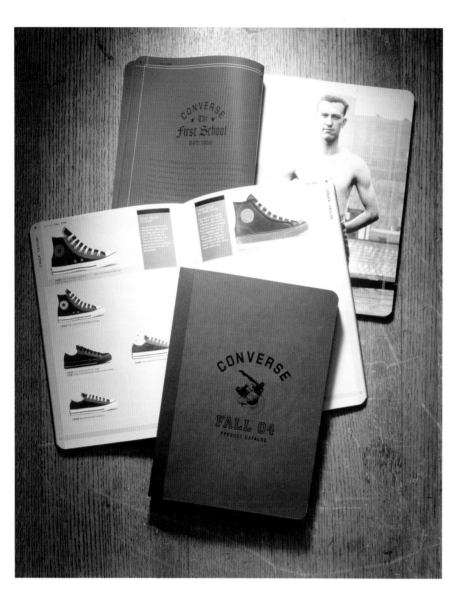

CATALOG

DESIGN James Parker and Kristin Anderson
. *Portland, Oregon*
ART DIRECTION James Parker
CREATIVE DIRECTION . . . Steve Sandstrom
PHOTOGRAPHY Dave Bradley
COPYWRITERS Joel Bloom and Jim Terry
DESIGN OFFICE Sandstrom Design
CLIENT Converse
PRINCIPAL TYPE Code, Princetown, Serifa, Square 40 (modified),
. and Trade Gothic
DIMENSIONS 8 x 11 IN. (20.3 x 27.9 CM)

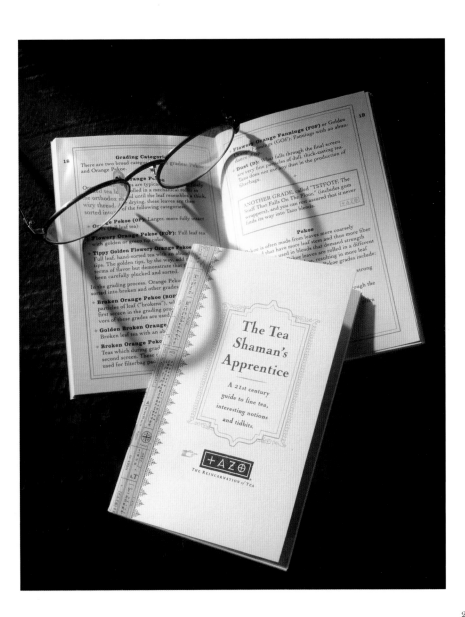

BROCHURE

DESIGN Steve Sandstrom and Kristin Anderson
. *Portland, Oregon*
ART DIRECTION Steve Sandstrom
CREATIVE DIRECTION . . . Steve Sandstrom
COPYWRITER Palmer Pettersen
. *Kirkland, Washington*
DESIGN OFFICE Sandstrom Design
CLIENT Tazo Tea
PRINCIPAL TYPE Clarendon, Cochin, Nicolas Cochin, and Futura
DIMENSIONS 3.5 x 5.25 IN. (8.9 x 13.3 CM)

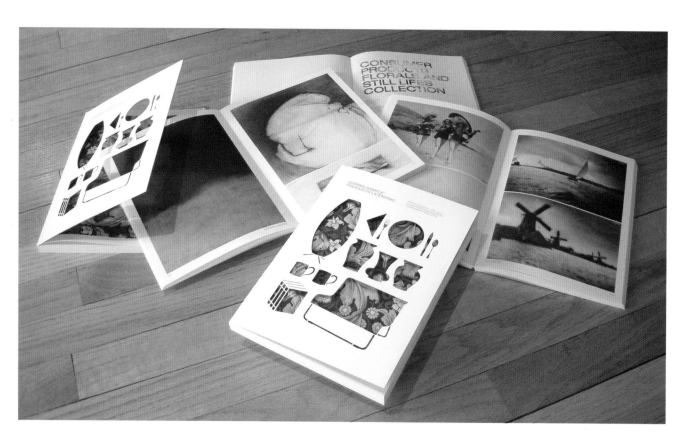

204 CATALOG

DESIGN Carlos Segura and Tnop
. *Chicago, Illinois*
ART DIRECTION Carlos Segura
CREATIVE DIRECTION . . . Carlos Segura
PRINTER Sioux Printing
. *Sioux Falls, South Dakota*
DESIGN OFFICE Segura Inc.
CLIENT Corbis
PRINCIPAL TYPE Helvetica
DIMENSIONS 6 x 9 IN. (15.2 x 22.9 CM)

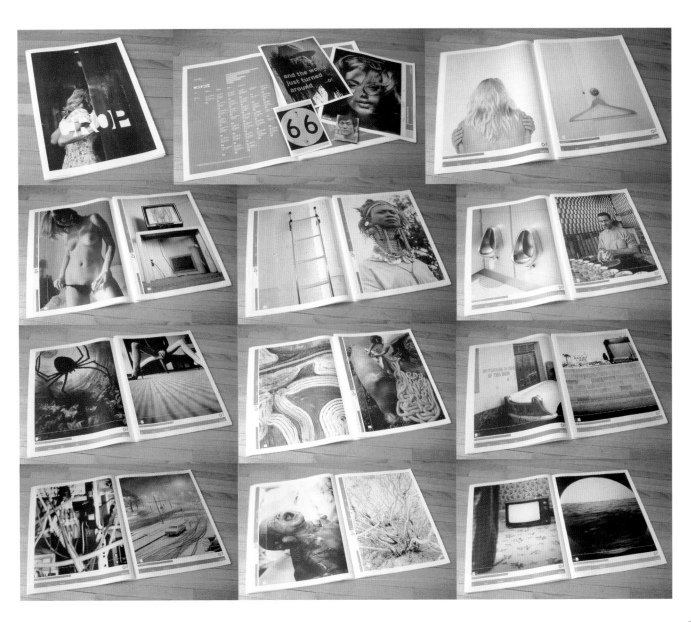

BROCHURE

DESIGN Ryan Halvorsen, Chris May, Carlos Segura, Tnop,
. and Dave Weik
. *Chicago, Illinois*
ART DIRECTION Carlos Segura
CREATIVE DIRECTION . . . Carlos Segura
PRINTER Sioux Printing
. *Sioux Falls, South Dakota*
DESIGN OFFICE Segura, Inc.
CLIENT Corbis
PRINCIPAL TYPE Interstate and various
DIMENSIONS 19.75 x 26.5 IN. (50.2 x 67.3 CM)

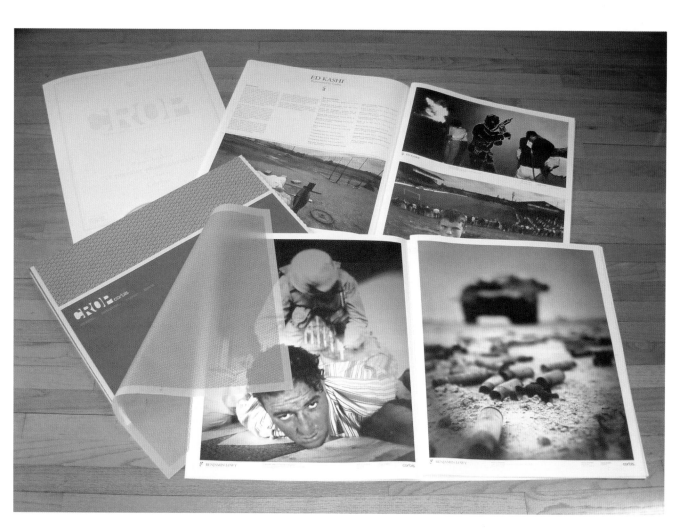

BROCHURE

DESIGN Chris May, Carlos Segura, and Tnop
. *Chicago, Illinois*
ART DIRECTION Carlos Segura
CREATIVE DIRECTION . . . Carlos Segura
PRINTER Sioux Printing
. *Sioux Falls, South Dakota*
DESIGN OFFICE Segura, Inc.
CLIENT Corbis
PRINCIPAL TYPE Interstate and Centaur
DIMENSIONS 18.5 x 23.5 IN. (47 x 59.7 CM)

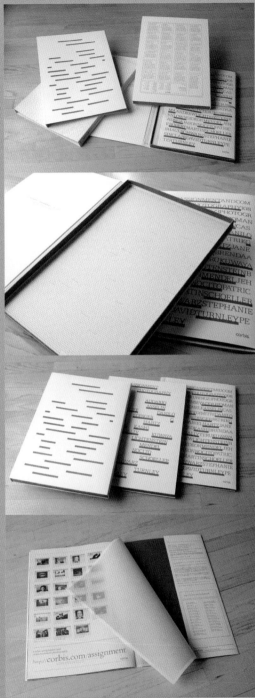

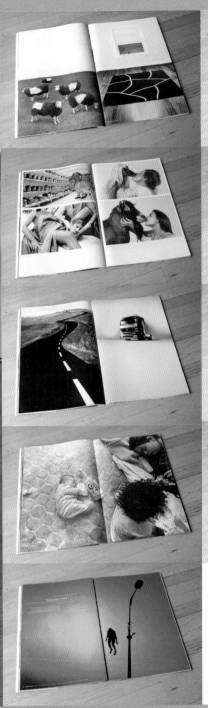

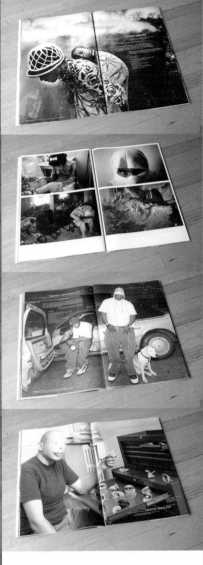

BROCHURE

DESIGN Chris May, Carlos Segura, and Tnop
. *Chicago, Illinois*
ART DIRECTION Carlos Segura
CREATIVE DIRECTION . . . Carlos Segura
PRINTER Sioux Printing
. *Sioux Falls, South Dakota*
DESIGN OFFICE Segura, Inc.
CLIENT Corbis
PRINCIPAL TYPE Interstate and Centaur
DIMENSIONS 13.25 x 19.5 IN. (33.7 x 49.5 CM)

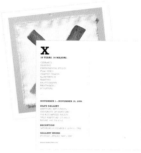

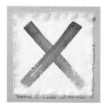
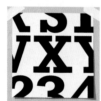
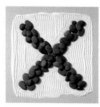

DESIGN Bazil Findlay and David Phan
. *New York, New York*
ART DIRECTION Bazil Findlay and David Phan
CREATIVE DIRECTION . . . Brett Gersteinblatt
PHOTOGRAPHY Holly Lindem
. *Pantego, Texas*
ILLUSTRATION Holly Lindem
STUDIO Sequel Studio, LLC
CLIENT The Hartford Art School
PRINCIPAL TYPE Rockwell
DIMENSIONS Various

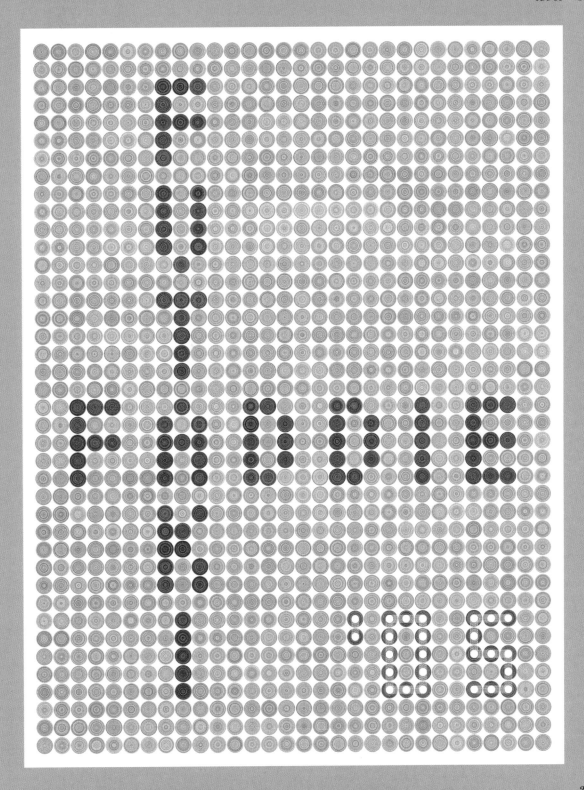

POSTER

DESIGN Ohsugi Gaku and Sunaga Eiji
. *Tokyo, Japan*
ART DIRECTION Ohsugi Gaku
DESIGN OFFICE 702 Design Works Inc.
CLIENT FUTAKI INTERIOR INC.
PRINCIPAL TYPE New York
DIMENSIONS 40.6 x 28.7 IN. (103 x 72.8 CM)

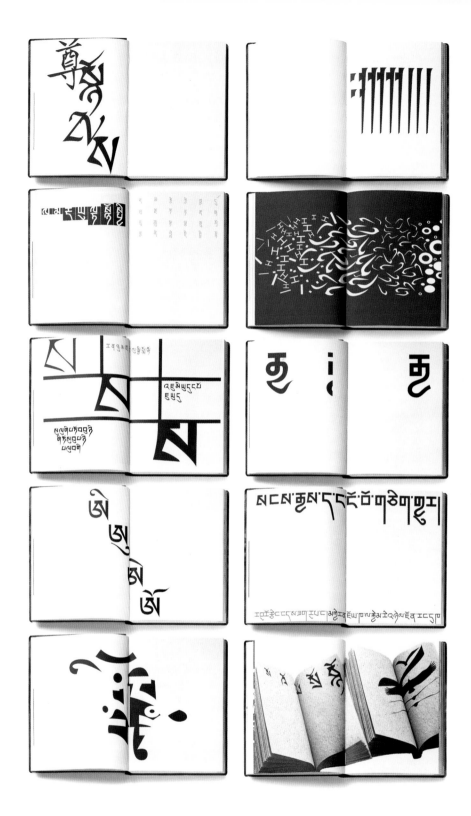

DESIGN Wang Yue Fei
. *Shenzhen, China*
ART DIRECTION Wang Yue Fei
CREATIVE DIRECTION . . . Wang Yue Fei
LETTERING Wang Yue Fei
DESIGN OFFICE Shenzhen Wang Yue Fei Design Company
PRINCIPAL TYPE Handlettering
DIMENSIONS 6 x 8 IN. (15.2 x 20.3 CM)

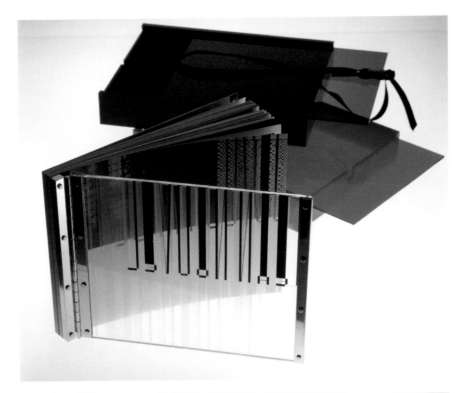

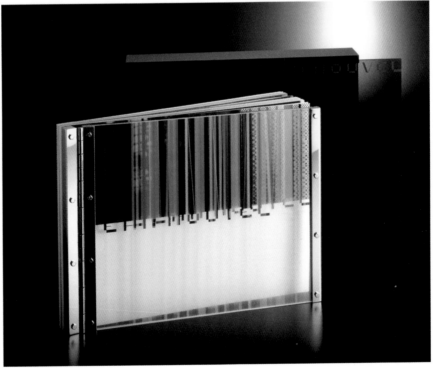

CATALOG

DESIGN Tamotsu Shimada and Miyuki Amemiya
. *Osaka, Japan*
ART DIRECTION Tamotsu Shimada
PHOTOGRAPHY Koichi Okuwaki
TRANSLATION Shinya Kamimura
DESIGN OFFICE Shimada Design, Inc.
CLIENT Suntory Museum, Osaka
PRINCIPAL TYPE DIN Medium, Futo Go B 101 Bold,
. KRMasurao M Regular, and custom
DIMENSIONS 9.8 x 12.4 IN. (25 x 31.5 CM)

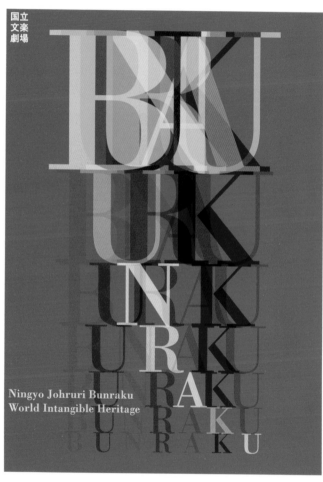

DESIGN Shinnoske Sugisaki
. *Osaka, Japan*
ART DIRECTION Shinnoske Sugisaki
DESIGN OFFICE Shinnoske Inc.
CLIENT Bunraku Kyokai
PRINCIPAL TYPE Bodoni
DIMENSIONS 28.7 x 40.6 IN. (72.8 x 103 CM)

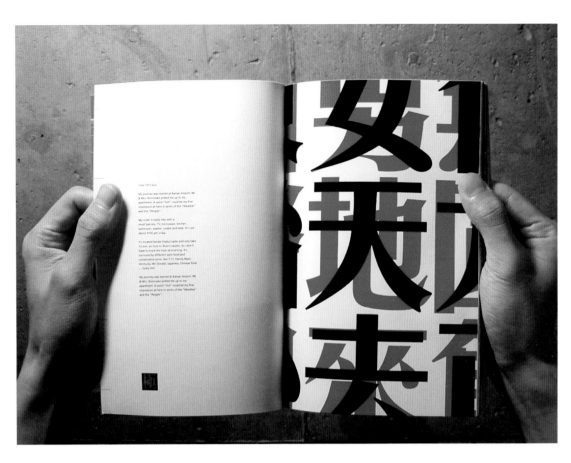

BOOK

DESIGN Hung Lam
. *Hong Kong, China*
ART DIRECTION Hung Lam
CREATIVE DIRECTION . . . Shinnoske Sugisaki
. *Osaka, Japan*
DESIGN OFFICE Shinnoske Inc.
CLIENT MCCM Creations
PRINCIPAL TYPE Frutiger and FF Din
DIMENSIONS 8.3 x 5.8 IN. (21 x 14.8 CM)

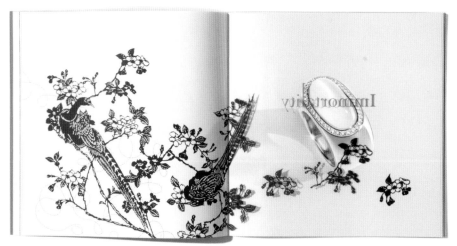

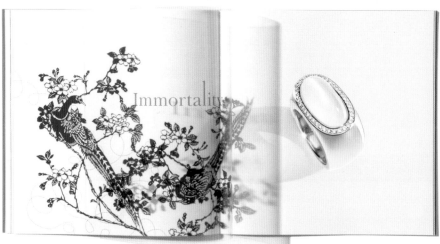

DESIGN Michael Sieger
. *Sassenberg, Germany*
ART DIRECTION Michael Sieger
CREATIVE DIRECTION . . . Michael Sieger
AGENCY Sieger Design
CLIENT Jochen Pohl
PRINCIPAL TYPE New Baskerville and HTF Gotham
DIMENSIONS 8.25 x 8.25 IN. (21 x 21 CM)

CATALOG

DESIGN. Franck Sarfati, Olivier Stenuit,
. and Joël Van Audenhaege
. *Brussels, Belguim*
ART DIRECTION. Franck Sarfati, Olivier Stenuit,
. and Joël Van Audenhaege
CREATIVE DIRECTION . . . Franck Sarfati, Olivier Stenuit,
. and Joël Van Audenhaege
AGENCY. [SIGN*] Signes Particuliers
CLIENT MAC's
PRINCIPAL TYPE Bryant Renewed
DIMENSIONS Various

Scholar, Teacher, Collector | Franklin Kelly
John Wilmerding & American Art

It is entirely possible that John Wilmerding was born to be a collector. Perhaps the urge to acquire was part of his genetic code, for collecting certainly runs in his family. Wilmerding's great-grandparents, Henry Osborne Havemeyer and his second wife, Louisine Waldron Havemeyer, amassed an extraordinary group of European and oriental works of art that was eventually bequeathed to the Metropolitan Museum of Art in New York. The Havemeyer Collection, renowned in its own day, as it still is today, for its old master and impressionist paintings and its Chinese and Japanese precious objects, prints, and textiles, is among the most magnificent gifts the Metropolitan has ever received. One of the Havemeyers' daughters, Electra Havemeyer Webb (Wilmerding's grandmother), was a voracious and eclectic acquirer of American fine and folk paintings and sculptures, decorative arts, quilts, tools, vernacular objects, toys, buildings, and transportation vehicles (fig. 1). Her remarkable and vast collection was the genesis of the Shelburne Museum in Vermont (founded in 1947), which consists of a complex of structures—many of them nineteenth-century buildings that were disassembled and moved under Mrs. Webb's direction—including houses, shops, barns, schoolhouses, a covered bridge, a lighthouse, and even a 220-foot-long steamship. Wilmerding fondly recalls growing up with many of his grandmother's possessions in his family's Long Island home and seeing other objects in the houses of various relatives (there were far too many for any one residence). He also remembers visiting the Webbs' grand New York apartment and seeing the paintings there, but only years later did he realize that they were by Edouard Manet (fig. 2), Claude Monet, Edgar Degas, Jean-Baptiste-Camille Corot, and other French painters, works his grandmother had inherited from her parents. For him, they represented simply part of the decor and were accepted as such. If thoughts of emulating his family in collecting entered Wilmerding's mind in those days, they were only fleeting. As he recalls, "I may have heard that my great-grandparents' collections were in the Metropolitan, but I had no idea what those collections were."

In the early 1950s, when Wilmerding went to boarding school, art history was all but unknown in American education below the collegiate level. Classes were offered in the standard disciplines, and Wilmerding remembers being particularly drawn to writing.

DESIGN Wendy Schleicher Smith
. *Washington, D.C.*
PUBLISHER National Gallery of Art
PRINCIPAL TYPE Adobe Caslon, Adobe Caslon Expert,
. and FB Interstate
DIMENSIONS 9 x 10.75 IN. (22.9 x 27.3 CM)

BIG OIL, LUBRICATING U.S. FOREIGN POLICY SINCE 2001.

Former Halliburton CEO and current U.S. Vice President, Dick Cheney, still receives deferred salary from Halliburton—the world's largest oil field services corporation.

STUDENT PROJECT

DESIGN May Sorum
. *Seattle, Washington*
INSTRUCTOR Annabelle Gould
SCHOOL University of Washington
PRINCIPAL TYPE Trade Gothic Condensed and Helvetica Rounded
DIMENSIONS 11.75 x 17.1 IN. (29.8 x 43.5 CM)

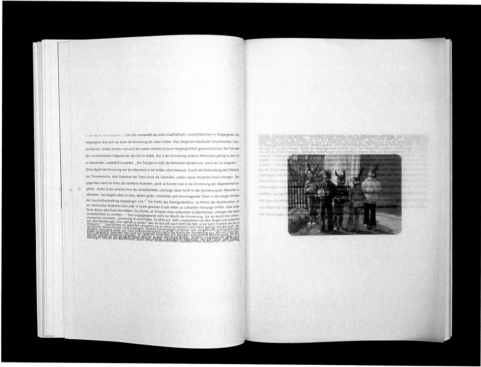

218 STUDENT PROJECT

DESIGN Andreas Stiller
. *Wuppertal, Germany*
PROFESSOR Uwe Loesch
SCHOOL University of Wuppertal
PRINCIPAL TYPE Syntax
DIMENSIONS 11 x 7.9 IN. (28 x 20 CM)

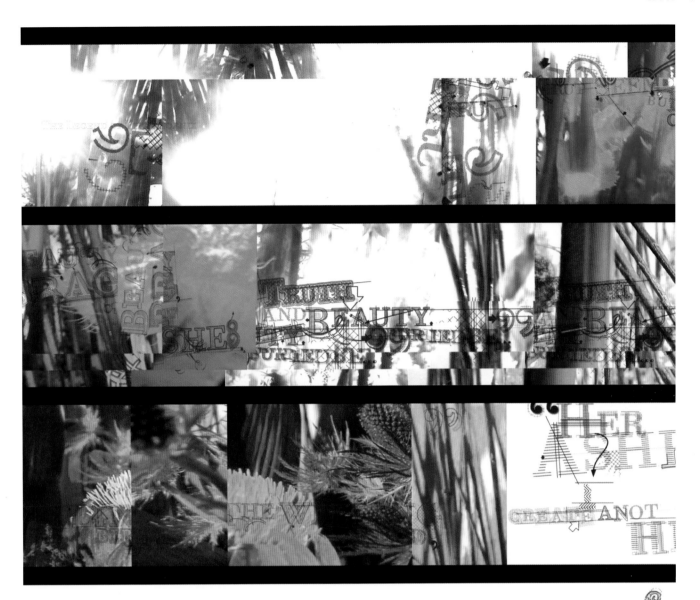

VIDEO GRAPHICS

DESIGN Ryan Pescatore Frisk and Catelijne van Middelkoop
. *The Hague, The Netherlands*
ART DIRECTION Ryan Pescatore Frisk and Catelijne van Middelkoop
CREATIVE DIRECTION . . . Ryan Pescatore Frisk and Catelijne van Middelkoop
DIRECTORS Ryan Pescatore Frisk and Catelijne van Middelkoop
PRODUCERS Anna Erdreich, Ben Erdreich, Jeremy Erdreich,
. and Carl Hess
. *Birmingham, Alabama*
DESIGN OFFICE Strange Attractors Design
CLIENT Metropolitan LLC
PRINCIPAL TYPE ITC Bodoni Six

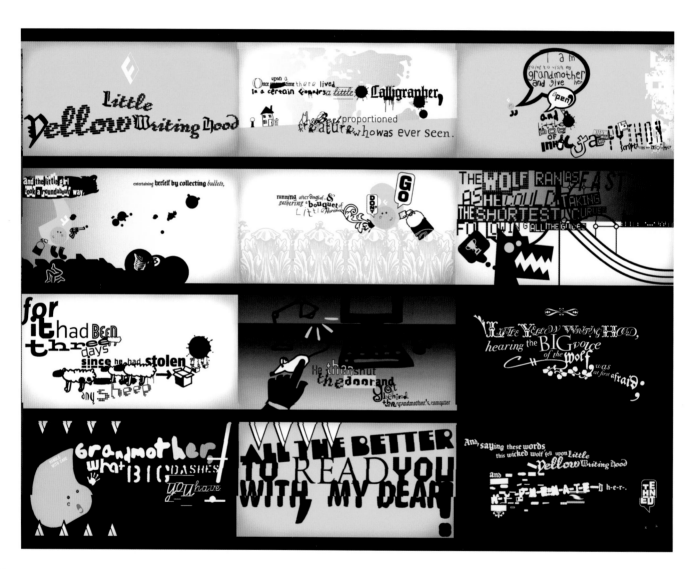

DESIGN Ryan Pescatore Frisk and Catelijne van Middelkoop
. *The Hague, The Netherlands*
ART DIRECTION Ryan Pescatore Frisk and Catelijne van Middelkoop
CREATIVE DIRECTION . . . Ryan Pescatore Frisk and Catelijne van Middelkoop
DIRECTORS Ryan Pescatore Frisk and Catelijne van Middelkoop
DESIGN OFFICE Strange Attractors Design
CLIENT FontShop International
PRINCIPAL TYPE Various

BOOK

DESIGN Kirsten Dietz, Susanne Hörner, Holger Jungkunz,
. Jochen Rädeker, and Felix Widmaier
. *Stuttgart, Germany*
ART DIRECTION Kirsten Dietz and Jochen Rädeker
CREATIVE DIRECTION . . Kirsten Dietz and Jochen Rädeker
PHOTOGRAPHY Niels Schubert
ILLUSTRATION Felix Widmaier
AGENCY strichpunkt gmbh
CLIENT Verlag Hermann Schmidt Mainz, Germany
PRINCIPAL TYPE Compatil and DIN Engschrift
DIMENSIONS 10 x 12.8 IN. (25.5 x 32.5 CM)

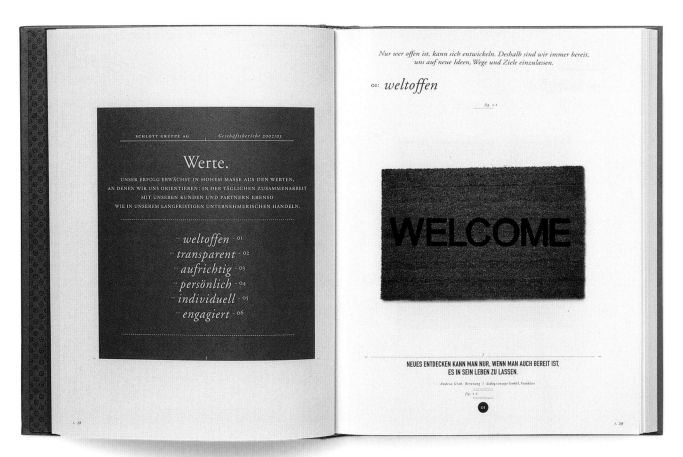

222 ANNUAL REPORT

DESIGN Kirsten Dietz and Stephanie Zehender
. *Stuttgart, Germany*
ART DIRECTION Kirsten Dietz and Tina Hornung
CREATIVE DIRECTION . . . Jochen Rädeker
PHOTOGRAPHY Kai Loges and Andreas Langen
AGENCY strichpunkt gmbh
CLIENT schlott gruppe Aktiengesellschaft
. *Freudenstadt, Germany*
PRINCIPAL TYPE Adobe Garamond and ITC Officina
DIMENSIONS 7.9 x 9.8 IN. (20 x 25 CM)

02 1876

FEBRUAR / FEBRUARY

01 02 03 04 05 (06) 07 08 09 10 11 12 (13) 14 15 16 17 18 19 (20) 21 22 23 24 25 26 (27) 28

CALENDAR

DESIGN Kirsten Dietz
. *Stuttgart, Germany*
ART DIRECTION Kirsten Dietz
CREATIVE DIRECTION . . . Jochen Rädeker and Kirsten Dietz
PHOTOGRAPHY Niels Schubert
ILLUSTRATION Gernot Walter
AGENCY strichpunkt gmbh
CLIENT Papierfabrik Scheufelen
PRINCIPAL TYPE FF Scala
DIMENSIONS 23.4 x 33.1 IN. (59.4 x 84 CM)

DESIGN Kirsten Dietz
. *Stuttgart, Germany*
ART DIRECTION Kirsten Dietz
CREATIVE DIRECTION . . . Kirsten Dietz
AGENCY strichpunkt gmbh
CLIENT Verlag Hermann Schmidt Mainz, Germany
PRINCIPAL TYPE DIN Engschrift and FF Scala
DIMENSIONS 14.6 x 4.7 IN. (37 x 12 CM)

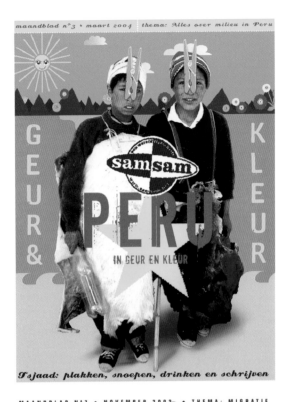

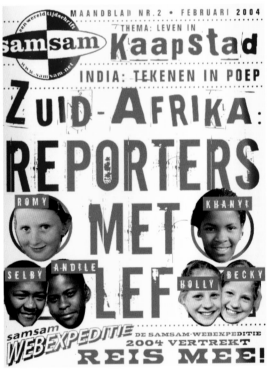

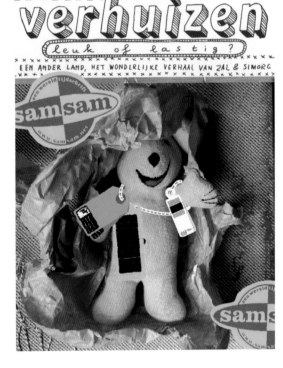

225

MAGAZINE

DESIGN Edwin Vollebergh
. *'s-Hertogenbosch, The Netherlands*
ART DIRECTION Petra Janssen and Edwin Vollebergh
CREATIVE DIRECTION . . . Petra Janssen and Edwin Vollebergh
LETTERING Petra Janssen and Edwin Vollebergh
ILLUSTRATION Edwin Vollebergh and Caroline van Pelt
DESIGN OFFICE Studio Boot
CLIENT KIT Publishers and Hotei Publishing
PRINCIPAL TYPE Sassoon Primary
DIMENSIONS 10.8 x 8.1 IN. (27.5 x 20.5 CM)

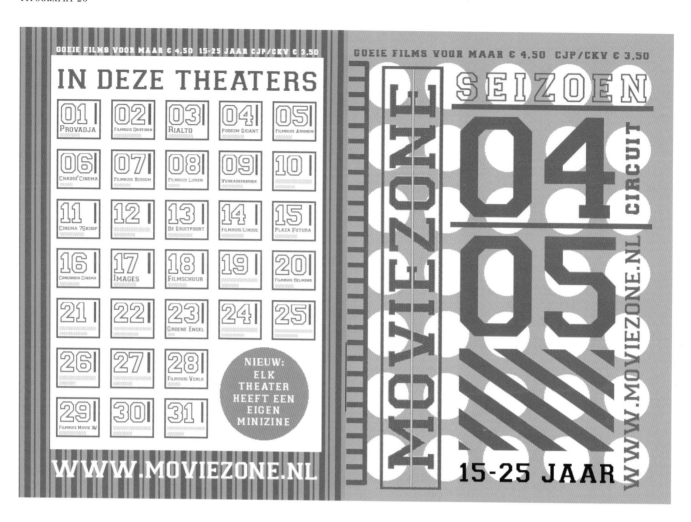

CATALOGS

DESIGN Petra Janssen and Edwin Vollebergh
. *'s-Hertogenbosch, The Netherlands*
ART DIRECTION Petra Janssen and Edwin Vollebergh
CREATIVE DIRECTION . . . Petra Janssen and Edwin Vollebergh
LETTERING Petra Janssen and Edwin Vollebergh
DESIGN OFFICE Studio Boot
CLIENT Nederlands Instituut Filmeducatie
PRINCIPAL TYPE College, Collegiate, and Neverland
DIMENSIONS 5.7 X 4.1 IN. (14.5 X 10.5 CM)

POSTER

DESIGN Choong Ho Lee
. *Seoul, Korea*
ART DIRECTION Choong Ho Lee
CREATIVE DIRECTION . . . Choong Ho Lee
DESIGN OFFICE SW20
CLIENT British Embassy, Seoul
PRINCIPAL TYPE Gill Sans
DIMENSIONS 20.5 x 29.5 IN. (52 x 75 CM)

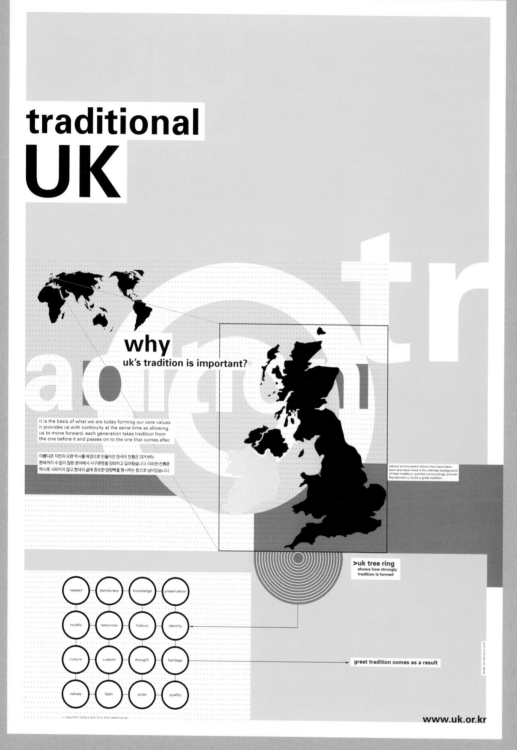

DESIGN Choong Ho Lee
. *Seoul, Korea*
ART DIRECTION Choong Ho Lee
CREATIVE DIRECTION . . . Choong Ho Lee
AGENCY SW20
CLIENT British Embassy, Seoul
PRINCIPAL TYPE Univers
DIMENSIONS 20.5 x 29.5 IN. (52 x 75 CM)

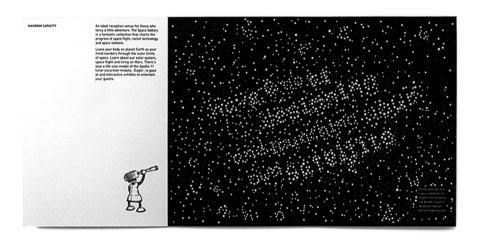

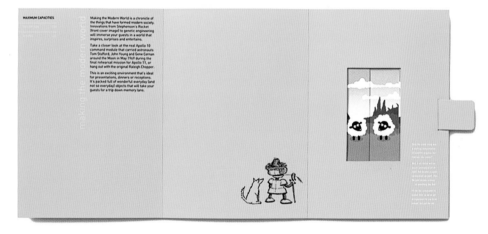

BROCHURE

DESIGN Alex Bane, Olly Guise, Luke Manning,
. and Karl Wills
. *Bristol, England*
ART DIRECTION Ryan Wills
CREATIVE DIRECTION . . . Spencer Buck
LETTERING Spencer Buck
STUDIO Taxi Studio
CLIENT Science Museum London
PRINCIPAL TYPE DIN Schriften
DIMENSIONS 5.9 x 8.3 IN. (15 x 21 CM)

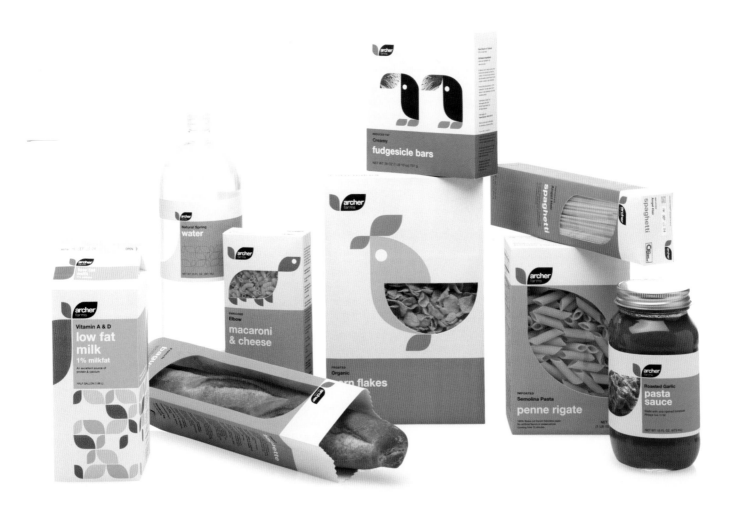

DESIGN Brian Gunderson
. *San Francisco, California*
CREATIVE DIRECTION . . . Joel Templin and Gaby Brink
DESIGN OFFICE Templin Brink Design
CLIENT Target Stores
PRINCIPAL TYPE Akzidenz Grotesk BE
DIMENSIONS Various

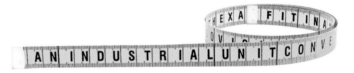

INVITATION

CREATIVE DIRECTION . . . Ben Casey
. *Manchester, England*
ARTWORKER. Andy Mairs
DESIGN AGENCY. The Chase
CLIENT A Brand
PRINCIPAL TYPE Swiss Bold Condensed
DIMENSIONS 59.1 x .6 IN. (150 x 1.5 CM)

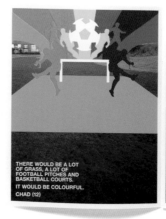
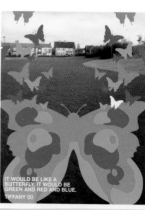

BROCHURE

DESIGN Stephen Royle and Harriet Devoy
. *London, England*
CREATIVE DIRECTION . . . Harriet Devoy
LETTERING Stephen Royle
AGENCY The Chase
CLIENT CABE Space
PRINCIPAL TYPE Helvetica
DIMENSIONS 11 x 13.7 IN. (28 x 34.7 CM)

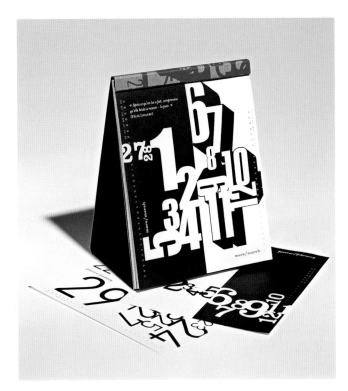

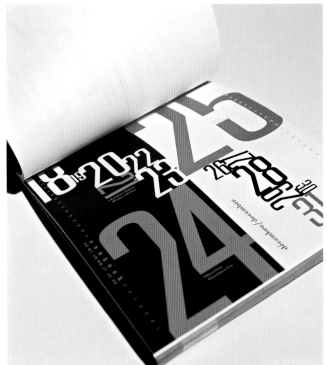

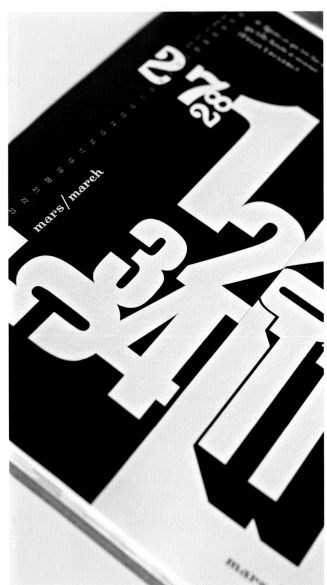

CALENDAR

DESIGN	Anne Thomas and Vill Mak
	Montreál, Canada
ART DIRECTION	Anne Thomas and Vill Mak
CREATIVE DIRECTION	Anne Thomas and Vill Mak
DESIGN OFFICE	thomas design + communication
PRINCIPAL TYPE	Clarendon, FF Din, House Gothic,
	and Neue Helvetica
DIMENSIONS	5.5 x 7.5 IN. (14 x 19.1 CM)

233

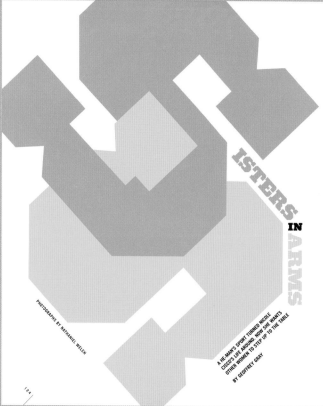

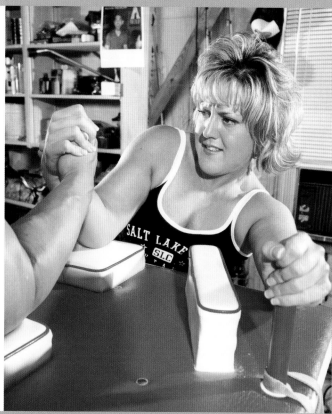

MAGAZINE SPREAD

DESIGN Kathie Scrobanovich
. *New York, New York*
ART DIRECTION Siung Tjia
CREATIVE DIRECTION . . . Siung Tjia
PHOTOGRAPHY Nathaniel Welch
PUBLICATION ESPN The Magazine
PRINCIPAL TYPE HTF Acropolis
DIMENSIONS 20 x 12 IN. (50.8 x 30.5 CM)

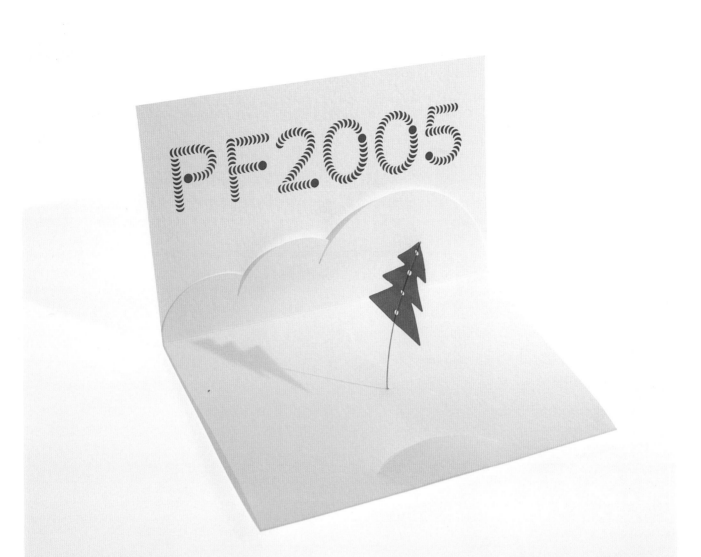

GREETING CARD

DESIGN Jan Tomáš
. *Prague, Czech Republic*
PRINCIPAL TYPE Digimon
DIMENSIONS 8.3 x 5.8 IN. (21 x 14.8 CM)

235

DESIGN Ben Horner and Andy Machin
. *Chattanooga, Tennessee*
CREATIVE DIRECTION . . . Michael Hendrix
PROGRAMMER Andy Montgomery
DESIGN OFFICE Tricycle, Inc.
PRINCIPAL TYPE Akzidenz Grotesk

TELEVISION COMMERCIAL

DESIGN Jens Mebes, Todd Neale, and Jean Pichot
. *New York, New York*
CREATIVE DIRECTION . . . Jakob Trollbäck and Joe Wright
DESIGN OFFICE Trollbäck & Company
CLIENT HBO Films
PRINCIPAL TYPE News Gothic Bold

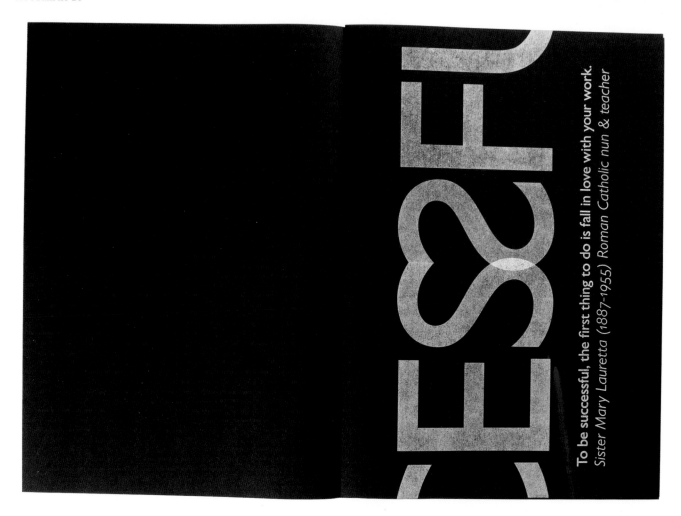

To be successful, the first thing to do is fall in love with your work.
Sister Mary Lauretta (1887-1955) Roman Catholic nun & teacher

238 BROCHURE

DESIGN Stuart Price
. *Manchester, England*
CREATIVE DIRECTION . . . Ady Bibby
AGENCY True North
PRINCIPAL TYPE Various
DIMENSIONS 16.5 x 11.7 IN. (42 x 29.7 CM)

Mycock
wrote this

Thanks for
using
Mycock

INVOICE

Compliments
from Mycock

Mycock
for hire

Type Directors Club
127 West 25 Street
New York, NY 10001

Please do
not bend

Will it be
much longer?

CORPORATE IDENTITY

DESIGN Stuart Price and Chris Jeffreys
. *Manchester, England*
ART DIRECTION Danny Mycock
CREATIVE DIRECTION . . . Ady Bibby
COPYWRITER Danny Mycock
AGENCY True North
PRINCIPAL TYPE Sauna
DIMENSIONS Various

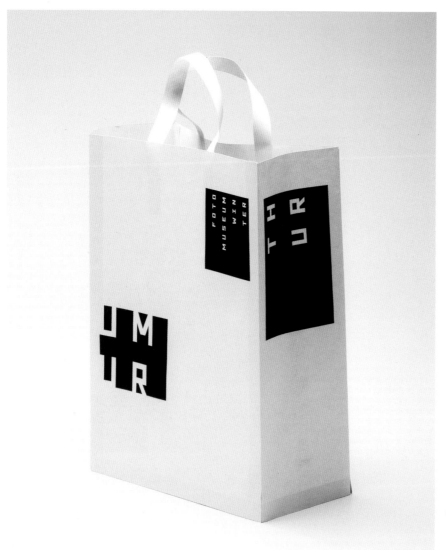

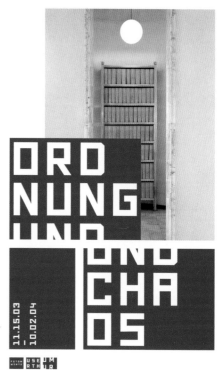

240 STUDENT PROJECT

DESIGN Lorenz Tschopp
. *Düdinjen, Switzerland*
PROFESSOR André Baldinger
SCHOOL Hochschule der Künste Bern
PRINCIPAL TYPE Fotomuseum Regular and Akzidenz Grotesk
DIMENSIONS 15.75 x 23.25 IN. (40 x 59.1 CM)

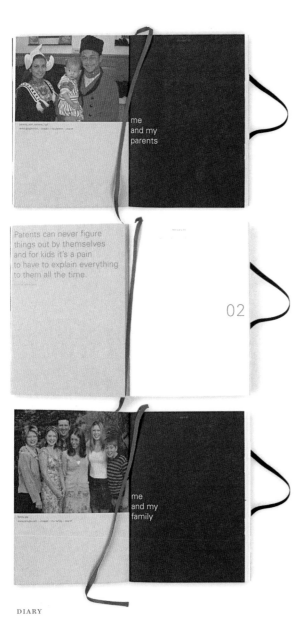

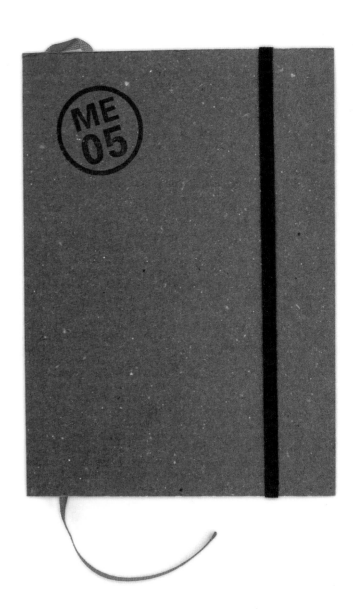

DIARY

DESIGN Michael Buchenauer and Tiemen Harder
. *The Hague, The Netherlands*
PRINTER De Longte Dordrecht
DESIGN OFFICE 2D3D
PRINCIPAL TYPE Univers
DIMENSIONS 5.1 x 7.1 IN. (13 x 18 CM)

U

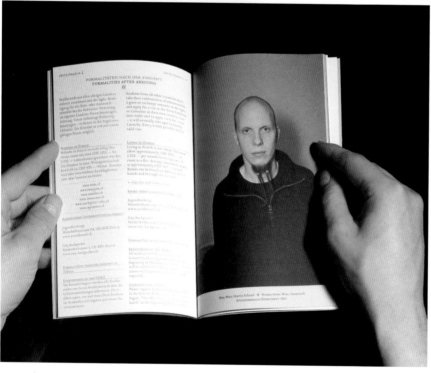

DESIGN unfolded
. *Zürich, Switzerland*
ART DIRECTION Friedrich-Wilhelm Graf
CREATIVE DIRECTION . . . Nadia Gisler
PHOTOGRAPHY Stefan Burger
MAP DESIGN Hin Van Tran
DESIGN OFFICE unfolded
CLIENT International Office/
. Hochschule für Gestaltung und Kunst Zürich
PRINCIPAL TYPE Tribute and Poppl
DIMENSIONS 5.1 x 8.3 IN. (13 x 21 CM)

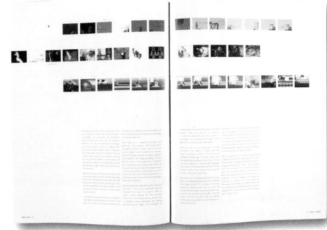

MAGAZINE 243

DESIGN Fabiola Elias, Nan Goggin, Daniel Goscha,
. Jennifer Gunji, Amy Hanlon, Lauren Hoopes,
. Chad Kellenberger, Mason Kessinger,
. Valerie Lohmann, and Jessica Mullen
. *Champaign, Illinois*
ART DIRECTION Jennifer Gunji
CREATIVE DIRECTION . . . Nan Goggin, Jennifer Gunji, and Joseph Squier
SCHOOL University of Illinois at Urbana-Champaign,
. School of Art & Design
CLIENT University of Illinois at Urbana-Champaign,
. Department of English
PRINCIPAL TYPE Adobe Garamond and Franklin Gothic
DIMENSIONS 9 x 12 IN. (22.9 x 30.5 CM)

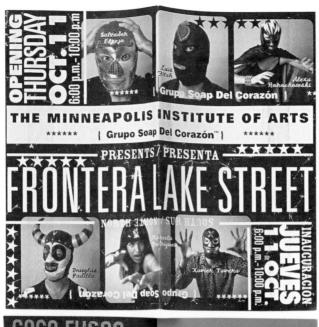

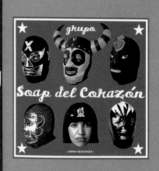

244 BROCHURE

DESIGN Luis Fitch
. *Minneapolis, Minnesota*
ART DIRECTION Luis Fitch
CREATIVE DIRECTION . . . Luis Fitch
LETTERING Luis Fitch
PHOTOGRAPHY Xavier Tavera
AGENCY UNO "Branding for the new majority"
CLIENT Minneapolis Institute of Art
PRINCIPAL TYPE Various
DIMENSIONS 6 x 10.5 IN. (15.2 x 26.7 CM)

Amid the turmoil of completing degrees and identities, we somehow survived.

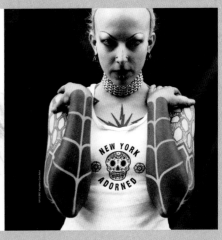

NEW YORK ADORNED

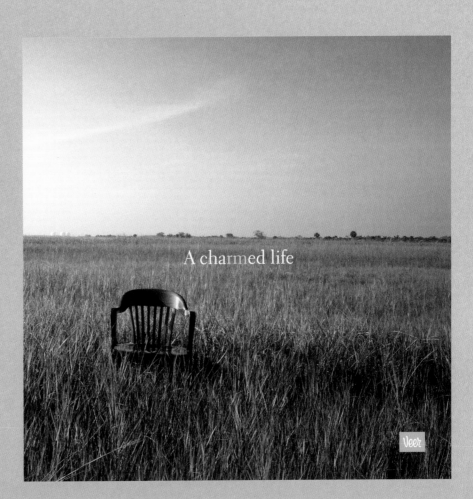

A charmed life

Veer

BROCHURE

DESIGN Donna Holesworth and Bryce Beresh
. *Calgary, Canada*
CREATIVE DIRECTION . . . Sheldon Popiel
COPYWRITERS. Duane Wheatcroft and Jon Parker
AGENCY Veer
PRINCIPAL TYPE Electra® Std 2
DIMENSIONS 9 x 9 IN. (22.9 x 22.9 CM)

AES ELETROPAULO

RELATÓRIO ANUAL 2003 ANNUAL REPORT

AES ELETROPAULO

RELATÓRIO ANUAL 2003 ANNUAL REPORT

ANNUAL REPORT

DESIGN Vicente Gil and Nasha Gil
. *Sao Paolo, Brazil*
ART DIRECTION Vicente Gil
CREATIVE DIRECTION . . . Vicente Gil
DESIGN OFFICE Vicente Gil Arquitetura e Design
CLIENT AES Eletropaulo
PRINCIPAL TYPE Monotype Bembo and FTF Morgan
DIMENSIONS 8.7 x 11 IN. (22 x 28 CM)

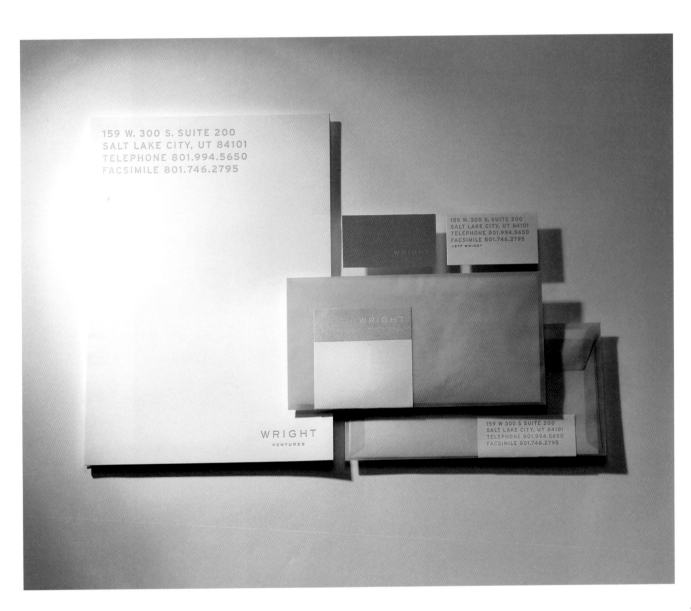

CORPORATE IDENTITY

DESIGN Chuck Williams
. *Salt Lake City, Utah*
AGENCY W
CLIENT Wright Ventures
PRINCIPAL TYPE AT Sackers and Interstate
DIMENSIONS Various

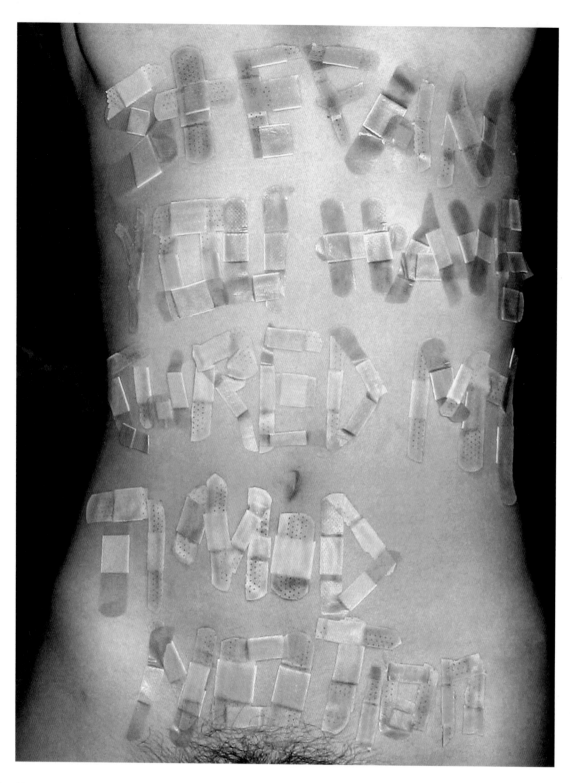

248 STUDENT PROJECT

DESIGN Susan Walsh
. *Brooklyn, New York*
PHOTOGRAPHY K-Fai Steele
INSTRUCTOR Stefan Sagmeister
SCHOOL School of Visual Arts
PRINCIPAL TYPE Band aids
DIMENSIONS 5 x 6.7 IN. (12.7 x 17 CM)

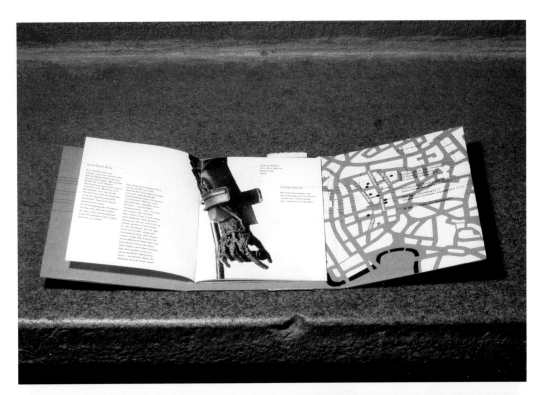

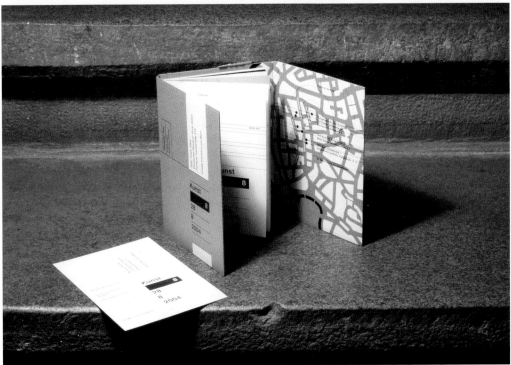

BROCHURE

DESIGN Mechthild Post and Stefan Waidmann
. *Braunschweig, Germany*
DESIGN OFFICE Waidmann/Post
CLIENT Kunst 8
PRINCIPAL TYPE Akzidenz Grotesk
DIMENSIONS 4.5 x 6.3 IN. (11.5 x 16 CM)

DESIGN Sharon Werner and Sarah Nelson
. *Minneapolis, Minnesota*
ART DIRECTION Sharon Werner
DESIGN OFFICE Werner Design Werks, Inc.
CLIENT Clean and Co., LLC
PRINCIPAL TYPE Adobe Clarendon, ITC Franklin Gothic,
. Adobe Futura, and Adobe News Gothic
DIMENSIONS Various

PACKAGING

DESIGN Sharon Werner and Sarah Nelson
. *Minneapolis, Minnesota*
ART DIRECTION Sharon Werner
DESIGN OFFICE Werner Design Werks, Inc.
CLIENT Clean and Co., LLC
PRINCIPAL TYPE Adobe Clarendon, ITC Franklin Gothic,
. Adobe Futura, and Adobe News Gothic
DIMENSIONS Various

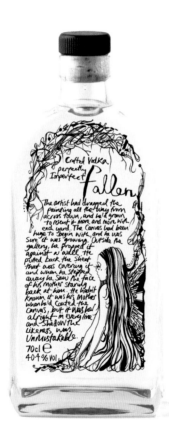
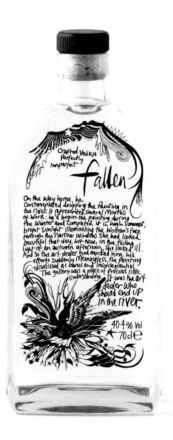
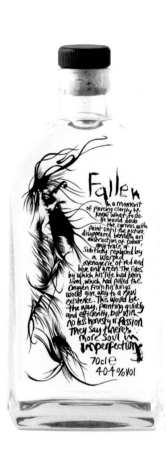

252 PACKAGING

DESIGN Fiona Curran
. *London, England*
ART DIRECTION Garrick Hamm
CREATIVE DIRECTION . . . Garrick Hamm
CALLIGRAPHY Fiona Curran
ILLUSTRATION Jo Radcliff
AGENCY Williams Murray Hamm
CLIENT Glenmorangil
PRINCIPAL TYPE Handlettering
DIMENSIONS Various

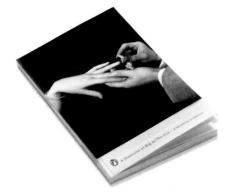

A DIAMOND AS BIG AS THE RITZ
– A WEDDING INVITATION

In the short space of 31 years, *Rachel O'Connor* has emerged as a highly respected and much admired writer of extremely long and convoluted emails. She was born in 1972 near the Middle of Nowhere in Cheshire and brought up in an Irish-Polish family where everyone claimed to understand each other, but nobody was really sure. After spending a year upside down in Australia and 12 months leaning in Pisa, she returned home fluid in several languages and making sense in none of them. She does, however, love her Mum and Dad, two sisters and her much missed brother, Dom – oh, and Scott, of course, we nearly forgot – and she drives a Ford Anglia. Well – *what more could you want?*

By a striking coincidence, *Scott Fitzgerald*, who is to marry Rachel, was born just a few months earlier in the City of Salford, much loved in fable and song. He was brought up surrounded by loving women – well, that's what it says here, anyway – and has never really got over it. Coming to terms with having the same name as a famous drunken American author, he fell in love with trees and became an arboriculturalist. Don't ask me, I can't pronounce it either. Briefly putting down roots in rural Derbyshire – 'you're a really rubbish root, you are!' – he transplanted himself back to Manchester just in time to cop 'a big, moody lady', who we can only presume to be Rachel. I mean, in his shoes you would, wouldn't you?

Contents

o

INVITATION

253

DESIGN	Helen Taylor
	Manchester, England
ART DIRECTION	Helen Taylor
CREATIVE DIRECTION	Helen Taylor
COPYWRITER	James Denley
TYPOGRAPHER	Lisa Frodsham
AGENCY	With
CLIENT	Rachel and Scott Fitzgerald
PRINCIPAL TYPE	Foundry Sterling and Columbus
DIMENSIONS	4.9 x 7.7 IN. (12.5 x 19.5 CM)

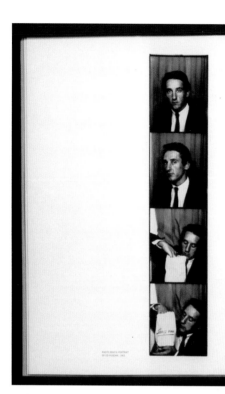

First Exposure

In an interview with John Coplans for the February 1965 issue of *Artforum* magazine, Ed Ruscha remarked, "I think photography is dead as a fine art; its only place is in the commercial world, for technical or information purposes." When Ruscha gave this interview, he had already baffled and bemused the art world with his book *Twentysix Gasoline Stations* (1963) that, true to its title, contained black-and-white photographs of twenty-six roadside filling stations. What Coplans did not know and Ruscha left unsaid was how much photography had been a part of his seeing for well over a decade. The artist's disinterest in the subject is characteristic of his ambivalence about his own photography. Although Ruscha has long been well-known for his photographic books made in the 1960s and 1970s, boxes of pictures have been tucked away in his studio along with rarely seen or unpublished images, that suggest a far broader engagement with photography. To focus attention on these works may feel like a violation of what we have come to believe about the artist's use of the medium. If, however, we set aside previous notions of Ruscha's interaction with photography, and examine the full range of his photographic production, there is much to be learned about how the medium has served the artist's career as a whole.

DESIGN Lorraine Wild and Robert Ruehlman
. *Los Angeles, California*
ART DIRECTION Rachel Wixom
CREATIVE DIRECTION/
CURATOR Sylvia Wolf
. *New York, New York*
PUBLISHER Whitney Museum of American Art
PRINCIPAL TYPE Century Expanded, Cooper Black, and Trade Gothic
DIMENSIONS 8 x 11 IN. (20.3 x 27.9 CM)

STUDENT PROJECT

DESIGN David Wolske
. *Bloomington, Indiana*
INSTRUCTOR Paul Brown
SCHOOL Indiana University
PRINCIPAL TYPE Times and various wood type
DIMENSIONS 12.5 x 19 IN. (31.8 x 48.3 CM)

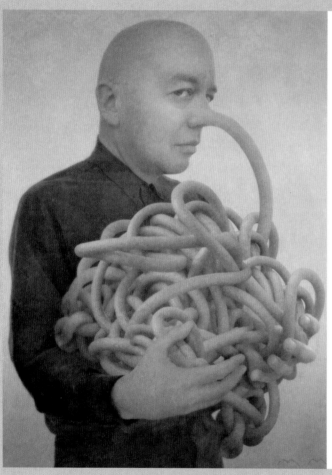

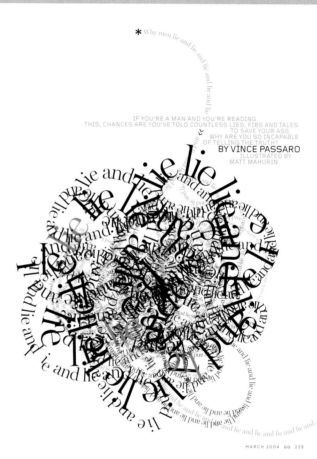

MAGAZINE SPREAD

DESIGN Sarah Viñas
. *New York, New York*
DESIGN DIRECTION Fred Woodward
ILLUSTRATION Matt Mahurin
PUBLICATION GQ
PRINCIPAL TYPE Miller
DIMENSIONS 15.6 x 11 IN. (39.6 x 27.9 CM)

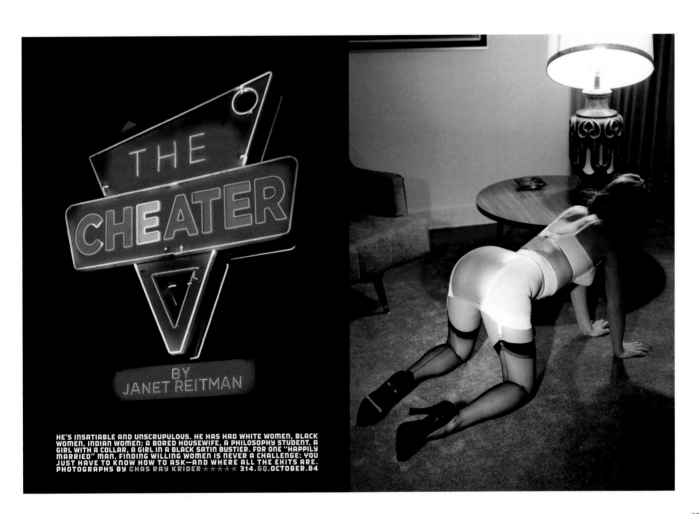

THE
CHEATER
BY
JANET REITMAN

HE'S INSATIABLE AND UNSCRUPULOUS. HE HAS HAD WHITE WOMEN, BLACK WOMEN, INDIAN WOMEN; A BORED HOUSEWIFE, A PHILOSOPHY STUDENT, A GIRL WITH A COLLAR, A GIRL IN A BLACK SATIN BUSTIER. FOR ONE "HAPPILY MARRIED" MAN, FINDING WILLING WOMEN IS NEVER A CHALLENGE: YOU JUST HAVE TO KNOW HOW TO ASK—AND WHERE ALL THE EXITS ARE. PHOTOGRAPHS BY CHAS RAY KRIDER ★★★★★ 314.GQ.OCTOBER.04

MAGAZINE

257

DESIGN Sarah Viñas
. *New York, New York*
DESIGN DIRECTION Fred Woodward
PHOTOGRAPHY Chas Ray Krider
PUBLICATION GQ
PRINCIPAL TYPE HTF Gotham
DIMENSIONS 15.6 x 11 IN. (39.6 x 27.9 CM)

Y

258 MAIN TITLE

DESIGN Harkim Chan
. *Hollywood, California*
ART DIRECTION Martin Surya
CREATIVE DIRECTION . . . Garson Yu
PRODUCER Jennifer Fong
PRODUCTION
COORDINATOR Ryan Robertson
VFX COMPOSITOR/
SUPERVISOR David Fogg
EDITOR Zachary Scheuren
3D ARTIST Chris Vincola
STORYBOARD ARTIST . . . Otto Tang
DESIGN STUDIO yU+co.
CLIENT Touchtone Pictures
PRINCIPAL TYPE Neue Helvetica and Times New Roman

&. Z

TDC² 2005

ሐC

LIBER

HED MONTHLY BY ERITREANS FOR

TDC² 2005
CHAIRMAN'S
STATEMENT

ERITREANS

THE JUDGES OF TDC² 2005

were concerned with the building blocks of typography. But any new typeface is not just a set of marks; it is part of the continuum of past and present written communication. The four judges—Rick Cusick, Cyrus Highsmith, Kris Holmes and Jean François Porchez—are part of the crosscurrents in contemporary typeface design. As a group they have wide experience and interest in typographic form. The jury considered the record-setting 165 entries, coming from 24 countries, appreciating the diversity and approaches to typography they represented.

In a single, concentrated day, nineteen winners from nine countries were selected but not without involved discussion. The work of the jury was to make sure that each design was first evaluated on its own terms—had the entrant fulfilled the task they had set themselves? A majority of those selected were display typefaces, a category that welcomes fresh interpretation. These ranged from freshly visualized single-case concepts to meticulously developed joining scripts. A few were brashly constructed, while their opposites used the more subtle vocabulary of handmade shapes.

Strikingly, the text and type system selections were equally diverse. These serif and sans serif faces tackled the longstanding requirements of type for lengthy reading, while encompassing multiple alphabets (such as Latin, Greek, and Cyrillic), referring to historical precedent or exploring frontiers in readability. The OpenType font format continued to gain acceptance and made possible the kind of freedom previously limited to hand-assembled lettering. Notably, the pi and ornamental category was filled by an important revival of expressive modernism. Taken together as a group, these wide-ranging choices reflect not just the efforts of the judges, but offer a glimpse into the typography of the future.

263

PETER BAIN, TDC² CHAIRMAN

hamburg

hamburg

PETER BAIN

Peter Bain is principal of Incipit, a firm whose practice is built upon letters. Incipit's work encompasses wordmarks, typeface design, handlettering, and typographic design. Clients such as Sony BMG Music have commissioned custom typefaces, while brand and identity consultants, publishers, advertising agencies, and others have requested distinctive letterforms and typography. His projects have been selected by the American Institute of Graphic Arts (AIGA), Type Directors Club (TDC), *Communication Arts*, and *Letter Arts Review*.

Bain's research into the era of phototype was presented in London at the St. Bride Printing Library Conference, and he co-curated the exhibition "Blackletter: Type and National Identity" at the Cooper Union School of Art in New York. He co-edited the companion monograph published by Princeton Architectural

HAMBURG

hamburg

hamburg

Press, and he has written and lectured on various aspects of typographic design.

Bain currently teaches digital lettering at Parsons School of Design, is a member of AIGA, American Printing History Association, Association Typographique Internationale (ATypI), and served on the board of directors for the Society of Scribes and TDC. Prior to founding Incipit, Bain was type director at Saatchi & Saatchi Advertising in New York for more than a decade.

265

TDC²
JUDGES

स्हिल

RICK CUSICK

Rick Cusick was born in Stockton, California, and began his professional life designing illuminated signs for Ad/Art, Inc., which provided much of the signage for casinos in Las Vegas, Lake Tahoe, and Reno. He studied lettering with James Lewis at San Joaquin Delta College and Mortimer Leach at Art Center College of Design. Cusick has worked for Hallmark in Kansas City since 1971 as a lettering artist and book designer, and is presently manager of font development there. In 1996 he designed the typeface Nyx for Adobe.

Cusick was design and editorial consultant to TBW Books of Woolwich, Maine, where he was responsible for *With Respect...to RFD*, a festschrift for Chicago calligrapher Raymond F. DaBoll; a collection of essays and calligraphy by the influential Reed College professor

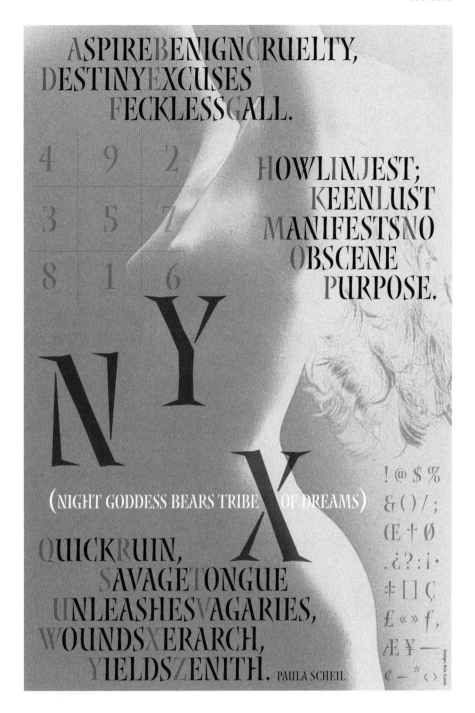

ASPIRE BENIGN CRUELTY, DESTINY EXCUSES FECKLESS GALL.

HOWL IN JEST; KEEN LUST MANIFESTS NO OBSCENE PURPOSE.

4 9 2
3 5 7
8 1 6

NYX

(NIGHT GODDESS BEARS TRIBE OF DREAMS)

QUICK RUIN, SAVAGE TONGUE UNLEASHES VAGARIES, WOUNDS XERARCH, YIELDS ZENITH. PAULA SCHEIL

! @ $ %
& () / ;
Œ † Ø
¿ ? : ¡ ·
‡ [] Ç
£ « » f,
Æ ¥ —
¢ – * ‹ ›

Design: Rick Cusick

Lloyd J. Reynolds; and *The Proverbial Bestiary*, featuring drawings by Warren Chappell with Cusick's calligraphy. He has taught at the University of Kansas and in 1992 began a ten-year stint as art director of *Letter Arts Review*. Cusick is also proprietor of Nyx Editions and a member of ATypI (Association Typographique Internationale), the American Printing History Association, and a corresponding (honorary) member of Bund Deutscher Buchkuenstler.

269

CONSTRUCTION
CONDENSED BLACK

Downtown Will Be Completely Demolished
COMPRESSED LIGHT

28 NEW BUILDINGS
REGULAR

Architects
COMPRESSED BOLD

I only hope I can still find my way home
LIGHT

EXITS
EXTENDED LIGHT

USED TO BE AROUND HERE SOMEWHERE
COMPRESSED BLACK

Structural
EXTENDED BLACK

THE BLUEPRINTS HAVE VANISHED
REGULAR

Permits Will Be Required
COMPRESSED REGULAR

APARTMENT RENTALS
EXTENDED REGULAR

Where is the door?
CONDENSED BOLD

AMENITY
BLACK

CYRUS HIGHSMITH

In 1997 Cyrus Highsmith graduated with honors from Rhode Island School of Design (RISD) and joined the Font Bureau. As senior designer, he concentrates on development of new typeseries. A faculty member at RISD, he teaches typography in the Graphic Design Department. He lectures and gives workshops across the United States, Mexico and Europe. In 2001 Highsmith was featured in *Print Magazine*'s New Visual Artist Review. His typefaces Prensa and Relay were among the winners at Bukva:Raz!, the international type design competition.

Highsmith's work has been exhibited in the United States and Europe, and his typefaces have been featured in *Martha Stewart Living*, *MensHealth*, *The Montreal Gazette* (Canada), the Spanish edition of *Playboy*, *Rolling Stone*, *The Source*, and *The Sunday Independent* (London). He has designed types

CRYSTAL GAZING

COMPRESSED BLACK

Live in the future, forget about the past

CONDENSED REGULAR ITALIC

MYSTERIOUS FORCES

BOLD

Palm readers

WIDE LIGHT

BLACK CATS KEEP CROSSING MY PATH

CONDENSED BLACK ITALIC

FUTURE

COMPRESSED BLACK

I am plagued by an ancient curse

LIGHT

WALKING THE EARTH

COMPRESSED MEDIUM ITALIC

No place to stop and rest

WIDE REGULAR

DOOMED FOR ETERNITY

CONDENSED BLACK

Old soothsayers warned me to be careful

REGULAR ITALIC

for *La Prensa Gráfica* (El Salvador) and *El Universal* (Mexico City). In 2002 Highsmith produced a new headline series for *The Wall Street Journal* that satisfied complex contemporary requirements while remaining within the traditional typographic character that distinguishes *The Journal*. The wide range of his work is important to Highsmith. He considers himself, above all, a draftsman.

271

MYRO'S PETS

ΑΚΡΙΔΙ ΤΑΙ ΚΑΤ ΑΡΟΥΡΑΝ ΑΗΔΟΝΙ, ΚΑΙ ΔΡΥΟΚΟΙΤΑΙ

ακριδι ται κατ αρουρας αηδ ρι δρυοκοιται

ΤΕΤΤΙΓΙ ΞΥΝΟΝ ΤΥΜΒΟΝ ΕΤΕΥΞΕ ΜΥΡΩ

τεττιγι ξυνος τυμβιος ετευξε μυρω,

ΠΑΡΘΕΝΙΟΝ ΣΤΑΞΑΣΑ ΚΟΡΑ ΔΑΚΡΥ ΔΙΣΣΑ ΓΑΡ ΑΥΤΑΣ

παρθενιος σταξ αο αλιο ρα δακρυδη σσ αρ αυ τας

ΠΑΙΓΝΙ Ο ΔΥΣΠΕΙΘΗΣ ΩΙΧΕΤ ΕΧΩΝ ΑΙΔΑΣ

παι γι ο δυσπειθης οι χετ εχ ως αιδας.

For her cricket, the nightingale of the fields,

and for her cicada that lived in the trees,

Myro made one grave, shedding the tears of a young girl;

for inexorable Hades had borne away both her pets.

Anyte, 300 B.C.

KRIS HOLMES

Kris Holmes is the president of Bigelow & Holmes Inc., a studio specializing in typeface design. Holmes began her study of letters with Lloyd Reynolds and Robert Palladino at Reed College and continued with Hermann Zapf at Rochester Institute of Technology and Ed Benguiat at the School of Visual Arts in New York. With her partner, Charles Bigelow, Holmes has designed over one hundred type-faces, including the Lucida Grande fonts for Apple Computer's OSX user interface, Lucida Console and Lucida Sans Unicode in Microsoft Windows, and the Lucida core fonts of Sun Microsystems Java development environment. Holmes authored Apple Chancery and Apple Textile, ITC Isadora, and Microsoft Wingdings and has contributed fonts to the free software movement.

In addition to Latin typefaces, Holmes has created complementary designs for Arabic,

POPOL WUJ

Are' uxe' Ojer Tzij

waral K'iche'ub'i'.

Waral xchiqatz'ib'aj wi,

xchiqatikib'a' wi Ojer Tzij.

This is the beginning of the Ancient Word

here in this place called Quiché.

Here we shall inscribe,

we shall implant the Ancient Word.

o o o o o o o o o

K'o nab'e wujil,

ojer tz'ib'am puch,

xa ewal uwach ilol re,

b'isol re.

There is the original book

and ancient writing,

but the one who reads and assesses it

has a hidden identity.

Cyrillic, Devanagari, Greek, Hebrew, and Thai scripts. Her work includes fonts for linguistics and mathematical and technical publishing and special designs for legibility research. More than 750 million copies of Holmes' typeface designs are in distribution from the world's major computer software and hardware manufacturers. Holmes is currently a graduate thesis student in the UCLA Animation Workshop.

273

K'iche' arrangement by Sam Colop. English translation by Dennis Tedlock.

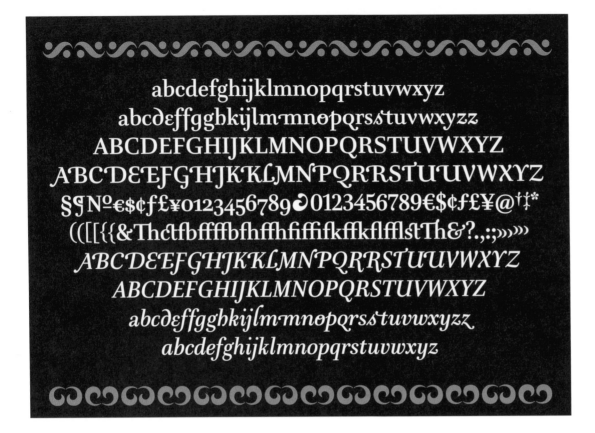

JEAN FRANÇOIS PORCHEZ

After training as a graphic designer, Jean François Porchez (born 1964) worked as type director at Dragon Rouge. By 1994 he had created a new typeface series for *Le Monde* in Paris. Today he designs custom typefaces for such companies as Costa Crocieres, France Télécom, Peugeot, and RATP (the public transport system in Paris), as well as distributing his retail typefaces internationally via his typo-fonderie.com website. For the Linotype Library Platinum Collection, he contributed a revival of Jan Tschichold's Sabon.

Porchez teaches at Ensad in France and is a visiting lecturer in the masters typeface design course at the University of Reading in the United Kingdom. He was president of the jury established by the Ministere de l'Éducation Nationale to select a new handwriting model and system for France. Porchez's publications include *Lettres*

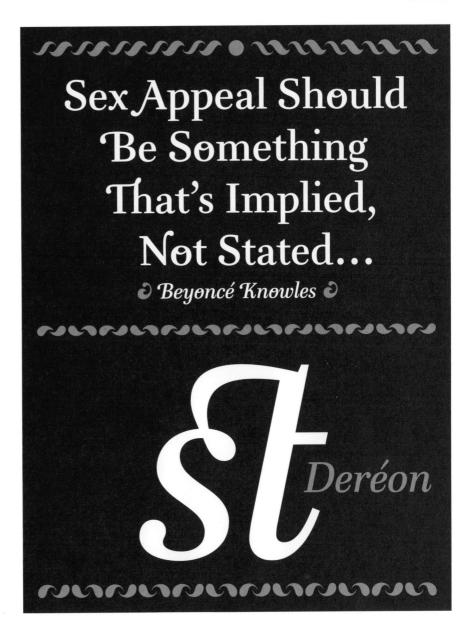

Sex Appeal Should Be Something That's Implied, Not Stated...
Beyoncé Knowles

st Deréon

Françaises, showing contemporary French digital typefaces. His awards include the Prix Charles Peignot in 1998, Morisawa for FF Angie in 1990 and for Apolline in 1993, and TDC2 for Costa in 2000. Ambroise, Anisette, Charente, Le Monde Journal, and Le Monde Courier were all prize-winning entries in the Bukva:Raz! international competition in 2001. He was elected president of ATypI (Association Typographique Internationale) in October 2004.

JUDGES'
CHOICES
& DESIGNERS'
STATEMENTS

XXVI Degustación del Vino de

Jerez

Unha tortilla de patacas e pementos de Padrón

¡Un Pincho de Atún!

y una copita de Rioja

Cafè amb llet

Designed by Laura Meseguer

* *

Whenever you need a playful type, use this new Spanish-flavored typeface family consisting of three fonts based on the same model but with different contrast, mood and construction. Rumba Small for texts, Rumba Large for headlines and Rumba Extra for big-size words.

RUMBA

TYPEFACE DESIGNER	. . . Laura Meseguer
.	*Barcelona, Spain*
TYPEFACE FAMILY Small, Large, and Extra

RICK CUSICK

The Rumba family appealed to me for its spirit and warmth and for the fact that it manages to retain a feeling of the artist's hand. The designer's unique approach to the idea of the font family might be more interesting than it is practical, but the results are interesting.

Rumba Small, inspired by the broad-pen, is very legible and particularly pleasing at small sizes. It would be effective for extended texts when something a little out of the ordinary, but still inviting, is desired.

Rumba Large, lighter in color than Rumba Small, owes its character to traces of the pointed pen. It might be a good alternative when a modern is called for, but the classic moderns in your library—either roman or italic—appear too rigid and cold.

Rumba Extra reminds me of the work of an idiosyncratic showcard artist. A few of the letters seem out of character with the rest, but they contribute to the idiosyncrasy, and I can easily imagine the typeface being used precisely for that reason. I hope the designer of the font will consider extending Rumba Extra to include a set of swash caps, beginning and ending characters, and perhaps some ligatures. These additions would reinforce the lively handlettered quality and expand the possibilities for users.

When viewed in context, each font in the Rumba family is successful for its stated purpose. And, while I might question the design of a few characters, most are nicely considered and exquisitely rendered.

DESIGNER LAURA MESEGUER

The Rumba family consists of three fonts: Rumba small for text, Rumba Large for headlines, and Rumba Extra for big-size words when a lettering flavor is desired. The basic concept behind the family bonds among these three fonts is that the relationship between fonts can be based on contrast, expressiveness, and use—not in the classical range of weights. These fonts go from roman to italic (in an upright version), from the broad nib to pointed pen model, and from high to extra-high contrast. I also outfitted Rumba with some particular features, such as old-style figures, alternative characters, and ligatures that appear where they are not expected.

This type has a lot of me in it, and it is the result of a process of development that meant a lot of hard work but that, in return, gave me back a lot of emotion and satisfaction.

馬鹿嫁さん。のお話

昔むかし、嫁にいく娘に親たちが、
「嫁にいったら猫のようにしているもんだ」
といった。娘は嫁入りした翌日、
親のいいつけを守り、さっそく早起きし、
るうすの上に、ちょこんとしゃがんでいた。
嫁入り先の親たちは、不思議に思い、
「そんなところに上がって、何してるんだ」と言った。
すると娘はなんと「ニャーン」とないたという。
馬鹿嫁さんのお話。

SHOUTENKAKU/SHOUTENMARU

TYPEFACE DESIGNER . . .	Yasushi Saikusa
.	*Tokyo, Japan*
FOUNDRY	Design Signal Inc.
CLIENT	Font 1000

JUDGE CYRUS HIGHSMITH

To find the winners, we judges had to look
at a lot of typefaces. And we had to talk
about them. And then look at them some
more. And on and on. It is rewarding, but it
also wears you out. Among all the typefaces
we looked at, Shoutenmaru and Shouten-
maku produced a unique reaction in me:
They made me want to run back to my of-
fice and draw. Their design is wonderful,
inventive, and imaginative. It energized me
on that very long day. I feel that the space
in which the typefaces exist extends beyond
what we can see in this character set. There
is a whole graphic universe that these marks
are a part of. And it looks like a really fun
and interesting place. That is why I choose
them as my judge's choice.

DESIGNER YASUSHI SAIKUSA

Being able to read a typeface is a prerequi-
site. But if it is just a thing that can be read,
there is no necessity for a new typeface. I
chose to represent the famous Japanese
comedy "Shouten" with these typefaces. I
wanted to create character in the typeface's
expression to make it very pleasant, even
funny. The smiling face asked to be pro-
duced, so I included it.

DB SANTIPAP

TYPEFACE DESIGNER . . .	Prinya R. Nont
.	*Bangkok, Thailand*
FOUNDRY	DB Designs Co., Ltd.
LANGUAGE	Thai

KRIS HOLMES

What struck me about DB SantiPap was how elegantly it distills the essence of a traditionally complex writing system into modern graphical geometry.

It doesn't distort traditional Thai letters into stiff, mechanical shapes but reinterprets their patterns of meaningful differences and similarities into a lively geometric idiom. Geometry serves the letters but does not rule them.

The result is a text image with warmth and wit but also logic and clarity. That combination immediately charmed me.

The individual shapes of DB SantiPap differ radically from the sensuous handwritten Thai letterforms, but in composition it immediately reminded me of the texture of traditional palm-leaf books, in which the writing is made by pressing an iron stylus into the soft fiber of palm leaves. DB SantiPap seemed to capture the ancient heart of Thai handwriting, while altering its outward appearance to make it effective in modern display and titling, both in print and on-line.

I also admired the craftsmanship, in which apparent simplicity is achieved by delicate treatment of all the details—terminal, joins, notches—resulting in more of an organic than a constructed look. It reminded me of flower seed pods and honeycombs. I thought it could be ardent in love letters, solemn in epitaphs, delightful in all uses.

PRINYA R. NONT

Defined by simple geometric shapes, the characters of Thai display type DB SantiPap emulate the appearance of Roman, Indian, Japanese, and other ancient scripts. When cast in a line, the characters create a look of glyphic text, which is a departure from conventional Thai alphabetic type designs. The name "SantiPap," which means "peace," reflects the harmonious coexistence of diverse cultures as suggested by the juxtaposition of the characters. This single-weight face is fashioned by DB Designs, a studio that has been involved in Thai type design since the early days of desktop publishing.

Terrible typists quivered

Laurence stepped outside

lit a CIGARETTE

& day-dreamed about

beer in Tahiti

Elementis

By Hans-Jürgen Ellenberger 2003–2004

ELEMENTIS

TYPEFACE DESIGNER . . . Hans-Jürgen Ellenberger
. *Hamburg, Germany*
FOUNDRY Linotype Library GmbH
TYPEFACE FAMILY Regular, Regular Small Caps, Light, Medium,
. and Bold

JEAN FRANÇOIS PORCHEZ

Designing a typeface family is acknowledged by many as a challenge, but I realize now that judging challenging typefaces is even more of a challenge. How, in a short amount of time, can we select 20 families, then chose one of them, when most of them take months, even years, to be designed?

Elementis is a typeface that shares some original forms and a bit of the usual standards. It's a family that seems to be a mono space with some references to typewriters fonts—not all the case, as the glyphs kept width modulation. Elementis is, in fact, a sort of nice combination of a typewriter font with fancy forms. Where some will see some reminiscence of typefaces like Souvenir and 70's style, I will answer that's why I like it. It's a family beyond trends, not a sans serif as we always see everywhere nowadays. When I learned that, in fact, Hans-Jürgen

Ellenberger started this design 30 years ago, I wasn't so surprised. The forms are built around a bit square circle, but the overall texture is quite roundish and friendly even with delightfully quirky glyphs. Perhaps the main problem with such families, sadly only available now in italic, is to find the right subject for it.

Learning recently that this family is not among the best sellers at Linotype, I can conclude that typeface designers don't look, in a certain context, at a typeface according to its final use, but as a final piece of art and achievement in itself. I say this based on how the designer played with forms, how he managed to mix various styles into one, etc. Finally, like any of my typeface designer colleagues when they have just finished a font, I hope, in the future, to be surprised by unexpected uses of it all over the world.

HANS-JÜRGEN ELLENBERGER

Hans-Jürgen Ellenberger dreamt up the initial concept for his design book in 1975 after wondering why most typewriter scripts appeared so cold and mechanical. Almost 25 years later, Ellenberger flushed out his alternative monospace family and digitized it, creating Elementis. The five-member-set letters display a delightfully quirky nature, lightening up the typewriter-

font genre. Although Elementis is primarily intended for use as a display face, it may also be used in short passages of text from 12 point on up.

고의 성능 , 최대의 만족을

에서 자신있게 추천해드리는 복사기

저의 가격으로 가장 좋은 복사기를

@ Wayne's got a crush on Miss Kramer. You act kind of funny when Rosemarie is here. Are you sweet on her? How are you, sweetie pie? It's so good to hug you!

ABCDEFGHIJKLMNOPQRSTUVWXYZ-_ (1234567890).,;:?!'''' ..." " « » & @
ES WAREN EINMAL ZWEI AMEISEN, DIE WOLLTEN NACH AUSTRALIEN REISEN. Doch bei Altona auf der Chaussee da taten ihnen die Füsse weh, und so verzichteten sie Weise auf den letzten Teil der Reise. Svegliatomi in affanno mi ha preso il desiderio e mi è bruciato dentro tutto il giorno, ma non volevo spegnerlo beato, restando a cuocermi nel forno. f f f f ff ffi ffl ffr fi fl fr v v v v v v v x x x z

signore e signora che ragazza! Arrivederci
Sig. & Sig.a che ragazza! Arrivederci

Arancio Bergamotto Corbezzolo Dattero Edera Ficus Giuggiolo
Hibiscus Iberis Jacaranta Kumquat Lentisco Multiflora
Nespolo Origano Pompelmo Quercia Ribes Sughera Timo
Ulivo Verbena Washingtonia Robusta Xanthium Yucca Zamia

DOLCE

TYPEFACE DESIGNER . . . Elena Albertoni
. Berlin, Germany

SUPER VELOZ

BARCELONA

MARIA

TYPOGRAPHY

LUPITA

Andreu Balius & Alex Trochut, from Joan Trochut (1920-1980) modular system originals

SUPER-VELOZ

TYPEFACE DESIGNERS . . . Andreu Balius and Alex Trochut
. *Barcelona, Spain*
FOUNDRY TypeRepublic
LANGUAGE Ornament system
TYPEFACE
FAMILY/SYSTEM Modular system with various groups of modules

Cinderella

Eleganza Fashions for him

Jordache Denim

ABCDEFGHIJKLMNOPQRSTUVWXYZ

abcdefghijklmnopqrstuvwxyz (0123456789) [$¢€¥f£ ¼½¾%]

{«¨ÆÇÐŁÑŒØ æçðłñœøıþ ~×+=<>@©&¡?}

ararraxcrdrererrexffbffififlfiflfrhriririrrixkrororrrrsstrururrux

ED SCRIPT

TYPEFACE DESIGNERS . . .	Ed Benguiat and Ken Barber
.	*New York, New York, and Yorklyn, Delaware*
FOUNDRY	House Industries

SONS OF THOR
Live Burlesque Show
KABLAM!
Good ol' Kentucky Shine

ABCDEFGHIJKLMNOPQRSTUVWXYZ (0123456789)
abcdefghijklmnopqrstuvwxyz [$¢€¥ƒ£ ¼½¾%]
{‹'ÆÇÐŁÑŒØæçdðłñœøíþ -×+=<>@©&!?}
acgkqrstuyffffiffififlfttt CGGGJKQRSU23569?$¢€£

ED GOTHIC

TYPEFACE DESIGNERS . . . Ed Benguiat and Ken Barber
. *New York*, *New York*, and *Yorklyn*, *Delaware*
FOUNDRY House Industries

←→↑↓↗↖↕↔

My sister tells me it was just an ordinary
evening, but evening is never ordinary is it?
På at springe ud af sig selv Mens kød
fyldes af orme Sollysets dunkle vand
Το θα και το να του θανάτου
Έτσι λοιπόν χωρέσανε
στα μάτια σου τόσες κοινές
HIJ GAAT OP WEG NAAR HET

ΑΒΓΔΕΖΗΘΙΪΚΛΜΝΞΟΠΡΣΤΥΫΦΧΨΩ
ΑΒΒΓΔΕΖΗΘΙΪΪΛΜΝΞΟΠΡΣΣΤΥΫΰΦΧΨΩ
αβγδεζηθιϊϊλμνξοπρςτυϋΰφχψω
АБВГДЕЖЗИКЛМНОПРСТУФХЦЧШ
ЩЪЫЬЭЮЯЃЂЄЅЁІЇЈЌЉЊЋЎЏЋӨV№
АБВГДЕЖЗИЙКЛМНОПРСТУФХЦЧШЩ
ЪЫЬЭЮЯЃҐЄЅЁІЇЈЍКЌЉЊЋЎЏЋӨV№
абвгдежзийклмнопрстуфхцчшщ
ъыьэюяѓҐєѕёӥϊjйкЌљњћўџђvɵ

ABCDEFGHIJKLMNOPQRSTUVWXYZ&@0123456789
ÀÁÂÃÄÅÅĄÆÆĆĈČĊÇĎĐÈÉÊËĒĔĖĘĜĞĠĢĤÌ
ABCDEFGHIJKLMNOPQRSTUVWXYZ&@0123456789ÀÁÂÃ
ÄÃÅÅĄÆÆĆĈČĊÇĎĐÈÉÊËĒĔĖĘĜĞĠĠĤĤÌÌÍÎÏĪĨĬİIıĴĶĹ
abcdefghijklmnopqrstuvwxyz⅛@0123456789àáâãä
āăåąæćĉčċçďđèéêëēĕėęĝĝğġħĥìíîïīĩĭịïĳĵķĺľļ·ń
ñ̃ňŋŋòóôõöōŏőøǿœþŕřŗśŝšşŝşţťŧùúûũūŭůűŷŵẁẃẅỳ
ýŷÿżźž#¤€\$£¥¢¶¤€,.:;…?¿Þ!i()[]{}/\|¦*•·†‡§°℮ℓ%
©℗®℠™@@ªºΔΩ∂∞≈ fi ff ffi fb fh fj ffk fl ft ćh čk čt ti tf tti

Noorden hij maakt een boek met zijn ogen
Я куколка, из которой рождается
Мои мозги сверкают и переливаются
Как цветок, ненасытный в любви

CALIBRI

TYPEFACE DESIGNER . . . Luc(as) de Groot
. *Berlin, Germany*
FOUNDRY Microsoft
LANGUAGE Latin, Greek, and Cyrillic
TYPEFACE FAMILY Regular, Italic, Bold, and Bold Italic

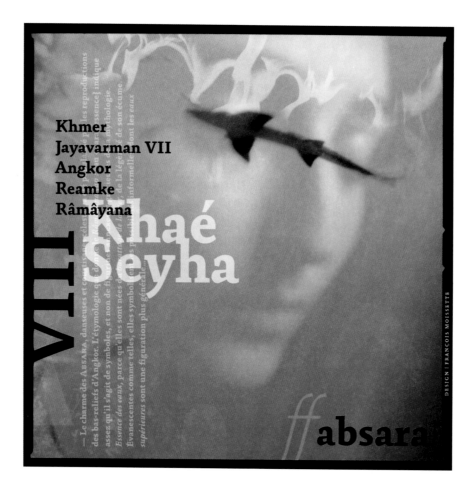

Khmer
Jayavarman VII
Angkor
Reamke
Râmâyana

FF Khaé Seyha

VIII

— Le charme des ABSARA, danseuses et créatrices célestes dont les reproductions des bas-reliefs d'Angkor. L'étymologie qu'en donne leur essence] indique assez qu'il s'agit de symboles, et non de figures sorties de la légende mythologique. Essence des eaux, parce qu'elles sont nées de l'écume de son écume. Évanescentes comme telles, elles symbolisent. Représentent] informelle sont les eaux supérieures sont une figuration plus générale.

ff absara

DESIGN | FRANÇOIS MOISSETTE

FF ABSARA

TYPEFACE DESIGNER . . .	Xavier Dupré
.	*Mercuer, France*
FOUNDRY	FontShop International
TYPEFACE FAMILY	Regular, Regular Italic, Regular Small Caps (SC),
.	Regular Italic SC, Medium, Medium Italic,
.	Medium SC, Medium Italic SC, Thin, Thin Italic,
.	Thin SC, Thin Italic SC Light, Light Italic, Light SC,
.	Light Italic SC, Bold, Bold Italic, Bold SC,
.	Bold Italic SC

1234567890.,:;!?(){}[]{}

SHIPFLAT

ABCDEFGHIJKLMN
OPQRSTUVWXYZ

"SLIDE & LOCK"

CARDBOARD

MANY STYLES IN MULTIPLE FINISHES

SHIPFLAT

TYPEFACE DESIGNER . . . Nicholas Felton
. New York, New York
FOUNDRY T-26

Corporate Typeface for a sports goods specialist.
With an alternative set of figures and icons.

0123456789 ABCDEFGHI
JKLMNOPQRSTUVWXYZ
abcdefghijklmnopqrstuv
wxyz

12,⁹⁰

Wieder ist, wie Du, lieber Max, wahrscheinlich bereits
festgestellt hast, ein Jahr vergangen, und ich weiß
nicht, ob es Dir so geht wie mir: allmählich wird mir
dieser ewigwährende Zyklus ein wenig leid, wozu ver-
schiedene Faktoren, deren Urheber ich in diesem Zu-
sammenhang, um mich keinen Unannehmlichkeiten,
deren Folgen, die in Kauf zu nehmen ich, der ich gern
Frieden halte, gezwungen wäre, nicht absehbar wären,
auszusetzen, nicht nennen möchte, beitragen.

0⁰1¹2²3³4 4⁵5⁶6⁷7 8⁸9⁹ €

SCHECK

TYPEFACE DESIGNER . . . Juergen Huber and Meta Design AG
. *Berlin, Germany*
TYPEFACE FAMILY/
SYSTEM Scheck-Slim and Scheck-Sale
CLIENT Sport Scheck GmbH

Minuscule.

A TYPEFACE FOR EXTREMELY SMALL SIZES, AVAILABLE IN FIVE VERSIONS, FROM SIX TO TWO POINTS.
THOMAS HUOT-MARCHAND, 256™, BESANÇON, FRANCE | www.256tm.com

MINUSCULE TROIS 4 pt. | 6 pt.

Since the limit for legibility is around seven points, the challenge to go beyond this point is important, at least for the cut of printing costs. Three methods are possible for that: to increase the x-height, in order to guarantee a good visibility for the significant parts of the letters; to optimize counters and letters spacing, in order to prevent inkspread in obtuse angles; to emphasize the differences between the characters, in order to limit confusion.

MINUSCULE DEUX 2 pt. | 4 pt.

THESE CHARACTERISTICS ARE PRESENT IN MINUSCULE, increasingly as the sizes reduce. In extremely small sizes, a work of formal simplification is necessary, in order to keep, in each sign, only what will allow us to distinguish one sign to another. At such scales, we mainly read the differences between letters.

Visible Legible

ABCDEFGHIJKLMN
OPQRSTUVWXY&Z
ABCDEFGHIJKLMN
OPQRSTUVWXYZ
abcdefghijklmnopq
rstuvwxyzæœàçéùö
123456789 | 0123456789
#´()*+,-./:;<=>!?¿¡@[\]‡®©™
¶º•ˆˇˉ˜ ≠«»_–—""'/‹›‡·%‰
{0123456789/0123456789}
½ ¼ ¾ ⅛ ⅜ ⅝ ⅞ ⅓ ⅔
↖↗↙↘↓↑←→ abdeilmorst
ÆŒØ§¥CE§ÀÁÂÃÄÅàáçéèê
ÈÊËÈÈÉEÉEGÔGÓGÒ₥ñílĺĺĺĺĺĺLĽĽĹŇÑÑÑÑ
ÑÓÒÔÕÖÕÒ₥RÀSŚŜŞŠŤŤÚÙÛÜÙÙ
ÒŴÝŶŶŻŽŽÐÞ₥CÐÀÁÂÃÄÅ₥EÈÉÊÌĹĺĹŃ
óòôõöôõÒ₥Ŷ?¼₥àáâãâåàₐₐæ¢ççčĉ
ɖéèêéëěēêɡfℓfℓ fff₥éèêŝħíĺĺĺĺĺkĺkĺĺin
ñ₥ñ₥Àₐ₥óòôõöôõóø₥ffſśŝşšıₐ₥rₗtₜ₥úùûúúúú
ùₐₐûₐₐŵÿ ÿÿżžₐƷƏ

MINUSCULE SIX	28 pt.	Typographie
MINUSCULE CINQ	28 pt.	Typographie
MINUSCULE QUATRE	28 pt.	Typographie
MINUSCULE TROIS	28 pt.	Typographie
MINUSCULE DEUX	28 pt.	Typographie

MINUSCULE

TYPEFACE DESIGNER	. . .	Thomas Huot-Marchand
.		*Besançon, France*
FOUNDRY	256™
TYPEFACE FAMILY	Minuscule Six, Minuscule Cinq, Minuscule Quatre,
.		Minuscule Trois, Minuscule Deux

abcdefghijklmnopqrstuvw
xyzABCƎƏEFGHIJKLMNO
PQRSTUVWXYZfiflß‹›‹›®
1234567890$¢£¥ƒ§¶∫†~
{[(!?,.:;/@#%&*©——""'')]}

áàâäãåçéèêëíìîïñóòôöõúùûüæÿøœ
ÄÅÇÑÖÆØÀÅÔŒÂÊÁËÈÍÎÏÌÓÔÒÚÛÙ

Bublik
Single; Display;
Latin; Original
www.paratype.com

BUBLIK

TYPEFACE DESIGNER . . . Oleg Karpinsky
. Moscow, Russia
FOUNDRY ParaType Inc.

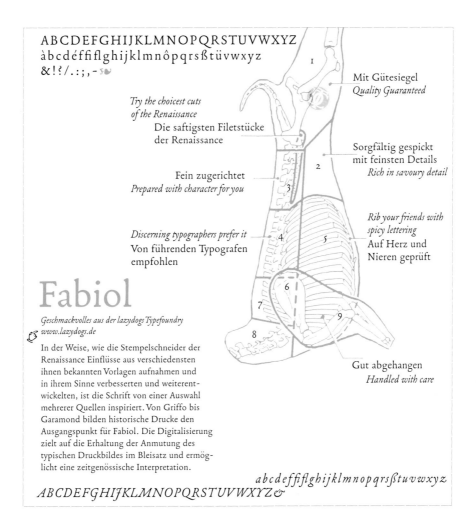

ABCDEFGHIJKLMNOPQRSTUVWXYZ
àbcdéffiflghijklmnôpqrsßtüvwxyz
&!?/.:;,-

*Try the choicest cuts
of the Renaissance*
Die saftigsten Filetstücke
der Renaissance

Mit Gütesiegel
Quality Guaranteed

Sorgfältig gespickt
mit feinsten Details
Rich in savoury detail

Fein zugerichtet
Prepared with character for you

Discerning typographers prefer it
Von führenden Typografen
empfohlen

*Rib your friends with
spicy lettering*
Auf Herz und
Nieren geprüft

Fabiol

*Geschmackvolles aus der lazydogs Typefoundry
www.lazydogs.de*

In der Weise, wie die Stempelschneider der
Renaissance Einflüsse aus verschiedensten
ihnen bekannten Vorlagen aufnahmen und
in ihrem Sinne verbesserten und weiterent-
wickelten, ist die Schrift von einer Auswahl
mehrerer Quellen inspiriert. Von Griffo bis
Garamond bilden historische Drucke den
Ausgangspunkt für Fabiol. Die Digitalisierung
zielt auf die Erhaltung der Anmutung des
typischen Druckbildes im Bleisatz und ermög-
licht eine zeitgenössische Interpretation.

Gut abgehangen
Handled with care

abcdeffiflghijklmnopqrsßtuvwxyz

ABCDEFGHIJKLMNOPQRSTUVWXYZ&

FABIOL

TYPEFACE DESIGNER	Robert Strauch
	Augsburg, Germany
FOUNDRY	Lazydogs
TYPEFACE FAMILY	Regular and Italic

A B C D E E
F G H I J K L L M
N O P Q R S
T T U V W
X Y & Z

abcdefghijklmnopqrstuvwxyzfifl
1234567890.,'' "";:!?
IVX

Pirouette Alternate and Ligature — *Pirouette Ornament*

PIROUETTE

TYPEFACE DESIGNER . . . Ryuichi Tateno
. *Tokyo, Japan*
FOUNDRY Linotype Library GmbH
TYPEFACE FAMILY Regular, Text, Alternates, Separate 1,
. Separate 2, and Ornaments

Auto

Underware

A triple-italic sans serif

Three numeral systems: non-lining figures, proportional lining figures and monospaced lining figures for all weights.

It is not recommended: but it happens.

YOU'RE EIGHT YEARS OLD AND YOU RIDE ON YOUR BICYCLE WITH HIGH SPEED.

No clue yet on issues of left and right,

you cross the street and you're under a car.

THE WHEELS MAKE A NOISE, BUT THEY DON'T HIT YOU.

Your head on the street, and the driver in shock.

A SCAR. LATER, HE BRINGS ORANGES TO YOUR BED. HE CARES.

His car is white, with chrome shining.

The bike was fine. I never asked if his car was.

Auto has three italics & an extended European character set for all weights. ✎ More info at: WWW.UNDERWARE.NL

AUTO

TYPEFACE DESIGNER	. . . Underware
.	*Den Haag, The Netherlands*
FOUNDRY Underware
TYPEFACE FAMILY Auto 1, Auto 2, and Auto 3 each with:
.	Light, Light Caps, Light Italic, Light Caps Italic,
.	Regular, Regular Caps, Regular Italic,
.	Regular Caps Italic, Bold, Bold Caps, Bold Italic,
.	Bold Caps Italic, Black, Black Caps, Black Italic,
.	Black Caps Italic

BETWEEN *the* GREEN HILLS
by THE SPRINGS OF THE RIVER NECHI
IN THE VALLEY *of* ABURRA
from THE NORTH *of*

Cerro de Quitasol

SETTLES *today* A BEAUTIFUL
VILLAGE *with* THE NICKNAME *of*
»CAPITAL DE LAS ORQUÍDEAS«

*Bello is a brush typeface for the headline point sizes
with automatic ligatures, start & ending swashes and other OpenType features.
A flourished script, some sturdy small caps, word-logotypes, ornaments…*

Further reading WWW.UNDERWARE.NL

BELLO

TYPEFACE DESIGNER . . . Underware
. *Den Haag, The Netherlands*
FOUNDRY Underware
TYPEFACE FAMILY Script, Small Caps, Ligatures, and Words

LO ENCONTRAMOS INTACT
O CUBIERTO POR LA MAL
EZA Y EL OLVIDO TRATA
MOS DE ENTRAR
PERO SUS
PUERTAS ESTABAN
BLOQUEADAS EL BUN
KER
ESTABA
MUERTO

WE FOUND IT INTACT
COVERED BY THE
UNDERGROWTH AND OBLIVION.
WE TRIED TO GET INSIDE
BUT THE DOORS WERE BLOCKED.
THE BUNKER WAS DEAD.

BUNKER

301

TYPEFACE DESIGNER . . . Leonardo Vazquez
. *Mexico City, Mexico*
FOUNDRY Mácizotype

ТОВА

ЛЯ ВАШЕГО-

СОБЛЮДАЙТ

COMP

FOR THE SAKE O

PRESERVE O

TDC2—1955

ИЩИ,

КЕ ЗДОРОВЬЯ

ЧИСТОТУ.

ES

YOUR HEALTH,

ANLINESS.

REPRODUCTION NOTES
Designer unknown. 8.5 x 10.9 IN. (21.5 x 27.8 CM), saddlestitched. All pages have been reduced 16.5% in order to show page trim. Interior pages were offset on Mohawk 70-pound Superfine Text. Cover stock is unknown. Interior pages were scanned at 600dpi grayscale, descreened, then scaled to reproduction size. Cover pages were scanned at 600dpi RGB, scaled to reproduction size, and converted to CMYK. *Additional information on the development of the TDC Competitions can be found on page 266 in Typography 23.*

THIS BOOK IS THE 51ST ANNUAL

of the Type Directors Club competition. The first competition, which grew from an annual series of lectures on typography in New York City, was held in 1954 for TDC members. The first catalog, reproduced in its entirety here, was introduced the next year when the competition was opened to all entrants. From 1955 to 1978, the competition catalog was produced as a relatively modest booklet. In 1979, after twenty-five years, the TDC Annual became a book. That explains why this Annual is called Typography 26 while this year's competition is called TDC 51.

Complete sets of early catalogs are extremely rare, so we have begun to reproduce each of them in their original form in this and future TDC Annuals. The following twenty-eight pages show that first catalog from 1955. Some pieces in it have become design icons of the 20th century. They may be found with better reproduction quality elsewhere, but this is more than a mere showing of winners. This catalog—and subsequent catalogs—represents the first time these works received awards of excellence. The catalogs are, as compilations of fine typography and design, remarkable documents.

TDC BOARD OF DIRECTORS

THE SECOND
ANNUAL AWARDS OF
TYPOGRAPHIC
DESIGN EXCELLENCE
MADE BY THE
TYPE DIRECTORS
CLUB OF
NEW YORK

TYPE DIRECTORS CLUB OF NEW YORK

The aim—to feature outstanding material in which typography was the predominant visual element.

The show demonstrated how type can provide impact and visual excitement in advertising and promotional material. The material selected showed that the typographic designer knows how to produce visual excitement where it is needed most. Although the material was entered by categories to try and cover as wide a range as possible, it was judged primarily for its impact, typographic qualities and visual excitement. Throughout the entire show the effects were achieved by the tasteful use of one or more of the following characteristics:

1. Contrast of size—extreme large letter forms used with small sizes creates visual excitement because our eye is accustomed to seeing reading matter without much contrast. Normal contrast in size is easy for the eye to see but extreme contrasts are unusual.

2. Contrast of direction—condensed faces create a vertical line while extended faces cause a horizontal movement.

3. Contrast of tone value—here again, extreme contrast is used to obtain a visual shock, something very black contrasting something very light sets up visual extremes.

4. Contrast of space—the blank space in contrast to the type elements is a subtle way to help achieve a visual shock.

5. Contrast of type forms—the use of a rigid, mechanical type such as a gothic used with a smooth flowing italic or script.

6. Contrast of color—large areas of dark value used with small quantities of brilliant color or the play of pastel shades in contrast to large areas of dark values. The over-printing of colors is a way to create visual shock.

7. Contrast of type with illustration—light illustrations used with dark areas of type and unusual integration of type with illustrations.

The panel of critics and judges included:
Mahlon A. Cline, *Chairman*
Aaron Burns (*Chairman of the TDC lecture series for 1956*)
Freeman Craw
Louis Dorfsman
Gene Federico
Edward Gottschall
Herbert Lubalin
Herbert Roan
William Taubin
Hal Zamboni

Folder by Herb Roan and Herb Lubalin (Sudler & Hennessey) for Wm. S. Merrell Company.

Announcement by Gene Federico for AIGA.

Booklet by Aaron Burns for Composing Room.

Announcement by Robert M. Jones for Glad Hand Press.

Booklet by Louis Dorfsman for CBS Radio.

307

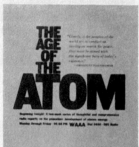

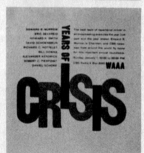

Small newspaper ads
for CBS Radio.

1955
1956

Greeting card by Peter Yang & James Ward

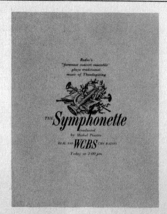

Libretto by Carl Fischer (Sudler & Hennessey) for RCA.

Newspaper ad by
Joe Schindelman
for CBS Radio.

Editorial Page by Arthur Paul
for Playboy Magazine.

Magazine advertisement by Louis
Danziger for the Kittleson Co.

Booklet by Irving Miller for CBS.

Program by Freeman Craw
for The Texas Company.

Booklet by Jerome Gould (Gould & Smith Assoc.) for Ford Motor Co.

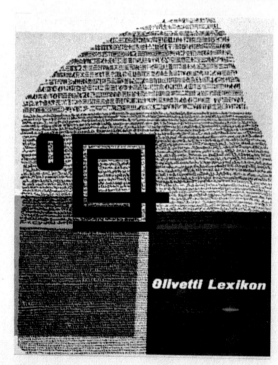
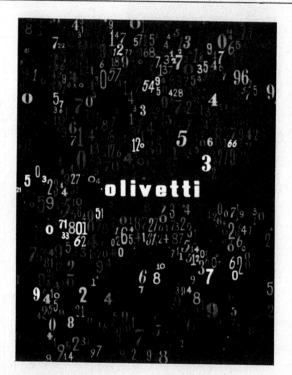

Folder printed by Davis-Delaney for Olivetti.

General practice aspects of Serpasil therapy in neuropsychiatry neurology and related fields

A REVIEW OF RECENT REPORTS

Perandren stronger sustained androgenic activity

Two self mailing folders and three cards by J. K. Fogelman for Ciba.

AROUND THE CLOCK REPLACE BARBITURATES WITH **Doriden**

sound sleep clear awakening! **Doriden**

New and different!

A rapid-acting nonbarbiturate hypnotic and sedative.

Rapid onset— 15 to 30 minutes. Moderate duration— 4 to 8 hours.

Doriden

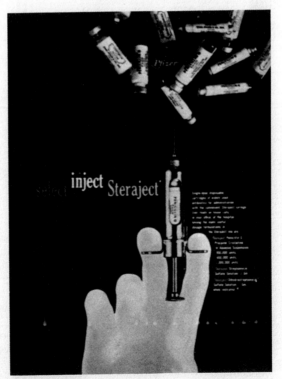

inject Steraject

Magazine ad by H & M Zelenko for Chas. Pfizer & Co.

SERPASIL-APRESOLINE

When blood pressure must come down SERPASIL-APRESOLINE

better response lower dosage fewer side effects.

Combined with Serpasil, Apresoline is effective in low dosage... thus, side effects such as headache and tachycardia seldom occur.

Newspaper ad by Herb Lubalin and J. K. Fogelman (Sudler & Hennessey) for Ciba.

311

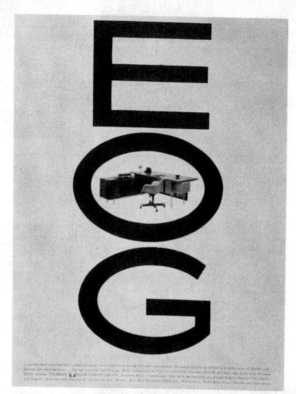

Magazine ad by George Nelson
(George Nelson Assoc.) for
Herman Miller Furniture Company.

Magazine ad by Herb Lubalin
for Sudler & Hennessey.

Newspaper ad series by Louis Dorfsman for CBS Radio.

Folder by Gene Federico
for Cinema 16.

Newspaper ad by Gene Federico
for L'Aiglon Apparel.

Magazine Cover and
three Section pages
by Bradbury Thompson
for Ford.

Folder by James Eng Associates
for Purdue Frederick Co.

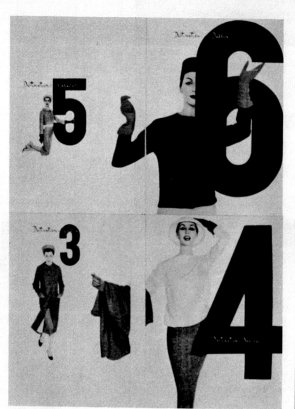

Editorial design by Alexey
Brodovitch for Harpers Bazaar.

Type specimens by
Robert M. Jones
for Glad Hand Press.

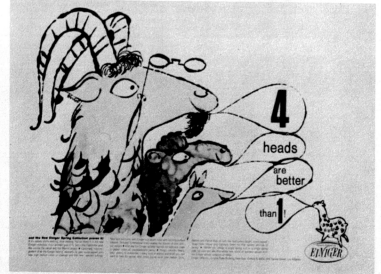

Newspaper ad by Gene Federico for Einiger Mills Inc.

Magazine ad by Glenn Foss for
Advertising Agencies' Service

Magazine ad by Herb Lubalin (Sudler &
Hennessey) for Wm. S. Merrell Co.

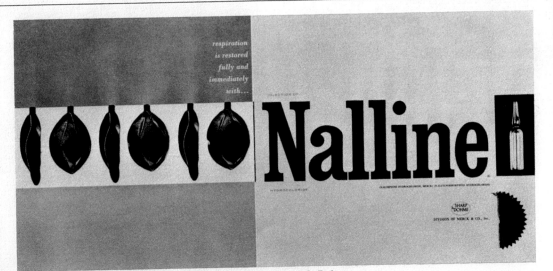

Folder by Herb Stricker (Sudler & Hennessey) for Sharp & Dohme.

315

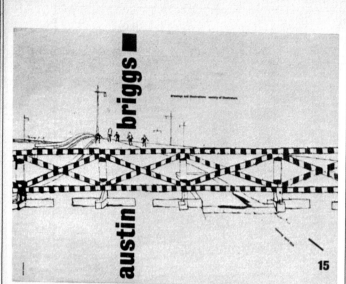

Exhibition announcement by Suren Ermoyan
(Lennen & Newell, Inc.) for Austin Briggs.

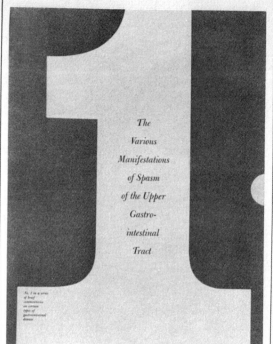

Direct Mail folder by Herb Lubalin
(Sudler & Hennessey) for Wm. S. Merrell Co.

Record Album cover by Herb
Lubalin, Bob Jones and
Carl Fischer (Sudler &
Hennessey) for
RCA Victor.

Brochure by Alvin Lustig
for Cushman & Wakefield.

Magazine ad by William Taubin for Robert Gage

Folder by Frank Wagner (Sudler & Hennessey) for The Upjohn Co.

Letterhead and announcements by Sylvester Brown for AGD.

Announcement by
Patrick Fitzgerald.

Program kit by John Graham and Herb Lubalin
(Sudler & Hennessey) for NBC.

Catalog by Herb Lubalin
for CBS-Columbia.

Booklet by Freeman Craw
for Municipal Art
Society of New York.

Magazine ad by William Taubin
for Ancient Age Dist. Co.

318

*Direct Mail card by
Mel Richman Studios
for Merck-Sharp & Dohme.*

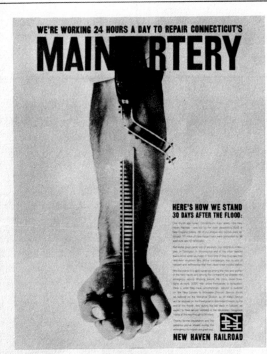

*Newspaper ad by William Taubin
for New Haven Railroad.*

*Letterheads (top three) by Louis Dorfsman and
Joe Schindleman for CBS Radio. Special bulletin
and photo release by Herb Lubalin (Sudler &
Hennessey) for CBS-Columbia.*

5
IDC
6/13-18
55
ASPEN

*Direct Mail card
by Louis Danziger
for IDC.*

*Letterhead and envelope
by Gene Federico for
William Helburn.*

*Announcement card
by Lester Beall.*

*Direct Mail card
by Gene Federico
for Warren Forma.*

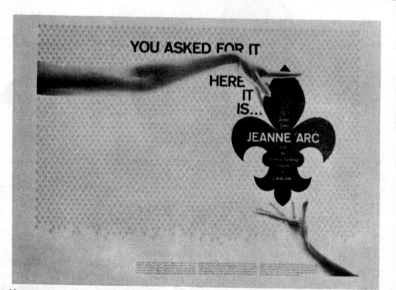

Newspaper ad by Gene Federico for L'Aiglon Apparel.

Booklet by Herb Meyers for Atlanta Paper Company.

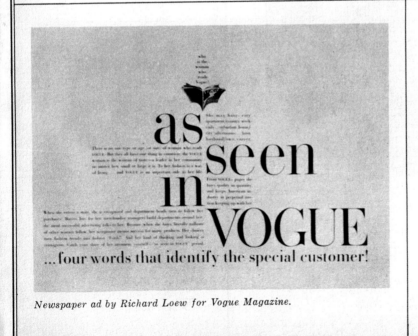

Newspaper ad by Richard Loew for Vogue Magazine.

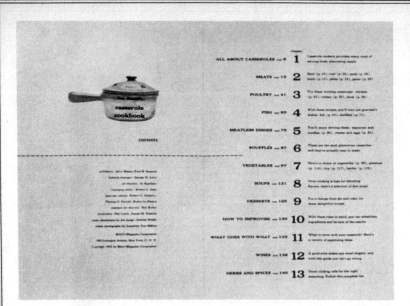

Editorial page by Al Squillage and Bob Keller for MACO Magazine Corp.

Package by H & M Zelenko for Doho Chemical Corp.

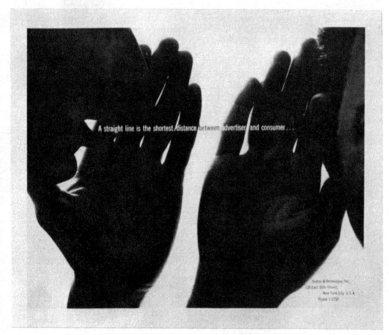

Magazine ad by Herb Lubalin for Sudler & Hennessey.

Folder by Robert M. Jones
for Glad Hand Press.

Folder by Saul Bass for Brett Lithographing Co.

Announcement by
Bob Gill for
Robert Gordon.

Inside cover pages by
Bradbury Thompson for Westvaco.

Folder by Mel Richman
Studios for Television
Association of Philadelphia.

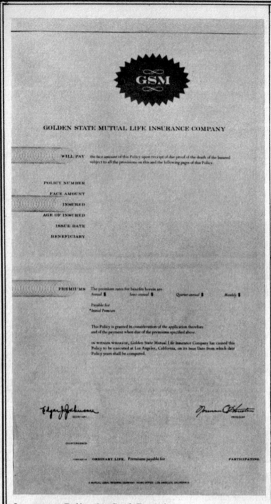

Insurance Policy by Saul Bass for
Golden State Mutual Life.

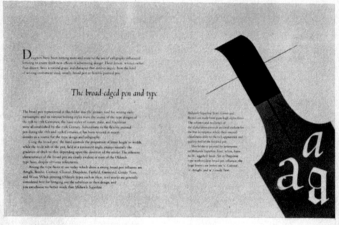

Folder by Freeman Craw
for Mohawk Paper Mills.

Promotion kit by Louis
Dorfsman for CBS Radio.

Cover by Fred
Wetzig for CBS Radio.

Letterhead and Envelope by Louis Danziger.

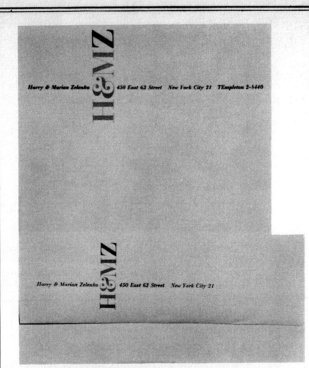

Letterhead and Envelope by H & M Zelenko.

BOB
GILL
47W
46ST
NYC
PL7-
6138

Letterhead by Bob Gill.

print
private
secretary
. . . .
CBS televitsiohn

TV slide by Bob Gill for CBS TV.

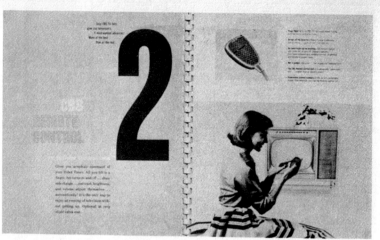

Catalog by Herb Lubalin (Sudler & Hennessey) for CBS.

Annual Report by Lester Beall for Torrington Manufacturing Company.

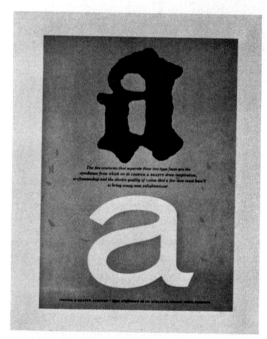

Magazine ad by Cooper & Beatty.

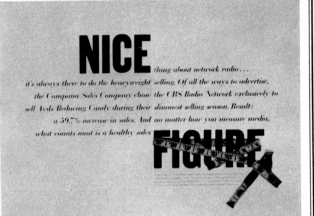

Direct Mail Booklet by Hap Smith (Dekovic-Smith Organization) for Harza Engineering Co.

(Above and below): Newspaper ads by Louis Dorfsman for CBS Radio.

Letterhead and Envelope by Gene Federico for Douglas D. Simon Advertising.

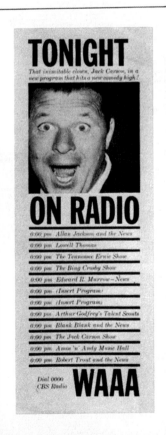

327

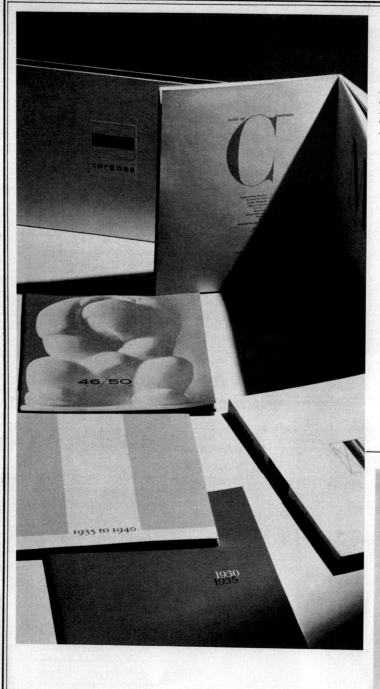

Slipcase and folders by Nat Super and
Seymour Robins, Gene Federico and
Lester Feldman, William Taubin
and Ernest Costa for 25th Anniversary,
Abraham Lincoln High School.

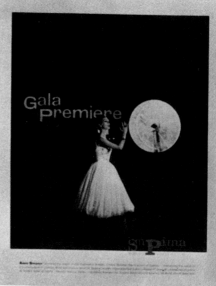

Magazine ad by Gene Federico
for Supima Association.

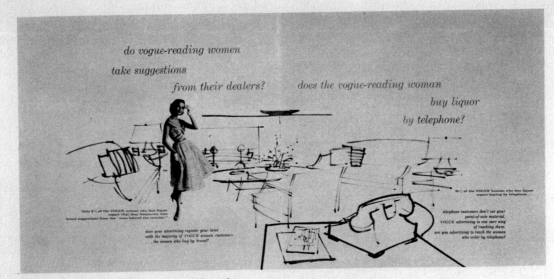

Booklet by Richard Loew for Vogue Magazine.

Folder by Ernest Costa for Lincoln Gallery.

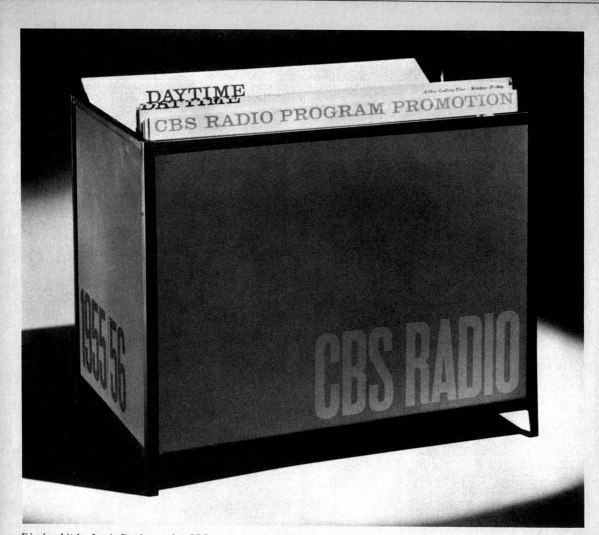

Display kit by Louis Dorfsman for CBS.

Printed by Offset on Mohawk 70# Superfine Text

Membership list

ARNOLD BANK
AMOS G. BETHKE
IRWIN L. BOGIN
BERNARD BRUSSEL-SMITH
AARON BURNS
BURTON CHERRY
TRAVIS CLIETT
MAHLON A. CLINE
FREEMAN CRAW
EUGENE DE LOPATECKI
ALFRED O. DICKMAN
LOUIS DORFSMAN
GENE DUNN
EUGENE M. ETTENBERG
GENE FEDERICO
SIDNEY FEINBERG
CHARLES J. FELTEN
BRUCE FITZGERALD
GLENN FOSS
VINCENT GIANNONE
LOUIS L. GLASSHEIM
WILLIAM P. GLEASON
EDWARD M. GOTTSCHALL
HOLLIS W. HOLLAND
HAROLD HORMAN
EDWARD N. JENKS
RANDOLPH R. KARCH
EMIL J. KLUMPP
EDWIN B. KOLSBY
ARTHUR B. LEE
CLIFTON LINE
GILLIS L. LONG
MELVIN LOOS
JOHN H. LORD
HERB LUBALIN
EDGAR J. MALECKI
FRANK MERRIMAN
ROSS MORRIS
TOBIAS MOSS
LOUIS A. MUSTO
ARIOSTO NARDOZZI
ALEXANDER NESBITT
GERARD J. O'NEILL
JERRY O'ROURKE
DR. G. W. OVINK
EUGENE P. PATTBERG
WILLIAM PENKALO
JAN VAN DER PLOEG
GEORGE A. PODORSON
FRANK E. POWERS
ERNEST REICHL
HERBERT ROAN
EDWARD RONDTHALER
FRANK ROSSI
GUSTAVE L. SAELENS
WILLIAM H. SCHULZE
JAMES SECREST
WILLIAM L. SEKULER
EDWIN W. SHAAR
HERBERT STOLTZ
WILLIAM A. STREEVER
DAVID B. TASLER
WILLIAM TAUBIN
GEORGE F. TENHOLM
ABRAHAM A. VERSH
MEYER WAGMAN
STEVENS L. WATTS
JOSEPH L. WEILER
HERMANN ZAPF
HAL ZAMBONI
MILTON K. ZUDECK

Sustaining Members

ADVERTISING AGENCIES SERVICE COMPANY INC.
THE COMPOSING ROOM INC.
ELECTROGRAPHIC CORPORATION
SUPERIOR TYPOGRAPHY INC.
WESCOTT AND THOMSON INC.
TUDOR TYPOGRAPHERS
ATLANTIC ELECTROTYPE & STEREOTYPE COMPANY
STERLING ENGRAVING COMPANY

...ພຽງມະຄອນບວງຈັນ

...ງ ທາດຂາຍພ້ອງ

ສ.ປ.ປ...

ສວນວັດທະນາທ...

XIENGKUANE BU...

ບັດກ້ອງຖ່າຍຮູ...

CAMERA & VDO...

№ 3019...

ລາຄາ 2.00...

PRICE

.........../..........

TDC
OFFICERS
& MEMBERS

BOARD OF DIRECTORS 2004/2005
OFFICERS

PRESIDENT	Gary Munch	*Munchfonts*
VICE PRESIDENT	Alex W. White	*AWVC*
SECRETARY/TREASURER	Charles Nix.	*Scott & Nix, Inc.*
DIRECTORS-AT-LARGE	Christopher Andreola	*adcStudio*
	Nana Kobayashi.	*Foote Cone Belding*
	Ted Mauseth	*Mauseth Design LLC*
	Susan L. Mitchell	*Farrar Straus & Giroux*
	Ilene Strizver.	*The Type Studio*
	Diego Vainesman	*MJM Creative Services*
	Maxim Zhukov	
CHAIRMAN OF THE BOARD	James Montalbano	*Terminal Design, Inc.*
EXECUTIVE DIRECTOR.	Carol Wahler	

BOARD OF DIRECTORS 2005/2006
OFFICERS

PRESIDENT	Gary Munch	*Munchfonts*
VICE PRESIDENT	Alex W. White	*AWVC*
SECRETARY/TREASURER	Charles Nix.	*Scott & Nix, Inc.*
DIRECTORS-AT-LARGE	Christopher Andreola	*adcStudio*
	Matteo Bologna	*Mucca Design*
	Graham Clifford.	*Graham Clifford Design*
	Susan L. Mitchell	*Farrar Straus & Giroux*
	Ted Mauseth	*Mauseth Design LLC*
	Diego Vainesman	*MJM Creative Services*
	Maxim Zhukov	
CHAIRMAN OF THE BOARD	James Montalbano	*Terminal Design, Inc.*
EXECUTIVE DIRECTOR.	Carol Wahler	

334 COMMITTEE FOR TDC51 AND TDC² 2005

CHAIRMEN.	Charles Nix and Peter Bain
COORDINATOR	Carol Wahler
ASSISTANTS TO JUDGES	Dale Allarde, Chris Andreola, Misha Beletsky, Lilian Citron,
	Fabio Costa, Christopher Fynn, Deborah Gonet,
	Elinor Holland, Paula Kelly, Nana Kobayashi, Julianna Lee,
	Ted Mauseth, James Montalbano, Omar Mvra, Gary Munch,
	Eric Neuner, Alexa Nosal, Daniel Pelavin, Peter Roth,
	Shinobu Sato, Diego Vainesman, Allan R. Wahler, Alex W. White,
	and Maxim Zhukov

TYPE DIRECTORS CLUB PRESIDENTS

Frank Powers	1946, 1947
Milton Zudeck	1948
Alfred Dickman	1949
Joseph Weiler	1950
James Secrest	1951, 1952, 1953
Gustave Saelens	1954, 1955
Arthur Lee	1956, 1957
Martin Connell	1958
James Secrest	1959, 1960
Frank Powers	1961, 1962
Milton Zudeck	1963, 1964
Gene Ettenberg	1965, 1966
Edward Gottschall	1967, 1968
Saadyah Maximon	1969
Louis Lepis	1970, 1971
Gerard O'Neill	1972, 1973
Zoltan Kiss	1974, 1975
Roy Zucca	1976, 1977
William Streever	1978, 1979
Bonnie Hazelton	1980, 1981
Jack George Tauss	1982, 1983
Klaus F. Schmidt	1984, 1985
John Luke	1986, 1987
Jack Odette	1988, 1989
Ed Benguiat	1990, 1991
Allan Haley	1992, 1993
B. Martin Pedersen	1994, 1995
Mara Kurtz	1996, 1997
Mark Solsburg	1998, 1999
Daniel Pelavin	2000, 2001
James Montalbano	2002, 2003
Gary Munch	2004, 2005

TDC MEDAL RECIPIENTS

Hermann Zapf	1967
R. Hunter Middleton	1968
Frank Powers	1971
Dr. Robert Leslie	1972
Edward Rondthaler	1975
Arnold Bank	1979
Georg Trump	1982
Paul Standard	1983
Herb Lubalin	1984
	posthumously
Paul Rand	1984
Aaron Burns	1985
Bradbury Thompson	1986
Adrian Frutiger	1987
Freeman Craw	1988
Ed Benguiat	1989
Gene Federico	1991
Lou Dorfsman	1995
Matthew Carter	1997
Rolling Stone magazine	1997
Colin Brignall	2000
Günter Gerhard Lange	2000
Martin Solomon	2003

SPECIAL CITATIONS TO TDC MEMBERS

Edward Gottschall	1955
Freeman Craw	1968
James Secrest	1974
Olaf Leu	1984, 1990
William Streever	1984
Klaus F. Schmidt	1985
John Luke	1987
Jack Odette	1989

2005 SCHOLARSHIP RECIPIENTS

Catalina Garcia	*School of Visual Arts*
Rachel Ann Hardy	*East Carolina University*
Jillian Harris	*Parsons School of Design*
William Hayden	*Pratt Institute*
Aleksi Jalonen	*Lahti Polytechnic Institute of Design*
Jee-Eun Lee	*Fashion Institute of Technology*
Roy Rub	*The Cooper Union*

2006 STUDENT AWARD WINNERS

First Place ($500)	Lauren Monchik *School of Visual Arts*
Second Place ($300)	Min K. Lew *Yale School of Art*
Third Place ($200)	Anna Ostrovskaya *School of Visual Arts*

INTERNATIONAL LIAISON CHAIRPERSONS

ENGLAND	David Farey *HouseStyle* 27 Chestnut Drive Bexleyheath Kent DA7 4EW
FRANCE	Christopher Dubber *Signum Art* 94, Avenue Victor Hugo 94100 St Maur Des Fosses
GERMANY	Bertram Schmidt-Friderichs *Verlag Hermann Schmidt* Mainz GmbH & Co. Robert Koch Strasse 8 Postfach 42 07 28 55129 Mainz Hechtsheim
JAPAN	Zempaku Suzuki *Japan Typography Association* Sanukin Bldg. 5 Fl. 1-7-10 Nihonbashi-honcho Chuo-ku, Toyko 104-0041
MEXICO	Prof. Felix Beltran Apartado de Correos M 10733 Mexico 06000
SOUTH AMERICA	Diego Vainesman 181 East 93 Street, Apt. 4E New York, NY 10128
SWITZERLAND	Erich Alb P. O. Box 5334 CH 6330 Cham
VIETNAM	Richard Moore 21 Bond Street New York, NY 10012

TYPE DIRECTORS CLUB

ADDRESS	127 West 25 Street, 8th Floor New York, NY 10001
TELEPHONE	212-633-8943
FAX	212-633-8944
E-MAIL	director@tdc.org
WEB	www.tdc.org
EXECUTIVE DIRECTOR	Carol Wahler

For membership information please contact the Type Directors Club office.

335

MEMBERS

Agnes Laygo Gregorio	'01
Simon Grendene	'02s
James Grieshaber	'96
Amelia Grohman	'02s
Rosanne Guararra	'92
Ivan Guarini	'01
Christiane Gude	'97
Ramiz Guseynov	'04
Olga Gutierrez de la Roza	'95
Einar Gylfason	'95
Peter Gyllan	'97
Tomi Haaparanta	'01
Brock Haldeman	'02
Allan Haley	'78
Debra Hall	'96
Stéphane Halmai-Voisard	'03s
Angelica Hamann	'03
Dawn Hancock	'03
Graham Hanson	'04
Egil Haraldsen	'00
Keith Harris	'98
Knut Hartmann	'85
Lukas Hartmann	'03
Williams Hastings	'05s
Randy Hawke	'04
Diane Hawkins	'04
Bonnie Hazelton	'75
Amy Hecht	'01
Eric Heiman	'02
Arne Heine	'00
Hayes Henderson	'03
Rebecca Henretta	'05s
Bosco Hernandez	'05
Earl M. Herrick	'96
Ralf Hermannn	'02s
Klaus Hesse	'95
Darren Hewitson	'05s
Fons M. Hickmann	'96
Jay Higgins	'88
Cheryl Hills	'02s
Helmut Himmler	'96
Kit Hinrichs	'04
Norihiko Hirata	'96
Charles Ho	'03
Michael Hodgson	'89
Ashley Hofman	'04
Fritz Hofrichter	'80
David Hollingsworth	'03a
Patrick Hornung	'02s
Kevin Horvath	'87
Fabian Hotz	'01
Diana Hrisinko	'01
Michael Hrupeck	'02
Anton Huber	'01
John Hudson	'04
Marilyn Hurey	'03s
Mariko Iizuka	'05
Anthony Inciong	'02
Yanek Iontef	'00
Alexander Isley	'05
Donald Jackson **	'78
Ed Jacobus	'03
Angela Jaeger	'02
Michael Jager	'94

Torsten Jahnke	'02
Mark Jamra	'99
Christopher Jankoski	'04s
Anna Jesse	'04s
Jenny Ji	'04s
Maria Johansson	'03
Frank Jonen	'03
Giovanni Jubert	'04s
William Jurewicz	'04
John Kallio	'96
Tai-Keung Kan	'97
Won Suk Kang	'02s
I-Ching Kao	'02s
Richard Kegler	'02
Brunnette Kenan	'99
Maureen Kenny	'04
Deny Khoung	'04s
Satohiro Kikutake	'02
Jang Hoon Kim	'97s
Yeon Jung Kim	'05
Rick King	'93
Robert King	'04s
Katsuhiro Kinoshita	'04
Nathalie Kirsheh	'04
Rhinnan Kith	'01s
Alicia Marie Knox	'05
Akira Kobayashi	'99
Nana Kobayashi	'94
Claus Koch	'96
Boris Kochan	'02
Masayoshi Kodaira	'02
Jesse Taylor Koechling	'98s
Eileen Koehler	'03s
Jonny Kofoed	'05
Steve Kopec	'74
Anders Kornestedt	'02
Damian Kowal	'05
Marcus Kraus	'97
Matthias Kraus	'02
Stephanie Kreber	'01
Bernhard J. Kress	'63
Gregor Krisztian	'05
Nicholas Kroeker	'03
Toshiyuki Kudo	'00
Larry Kulp	'02s
Felix Kunkler	'01
Christian Kunnert	'97
Dominik Kyeck	'02
Gerry L'Orange	'91
Raymond F. Laccetti	'87
Melchior Lamy	'01
John Langdon	'93
Guenter Gerhard Lange	'83
Jean Larcher	'01
Yvon Laroche	'04
Jessica Lasher	'03
Marcia Lausen	'05
Christine Lee	'02s
Julianna Lee	'04
Jennifer Lee-Temple	'03
David Lemon	'95
Olaf Leu	'65
Howard Levine	'05
Laura Lindgren	'05

Jan Lindquist	'01
Christine Linnehan-Sununu	'04
Domenic Lippa	'04
Wally Littman	'60
Uwe Loesch	'96
Oliver Lohrengel	'04
John Howland Lord *	'47
Christopher Lozos	'05
Alexander Luckow	'94
Frank Luedicke	'99
Gregg Lukasiewicz	'90
Elizabeth MacFarlane	'03s
Danusch Mahmoudi	'01
Boris Mahovac	'04
Bryan Mamaril	'04s
Donna Meadows Manier	'99
Joe Mann	'04
Marilyn Marcus	'79
Jewels Marhold	'03s
Peter Markatos	'03s
Erica Marks	'04s
Nicolas Markwald	'02s
Gabriel Meave Martinez	'01
Magui Martinez-Pena	'05
Christopher Masonga	'03s
Ted Mauseth	'01
Andreas Maxbauer	'95
Loie Maxwell	'04
Trevett McCandliss	'04
Rod McDonald	'95
Mark McGarry	'02
John McGrew	'01
Joshua McGrew	'05s
Kelly McMurray	'03
Marc A. Meadows	'96
Pablo Medina	'04
Matevz Medja	'02
Roland Mehler	'92
Uwe Melichar	'00
Bob Mellett	'03s
Francesa Messina	'01
Frédéric Metz	'85
JD Michaels	'03
Tony Mikolajczyk	'97
Joe Miller	'02
Ron Miller	'02
John Milligan	'78
Elena Miranda	'05
Michael Miranda	'84
Ralf Mischnick	'98
Can Misirlioglu	'03s
Susan L. Mitchell	'96
Bernd Moellenstaedt	'01
Sakol Mongkolkasetarin	'95
Stephanie Mongon	'05s
James Montalbano	'93
Chemi Montes-Armenteros	'03
Richard Earl Moore	'82
Minoru Morita	'75
Michael Morris	'04
Jimmy Moss	'04
Clark Most III	'04
Lars Müller	'97
Joachim Müller-Lancé	'95

337

Gary Munch	'97
Christopher Muñiz	'03
Matthew Munoz	'02s
Claire Murphy	'05
Jerry King Musser	'88
Louis A. Musto	'65
Steven Mykolyn	'03
Margo Nelson	'04
Cristiana Neri-Downey	'97
Helmut Ness	'99
Nina Neusitzer	'03s
Robert Newman	'96
Vincent Ng	'04
Charles Nix	'00
Shuichi Nogami	'97
Gertrud Nolte	'01s
Alexa Nosal	'87
David O'Connor	'04
Jack Odette	'77
Robb Ogle	'04
Akio Okumara	'96
Robson Oliveira	'02
Jourdanet Olivier	'05
Toshihiro Onimaru	'03
Almir Otajagic	'05s
Petra Cerne Oven	'02s
Robert Overholtzer	'94
Ryan Pace	'04s
Michael Pacey	'01
Jesse Packer	'04
Norman Paege	'99
Frank Paganucci	'85
Amy Papaelias	'05s
Enrique Pardo	'99
Jesse Parker	'04s
Jim Parkinson	'94
Guy Pask	'97
Gudrun Pawelke	'96
Lauren Payne	'04
Harry Pearce	'04
Daniel Pelavin	'92
Triveni Perera	'02s
Giorgio Pesce	'05
Steve Peter	'04
Oanh Pham-Phu	'96
Jennifer Phillips	'04s
Ken Phillips	'99
Max Phillips	'00
David Philpott	'04
Clive Piercy	'96
Ian Pilbeam	'99
Michael James Pinto	'05
Bernhard Pompey	'04s
Albert-Jan Pool	'00
Will Powers	'89
Nicole Powlowski	'05s
Vittorio Prina	'88
James Propp	'97
Jochen Raedeker	'00
Erwin Raith	'67
Sal Randazzo	'00
Bob Rauchman	'97
Robynne Raye	'05
Ariana Reaven	'03s
Heather L. Reitze	'01
Renee Renfrow	'04
Fabian Richter	'01
Claudia Riedel	'04s
Helge Dirk Rieder	'03
Robert Rindler	'95
Tobias Rink	'02
Phillip Ritzenberg	'97
Jose Rivera	'01
Chad Roberts	'01
Phoebe Robinson	'02
Luis Roca	'05
Frank Rocholl	'99
Salvador Romero	'93
Edward Rondthaler*	'47
Kurt Roscoe	'93
Giovanni Carrieri Russo	'03
Jennifer Russo	'04
Erkki Ruuhinen	'86
Timothy J. Ryan	'96
Carol-Anne Ryce-Paul	'01s
Michael Rylander	'93
Greg Sadowski	'01
Gus Saelens	'50
Jonathan Sainsbury	'05
Mamoun Sakkal	'04
Ilja Sallacz	'99
David Saltman	'66
Ina Saltz	'96
Rodrigo Sanchez	'96
Michihito Sasaki	'03
Shinobu Sato	'04s
Nathan Savage	'01
John Sayles	'95
David Saylor	'96
Hartmut Schaarschmidt	'01
David Schimmel	'03
Peter Schlief	'00s
Hermann J. Schlieper	'87
Holger Schmidhuber	'99
Hermann Schmidt	'83
Klaus Schmidt	'59
Markus Schmidt	'93
Christian Marc Schmidt	'02s
Bertram Schmidt-Friderichs	'89
Guido Schneider	'03
Werner Schneider	'87
Markus Schroeppel	'03
Eileen Hedy Schultz	'85
Eckehart Schumacher-Gebler	'85
Alan Schutte	'04
Peter Scott	'02
Leslie Segal	'03
Todd Seipert	'04s
Jason Seldon	'05s
Enrico Sempi	'97
Ronald Sequeira	'04s
Thomas Serres	'04
Li Shaobo	'04
Paul Shaw	'87
Elizabeth Sheehan	'03
W. Douglas Sherman, Jr.	'04
Hyewon Shin	'03s
Ginger Shore	'03
Philip Shore, Jr.	'92
Derek Shumate	'05s
Robert Siegmund	'01s
France Simard	'03
Mark Simkins	'92
Scott Simmons	'94
Leila Singleton	'04
Finn Sködt	'00
Martha Skogen	'99
Jamie Slomski	'04
Sarah Smith	'05
Steve Snider	'04
Silvestre Segarra Soler	'95
Martin Solomon	'55
Jan Solpera	'85
Mark Solsburg	'04
Irmgard Sonnen	'05
Ronnie Tan Soo Chye	'88
Brian Sooy	'98
Erik Spiekermann	'88
Denise Spirito	'02
Christoph Staehli	'05
Frank Stahlberg	'00
Rolf Staudt	'84
Dmitrios Stefanidis	'04s
Olaf Stein	'96
Notburga Stelzer	'02
Charles Stewart	'92
Clifford Stoltze	'03
Sumner Stone	'05
Peter Storch	'03
Lorna Stovall	'05
William Streever	'50
Jim Stringer	'03
Ilene Strizver	'88
Alison Stuerman	'04s
Hansjorg Stulle	'87
Mine Suda	'04s
Derek Sussner	'05
Zempaku Suzuki	'92
Caroline Szeto	'02s
Laurie Szujewska	'95
Barbara Taff	'05
Douglas Tait	'98
Yukichi Takada	'95
Yoshimaru Takahashi	'96
Milack Talia	'01s
Katsumi Tamura	'03
Jack Tauss	'75
Pat Taylor	'85
Rob Taylor	'04
Anthony J. Teano	'62
Marcel Teine	'03
Régine Thienhaus	'96
Wayne Tidswell	'96
Eric Tilley	'95
Colin Tillyer	'97
Siung Tjia	'03
Alexander Tochilovsky	'05
Laura Tolkow	'96
Jack Tom	'05
Klemen Tominsek	'05s
Jakob Trollbäck	'04
Klaus Trommer	'99

Niklaus Troxler	'00
Minao Tsukada	'00
Marc Tulke	'00
François Turcotte	'99
Michael Tutino	'96
Anne Twomey	'05
Andreas Uebele	'02
Thomas Gerard Uhlein	'05
Diego Vainesman	'91
Patrick Valleé	'99
Christine Van Bree	'98
Jan Van Der Ploeg	'52
Janine Vangool	'01
Jeefrey Vanlerberghe	'05
Yuri Vargas	'99
Thomas Vasquez	'04
Brady Vest	'05
Barbara Vick	'04
Anna Villano	'99s
Robert Villanueva	'02s
Prasart Virakul	'05
Adam Vohlidka	'02s
Matthew Vohlidka	'02s
Edwin Vollenbergh	'04
Annette von Brandis	'96
Thilo von Debschitz	'95
Alex Voss	'98
Frank Wagner	'94
Oliver Wagner	'01

Allan R. Wahler	'98
Jurek Wajdowicz	'80
Sergio Waksman	'96
Garth Walker	'92
Min Wang	'02
Katsunori Watanabe	'01
Harald Weber	'99
Kim Chun Wei	'02
Kurt Weidemann	'66
Claus F. Weidmueller	'97
Sylvia Weimer	'01
Ramon Wengren	'02
Marco Wenzel	'02
Sharon Werner	'04
Judy Wert	'96
Alex W. White	'93
Christopher Wiehl	'03
Heinz Wild	'96
Richard Wilde	'93
K. Wilder	'04
James Williams	'88
Steve Williams	'05
Grant Windridge	'00
Carol Winer	'94
Conny J. Winter	'85
Andi Witczak	'04
Delve Withrington	'97
Burkhard Wittemeier	'03
Pirco Wolfframm	'03

Loni M. Wong	'04s
Fred Woodward	'95
René Wynands	'04
Sarem Yadegari	'03s
Azadeh Yaraghi	'04
Garson Yu	'05
David Yun	'04s
Azadeh Yaraghi	'04s
Hermann Zapf **	'52
David Zauhar	'01
Phillip Zelnar	'04s
Maxim Zhukov	'96
Piotr Zmuda	'03
Roy Zucca	'69
Jeff Zwerner	'97

SUSTAINING MEMBERS

Diwan Software	'03
Pentagram Design, Inc., New York	'04
The New York Times	'04
Warner Books	'05

* Charter member
** Honorary member
s Student member
a Associate member

Membership as of April 15, 2005

339

TYPE INDEX

When there are several variations of a typeface, faces are grouped together under the primary name. Some typeface names are preceded by the name or abbreviation of the type foundry that created them (such as Monotype or ITC), but they are alphabetized under the generic name.

341

343

GENERAL INDEX

ABOUT THE DIVIDER PAGES

The Latin alphabet is used by an estimated 1.5 billion people worlwide. Much of the world—an estimated 5 billion people—uses one of four alternative systems. They are: (1) *complex scripts* in the form of logograms, ideograms, and/or semantic-phonetic compounds (Chinese & Vietnamese); (2) *abjad,* consonant only systems, (Arabic, Hebrew, and Aramaic); (3) *abugida* or *alphasyllabaric*, symbols for consonants and vowels (Hindi, Thai, Ethiopian, and Lao); (4) *syllabaric*, symbols representing phonetic syllables (Japanese, Cypriot, and Cherokee); and other phonemic alphabets similar to the Latin alphabet in the form of Cyrillic, (Russian, Ukrainian, and Serbian), Greek, and Korean.

Chinese
NUMBER OF SPEAKERS:
Estimated 1,300,000,000

Hindi (Devanagari)
NUMBER OF SPEAKERS:
Estimated 480,000,000

Arabic
NUMBER OF SPEAKERS:
Estimated 275,000,000

Russian
NUMBER OF SPEAKERS:
Estimated 255,000,000

Japanese
NUMBER OF SPEAKERS:
Estimated 127,000,000

Korean
NUMBER OF SPEAKERS:
Estimated 78,000,000

Thai
NUMBER OF SPEAKERS:
Estimated 50,000,000

Ethiopic (Ahmaric)
NUMBER OF SPEAKERS:
Estimated 17,000,000

Greek
NUMBER OF SPEAKERS:
Estimated 15,000,000

Laotian
NUMBER OF SPEAKERS:
Estimated 15,000,000

PURE+APPLIED

Designed and typeset by Pure+Applied

Printed by Everbest Printing Co. Ltd.

Primary typefaces used in the composition of *Typography 26* are MillerText Roman, MillerText Italic, MillerDisplay Roman SC and Elderkin Bold

Paper is 128gsm Korean matte artpaper
Endpaper is 140gsm Japanese woodfree
Casewrap is Wibalin (Spine)

is Urshula Barbour, Paul Carlos, and Andy Pressman and is a studio specializing in the design of visual and textual content for books, exhibitions, magazines, and web sites and other image-and-type projects. (www.pureandapplied.com)

Our special thanks go to the Charles F. Nix and Carol Wahler of the TDC; Nancy Heinonen and George Dick of Four Colour Imports; Ilana Anger and Marta Schooler of Collins Design; Phillip Loo of Classic Scan; Lisa Kahan; Martin Paddio of the Monthly Review Press; our interns, Mandy So, Nao Kato, and Claudia Mark; and New York City with its shops and markets full of polyglottic diversity.

Total Net Weight
Each via

Total Net Weight
Each Vial